JEWISH "JUNIOR LEAGUE"

Acknowledgments

This book would never have been written had it not been for Associate Professor Stephen E. Maizlish, the conscientious graduate-student advisor at the University of Texas at Arlington. In January 2003, when I attempted to register for a three-credit Civil War class, Dr. Maizlish blocked my enrollment pending a face-to-face counseling session. It was the last day to register without incurring a financial penalty, and I was peeved that he had put up a bureaucratic roadblock when all I wanted was to take one measly course. I was a nontraditional student, taking scattered classes here and there with no goal in mind.

As it was late in the day, my advisor and I arranged to meet at his house that evening. When I entered his living room, I learned that he had pulled my student records and figured out what it would take for me to complete a master's degree. He predicted that I could finish the course work in eighteen months and write my thesis over a summer. Didn't I have a topic in mind already? Didn't that sound better than aimlessly enrolling in one class at a time?

In the calm of his living room, I listened to his logic. I recalled that the Jewish Women's Archive was awarding grants for research into "Jewish Women Building Community." I did indeed have a topic in mind, and it might dovetail as a thesis. The subject, which I related to Dr. Maizlish, was the heyday and disintegration of the Fort Worth Council of Jewish Women. As I related the local Council's rise and demise, Dr. Maizlish remarked that it was an interesting narrative, but it needed context. What was happening to other women's clubs throughout the century? Did the Fort Worth saga reflect a larger story? He suggested that women's historian Dr. Stephanie Cole would be an ideal thesis advisor—and she was. He advised taking seminars from urban historian Dr. Robert Fairbanks and counterculture guru Dr. Jerry Rodnitzky and including them on my thesis committee. When I left my advisor's residence, I com-

pleted my registration by computer. At the age of fifty-six, I was on my way toward a master's degree in history.

Dr. Cole proved to be an excellent advisor and colleague. With her assistance, I completed a grant application that was accepted by the Jewish Women's Archive in Brookline, Massachusetts. The prestigious JWA fellowship led to important speaking engagements, including a panel on "Jewish Women Building Community" at the Library of Congress during the 2004 Biennial Scholar's Conference on American Jewish History. During the conference, I received constructive critiques from Dr. Joyce Antler, Dr. Karla Goldman, Dr. Andrew Heinze, and Dr. Riv-Ellen Prell.

Later that year, Dr. Cole spoke about my master's thesis to Mary Lenn Dixon, editor-in-chief at Texas A&M University Press. Ms. Dixon and I had previously worked together on my first book, *Jewish Stars in Texas: Rabbis and their Work*. The experience was most positive. She was eager to review my thesis and assess its potential as a book in TAMU Press's Women's Studies series.

Trimming my master's thesis into book form was accomplished largely with the assistance of a thorough but anonymous peer reviewer who wrote notes in the margins of almost every page and recommended additional reading. Also of invaluable assistance was my friend and colleague Laurie Barker James, who helped extract the meat of each chapter for the introductory paragraphs. For proofreading the original thesis, I thank Esther Winesanker, Rabbi Ralph Mecklenburger, and my loving husband Bruce, an excellent speller. Historian Ruth Karbach read and reread the manuscript and caught a common mistake when I confused women's-club leader May Swayne with her sister-in-law Mary Swayne. For proofreading the final book manuscript, my gratitude goes to Roger Simon, a legal-writing professor at Texas Wesleyan University. This is our second collaboration. I appreciate Roger's eye for consistency and his expertise on commas, colons, and capitalization.

Deepest thanks to Brenda McClurkin and Gary Spurr, archivists, colleagues, and friends at the University of Texas at Arlington's Special Collections, which houses the *Fort Worth Star-Telegram* photo collection. That collection contains priceless news photos of NCJW women through the decades. The faces in the photos bring the dry sociology to life. Many other photos come from the collections at the Fort Worth Jewish Archives, which is funded by the Jewish Federation of Fort Worth and Tarrant County, and the Beth-El Congregation Archives, repositories where I volunteer and where the notes from this research are housed.

My sincere thanks to the *Fort Worth Star-Telegram*'s librarian, Marcia Melton, who allowed me access to clippings pertaining to local chapters of the Council of Jewish Women and the National Organization for Women. For access to

group's various programs were of interest to her. Not everyone joined, but those who did tended to get involved and to bring new programming ideas, as well as candid comments about their first impressions of the Fort Worth Jewish community. We also encouraged unaffiliated women—meaning Jewish women who did not belong to any synagogue but wanted some connection to institutional Judaism—to join the Sisterhood. And we started offering babysitting services, so that women with young children could attend Saturday morning services, summer activities, and special workshops. Until this point, babysitting services were only offered during Friday evening services, September through May.

We observed that few women attended general membership meetings. We stopped having them. Instead, WRJ instituted Chavurah Arts classes. *Chavurah*, from the Hebrew root word for *friend*, is a creative circle of Jewish companions. Women in the Jewish community who were painters, potters, knitters, jewelry makers, and collage artists taught these classes.

The Sisterhood of old was mainly associated with the kitchen. Current members did not want to become slaves to the stove, but they did want to learn their grandmothers' recipes. We started Art of Jewish Cooking classes, which were taught by our own members who shared their skills in *challah* braiding, blintz making, and *rugelach* baking. In the Chavurah Arts and cooking classes, young women bonded with older congregants as they shared techniques and traded kitchen anecdotes. The camaraderie in the kitchen fostered friendships unheard of in the cliquish Council. Last but not least, the women who coordinated the Chavurah Arts classes, the Art of Jewish Cooking classes, and an ongoing knitting group called Knitzvah were all participants at the initial Women's Seder.

One unanswered question is: Why try to resuscitate a veteran organization? Why not launch a new one? Because the old institution already has a deep sentimental base of support, a national office that can assist with leadership training, a written constitution that can be amended, stationery with a logo, funding sources, and a history that brings continuity and flavor to its activities. Rather than reinventing the wheel, WRJ adapted to changing conditions, both nationally and locally. The Fort Worth Council of Jewish Women failed to adapt in a timely fashion. As a result, the local chapter expired.

ing whose average age was seventy-five, seemed destined to fade through attrition. The Ladies Auxiliary to Ahavath Sholom, the equivalent of Beth-El's Women of Reform Judaism, called an emergency meeting in March 2003 to plead for someone to fill its presidency. Three sisters stepped in to share the office and to provide continuity by rotating their terms over a six-year period.

The National Council of Jewish Women (NCJW), at that time the subject of my master's thesis, had disbanded in 2002 after a proud 101-year history. It had expired because it was too conventional to adjust to an age of single motherhood, working women, and emphasis on religious identity. The local NCJW section had brought substantial changes to those it served and to the larger community, but not to its internal agenda. It had steered clear of women's-liberation rhetoric and edgy ideas colored with feminism. The Council was more concerned with placing its members into the secular world of nonprofit civic endeavors than with strengthening the sense of Jewish women's community in Fort Worth. For months, I had been interviewing past presidents of the Council, listening to them assess reasons for the group's dissolution. How they missed the Council and the book fairs, the cookbooks, and the public-policy discussions that it had sponsored. If the Beth-El Sisterhood folded, I would spend the rest of my life listening to local women lament the loss of yet another beloved female organization.

From the ivory tower of academia and infused with energy from the women's Seder, I jumped in and volunteered to lead the Women of Reform Judaism. A one-year apprenticeship as president-elect would be followed by a two-year term as president. Intellectually, I thought I understood what the problems were and how to fix them. Of course, it is easier to critique from an ivory tower than to confront problems on the ground. I looked around and realized that some of the women who had attended the first feminist Seder might provide the nucleus for the revival of Women of Reform Judaism (WRJ).

WRJ had been on the decline for a decade. There were no minutes of recent vintage—only sparse budget records from the previous year, negative attitudes, and warnings not to change "the way we have always done things." Reinventing the organization meant rereading *Bowling Alone* and many other source materials used in my master's research. These studies analyze the general decline of chapter-based organizations throughout the United States. Resuscitating WRJ also entailed developing deeper relationships with the women who supported the feminist Seder, finding out what they yearned for in a Jewish women's community, and understanding why they chose not to become involved in local Jewish women's groups.

Four years have passed. WRJ has grown from 110 to 184 members—still less than half of the 400 eligible women, but it has a strong pulse. Part of the for-

mula for growth was to utilize advice from the academic experts. According to sociologists and anthropologists, career women have not stopped volunteering. Blaming the decline of a nonprofit organization on the fact that more women work full time is often an indication of intransigence within an institution. When young, twenty-first-century career women volunteer their time, they prefer to utilize their professional talents, rather than spend hours addressing invitations or pricing rummage. For example, when the WRJ organized a sex-education panel for a program dubbed "More than the Birds 'n the Bees," a pediatrician, a child psychologist, a school counselor, and a Planned Parenthood educator from among the membership were delighted to participate. A Certified Public Accountant became the treasurer. A woman with a graphics business was flattered when asked to design invitations to a WRJ fundraiser. A writer like myself would rather revise the Haggadah—the Passover Seder service—than be a Sunday school room mom.

Jewish women's priorities have changed. National focus groups indicate that Jewish women's preferences for volunteer work are oriented not only around their professions, but also around their children, women's issues, and Jewish causes. They relish having a Jewish component to their volunteer work. The rise of identity politics has made Jewish women more open about declaring their religion. There is a new flip phrase, "Just Jew it," which might mean lighting Hanukkah candles in a restaurant or wearing a T-shirt with a Hebrew slogan. By contrast, the emphasis within Fort Worth's Council of Jewish Women—the subject of this book—had very little to do with Judaism. The Council helped women blend in and "pass" into secular social-service endeavors. In fact, it was a former NCJW officer and Junior League president who referred to the NCJW as a "Jewish 'Junior League.'" (See chapter 4.) And she was not alone in bestowing that sobriquet.

The NCJW was perceived as elitist, as an organization for married women who could afford to leave their children with a maid while they did volunteer work and attended monthly luncheons. In the words of Laurie Barker James, who assisted with this manuscript and with the revival of the WRJ, "My grandmother's Council was as much about social action as about dressing up and entertaining."

In Fort Worth, one of the first steps toward reviving the Sisterhood was to welcome all women. The Sisterhood had to be egalitarian—an avenue to activism open to the married, the single, the divorced, the widowed, the non-Jew married to a Jewish spouse, and women studying for conversion. We instituted a one-year free membership for women new to the congregation. Each new congregant received a personal phone call. To join, she had to complete one requirement—fill out a membership application and indicate which of the

Preface

Why is this night different from all other nights? That inquiry is the first of Four Questions asked at every Passover Seder, the world over. But why was the night of April 18, 2003, especially different from all other nights, and why did that evening mark the start of my personal journey into the web of Jewish women's organizations? Until then, I had been researching the rise and demise of the Fort Worth National Council of Jewish Women (NCJW) from afar, with the detachment of a journalist or an academician.

On that night, twenty women participated in Fort Worth's first women's Seder, a feminist ritual that challenged tradition. The twenty women who gathered in my living room for that pioneering Passover potluck were handpicked, because in Fort Worth, feminism is an "F" word. The notion of a women's Seder—as opposed to a traditional family Seder celebrating the ancient Exodus from Egypt—was offensive or downright confusing to many. A women's Seder retells the story of Passover, but it replaces Moses' leadership role with his sister Miriam's deeds of bravery. Instead of describing four sons who ask questions about the holiday, the narrative features four daughters. The ten plagues of Egypt are followed by ten plagues historically suffered by Jewish women.

Such gender bending of the biblical narrative does not appeal to all. Indeed, it sounded radical to many women within my circle of acquaintances. The first woman invited to the Seder was enthusiastic but, for professional reasons, declined to attend. The second woman I approached doubted that we could assemble twenty kindred spirits. Some women were puzzled at the concept. Others said that it sounded interesting, but they could not attend a religious event without their husbands. Some contended that it bordered on male bashing. Women's Seders, which had begun in 1979 in New York and Israel, were common enough elsewhere in the Jewish world but crossed a threshold in Fort Worth. Soon, I was hesitant to extend invitations, lest I offend another person.

I began asking for referrals and started telephoning people whom I barely knew—friends of friends, university women, and newcomers to town.

The final guest list included sixteen women from Fort Worth, three from Dallas, and one from Houston. They were single, widowed, married, and divorced. They ranged in age from sixteen to eighty-five and included three sets of mothers and daughters. A handful had been active in the defunct NCJW section. One of the guests wrote up the occasion for the *Texas Jewish Post*'s "Around the Town" column. As a result, we heard from women who wished that they had been invited. The next year, the Seder expanded to forty guests from throughout Tarrant County. The year after, it went public, jointly sponsored by four Jewish women's organizations, with attendance topping 120. Also spurring attendance was the backlash created when the local Conservative rabbi, who thought the Seder sacrilegious, asked us to cancel it.

Looking back, the women breaking Matzoh and breaking tradition in my living room composed a web of women who would spark organizational changes in Fort Worth. The groundswell of support and the friendships that the Seder fostered led us to wonder what else we might do with this newfound camaraderie. Why couldn't our local Sisterhood, Hadassah, or B'nai B'rith Women chapters spearhead gatherings such as this? Why hadn't the local section of the National Council of Jewish Women attempted a women's Seder? (Because the Council was not attuned to changing currents vis-à-vis gender and Judaism.) Why couldn't our local Jewish women's groups break out of the staid, club-meeting mold? What was holding us back?

Six months following that first women's Seder, I learned that the Beth-El Congregation Sisterhood—a.k.a. Women of Reform Judaism, or WRJ—was on the verge of dissolving. Its president and treasurer had recommended combining the Sisterhood with the Brotherhood, the congregation's men's club. I fretted that Fort Worth was about to lose another Jewish women's organization, and what a pity. Single-gender groups add a significant dimension to a congregation and to a community. They provide easy entry points for newcomers, forums for relatively uninhibited discussion, and common ground for people of diverse ages, occupations, and marital status. Single-gender networks can often innovate and get things done expeditiously, bypassing the usual bureaucracy through personal contacts and know-how. Traditionally, in synagogues as well as churches, women's groups have filled unmet needs until the congregation as a whole absorbs such programs into the larger scheme.

In Fort Worth, Jewish women's organizational networks seemed on the wane. Already, the local Brandeis University Women's chapter was a thing of the past, with nothing left but two archival boxes of scrapbooks and minutes. Jewish Women International (previously B'nai B'rith Women), with a follow-

Illustrations

Contents

*To the Jewish Women's Archive in Brookline, Massachusetts,
www.jwa.org, for providing the impetus, validation, encouragement,
and initial funding for the research that evolved into this book*

HOLLACE AVA WEINER

Jewish
"Junior League"

The Rise and Demise of the
Fort Worth Council of Jewish Women

TEXAS A&M UNIVERSITY PRESS, COLLEGE STATION

LIBRARY OF CONGRESS CATALOGING-IN-PUBLICATION DATA

Weiner, Hollace Ava, 1946–

Jewish "Junior League" : the rise and demise of the Fort Worth Council
of Jewish Women / Hollace Ava Weiner.

p. cm.

Includes bibliographical references and index.

ISBN-13: 978-1-60344-012-7 (cloth : alk. paper)

ISBN-10: 1-60344-012-7 (cloth : alk. paper)

1. National Council of Jewish Women. Fort Worth Section. 2. Jewish
women—Texas—Fort Worth—Societies and clubs—History. 3. Jewish
women—Texas—Fort Worth—History. 4. Jewish women—Texas—Fort
Worth—Social life and customs. 5. Fort Worth (Tex.)—Ethnic relations.

I. Title.

E184.36.W64W45 2008

305.89240764'531—dc22

2007033911

records from a century ago, I thank Dawn Letson, Texas Woman's University's assistant director of libraries for special collections, and Ann McGuffin Barton, TWU's library assistant for its remarkable Woman's Collection. That collection includes handwritten minutes from the Fort Worth Federation of Women's Clubs, whose early recording secretaries were generally the presidents of the Council of Jewish Women. Additional thanks go to the staffers at the Library of Congress who pulled the National NCJW files out of remote storage. In Cincinnati, the staff at the Jacob Rader Marcus Center of the American Jewish Archives in Cincinnati—specifically, Kevin Proffitt, Camille Servizzi, and Dr. Gary P. Zola—have helped me in this and many other endeavors. My gratitude also goes to the Southern Jewish Historical Society for a grant toward completion of this book and to the society's Dr. Mark K. Bauman, my mentor from way back.

Last but not least, completion of my master's thesis prompted me to organize a panel titled "Women of Worth" for the 2006 Texas State Historical Association conference in Austin. My Fort Worth colleagues Ruth Karbach and Jan Jones participated on the panel, from which sprang the idea for an anthology about Fort Worth women. Judy Alter, director of the Texas Christian University Press, embraced the idea. The subsequent book, Grace & Gumption: Stories of Fort Worth Women, is in print with a chapter that expands upon my thesis-research into Amelia Rosenstein, dean of the NCJW's Americanization School. Thus, my journey toward a master's degree led to many side trips, replete with new travel companions, all thanks to a graduate-student advisor who put up a roadblock before permitting me to register for classes.

CHAPTER ONE

Introduction

Looking Backward at a Product of its Times

Throughout the early twentieth century, the National Council of Jewish Women was the United States' largest Jewish women's voluntary organization, both nationwide and in Fort Worth. But times change. By the early twenty-first century, seven states—Alabama, Arkansas, Kansas, New Hampshire, North Carolina, Oklahoma, and Vermont—no longer had chapters. In Nevada, despite Las Vegas's status as the nation's fastest-growing Jewish community, no Council section had ever been established. Of twenty-two Council affiliates that had once thrived in Texas, six remained—in Austin, Dallas, Houston, San Antonio, El Paso, and Fort Worth, and the latter three faced dissolution. In its heyday, the Council had helped women bridge the transition from home to social action. In Fort Worth, it helped Jewish women succeed in the civic sphere despite covert anti-Semitism and limited opportunities to join secular and social clubs. There is no doubt that Fort Worth's Jewish women integrated into the community's mainstream collectively via the National Council of Jewish Women. From the beginning, however, critics of the Council viewed it as an elitist organization that welcomed affluent and American-born Jewish women but not immigrants with Yiddish accents. It seemed to be the Jewish equivalent of the Junior League, a prestigious women's organization that performed social service and conferred social status. During feminism's "second wave" in the 1970s, when egalitarianism and equal opportunity became bywords, many Jewish women found the Council to be irrelevant. By the end of the century, Jewish women and the times had changed more rapidly than their institution. A variety of factors combined to sap the Council of the very women who had been its lifeblood. In Fort Worth, during the winter of 1999, past presidents and current members pondered the future and gathered with one question in mind.

Could Fort Worth's beloved Council of Jewish Women be revived? Convinced that their ninety-eight-year-old institution had merely faltered, not

fallen apart, thirty-five women convened at the home of Rosalyn G. Rosenthal with the hope of rejuvenating the chapter. Rosenthal, who had summoned two national representatives to facilitate the gathering, had served as Council president thirty-nine years before. Most of the women in her living room were past presidents, too. The Fort Worth Council of Jewish Women had been without a president or executive board for nearly three years. Yet the group had money— $98,600 in the bank.[1] It had committed people—104 life members.[2] It enjoyed a sterling reputation in the community. Surely the factors draining leadership from the organization could be remedied.

As these clubwomen, who ranged in age from thirty-five to seventy-five years of age, filled sofas, arm chairs, and folding chairs, they sipped iced tea and hot coffee and geared themselves for the tasks ahead. They directed their focus toward a flip chart in a corner of the living room where two national representatives—longtime New York staff member Beth Levy and veteran board member Charlene Spielvogel—began writing down strengths and weaknesses and pros and cons for reviving the local group. On the down side, intergenerational ties had slipped away.[3] Many a senior in the room was a stranger to the current membership. Until receiving an emergency letter about the meeting, most of the older women had been unaware of the drop in Council participation and the vacancy at the helm. They had moved on to professional careers and other volunteer commitments.

"If only you had notified us," a president from yesteryear implored the group's last president, "we would have come to your aid." "It's not her fault, it's our fault," piped up another president from decades before. "We went on to other pursuits. We should have stayed involved like the women in Hadassah," the women's Zionist organization that had become proactive on the local medical front. "The Junior League began drafting Jewish girls," asserted another participant, laying the blame on the higher-status group that until 1972 had excluded local Jews. The nationwide push for multiculturalism had led the Junior League to look beyond the social directory for recruits. "The Junior League is having trouble getting volunteers, too," interjected another participant. "Women are working nowadays."[4]

Despite the flow of women into the workforce and changing demographic patterns, Fort Worth's Jewish women remained high-profile volunteers. The Council, however, was no longer their springboard to civic involvement. Seven years before, two Jewish women had launched the local Susan B. Komen Race for the Cure, raising millions for breast-cancer research.[5] Jewish women also headed executive boards of religious and civic institutions that had once scoffed at gender equality. Indeed, across Fort Worth, Jewish women were advancing causes that the Council advocated, but they no longer volunteered

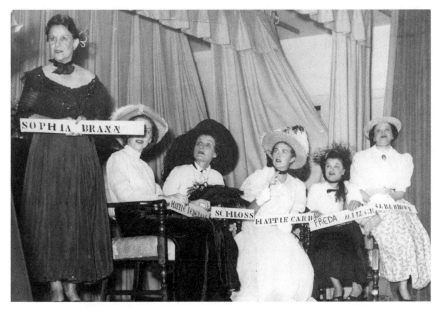

*Nostalgia. At the Fort Worth NCJW's fiftieth anniversary party in 1951,
members in turn-of-the-century costumes performed skits about the section's
founders. Courtesy, Beth-El Congregation Archives, Fort Worth.*

under the mantle of the NCJW or as representatives of the Jewish community. With the gradual elimination of religious barriers in American society and with moves toward gender equality, professional parity, and egalitarianism, Fort Worth's young Jewish women no longer needed the Council as their conduit to the civic arena.

The Council veterans seated in Roz Rosenthal's living room talked nostalgically of the camaraderie that their organization had once fostered among Jewish women, and they lamented that advances on other fronts had eroded the solidarity of their Jewish female network.[6] They reminisced about the Book Fair—the Council's citywide used-book sale that from 1958 to 1996 had fostered a sense of community across Fort Worth. They recalled the Council's Americanization School that from 1907 to 1973 had helped immigrants of all creeds receive U.S. citizenship. They reminded one another that the Fort Worth Council had resuscitated the Reform congregation after its collapse in 1903. The Council, long perceived as a Jewish organization on a par with the local Junior League, had also served as a model for launching other local Jewish women's organizations that were now outpacing it. Gone was the era when the Fort Worth Council's president was looked upon as the lay leader of the Jewish

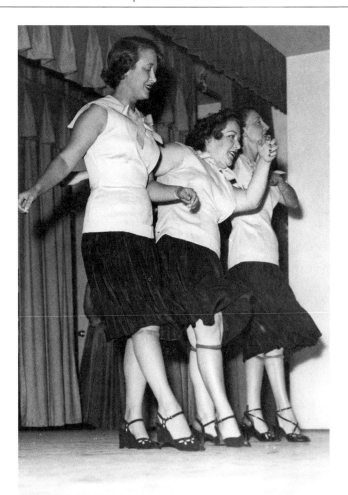

Memory lane. Skits performed at the NCJW's Golden-Anniversary Gala included a trio dancing the Charleston. Bernice Meyerson (left) swings her arms alongside Ceil Echt and Carolyn Gernsbacher Rayel. Courtesy, Beth-El Congregation Archives, Fort Worth.

community and was among the stars in "Leadership Fort Worth," which groomed future civic figures.

However, as the older women waxed nostalgic about Council's heyday, they were unaware that nationwide the number of NCJW sections had plummeted more than 50 percent—from 245 at Council's peak in 1960 to 122 in 1999. Beside their own chapter, at least twenty more were facing extinction, including affiliates in Boston, Tucson, and El Paso.[7] The national representatives leading

the emergency meeting did not disclose that the Fort Worth experience illustrated why the drop, both locally and nationally, was occurring. Nor, amid the finger-pointing and breast-beating, did anyone suggest that the local Council might have been a victim of its own success.

Since its inception during the Progressive era, the Fort Worth Council had worked toward integrating Jewish women into the city's mainstream, and it had succeeded. The organizational patterns propelling the local Council's success had sowed seeds for its gradual demise. Yet at the reorganization meeting in 1999, attention focused on reenergizing the chapter according to past models—through tried-and-true social-service projects such as collecting cast-off school clothing for Catholic Charities Inc. The focus was not about researching or addressing unmet needs of contemporary Jewish women and finding a fresh niche.

The Fort Worth section of the NCJW had traversed the spectrum of twentieth-century American women's experiences, from the Progressive era's expansion of civic housekeeping to feminism's second wave. The group's creation and its members' integration into the mainstream occurred as Fort Worth had grown in size and sophistication from a cow town of 26,000 into a metropolis of 500,000. Cultural and civic priorities had changed as radically as the city. The Council of Jewish Women's successes and adaptations, as well as its gradual disintegration, reflected the currents of the century.

The Fort Worth Council of Jewish Women's historical narrative tells much about the meaning of community in a place like Fort Worth, a conservative, medium-sized Southwestern city that retains a frontier flavor. A river bluff town, Fort Worth originated in 1849 as a military camp, one in a line of Army forts protecting eastern settlements from the Comanches, Caddos, Kiowas, and Tonkawas. As the frontier receded west, the soldiers departed. Settlers took over the barracks and stables and gradually built a village. After the Civil War and Reconstruction, the strategic settlement overlooking the twin forks of the Trinity River developed into a watering stop for cowboys herding cattle north to Kansas via a branch of the Chisholm Trail. Because Fort Worth was one of the last places for cattle drivers to let off steam and stock up on provisions before crossing into Indian Territory, business flourished for merchants, blacksmiths, bartenders, and gamblers. The swinging doors of saloons were in motion day and night. For target practice, cowboys shot bullet holes into merchants' metal signs.[8]

A dozen or so Jewish families came to Fort Worth between 1858 and the 1870s. These Jewish settlers had roots in Poland, Prussia, Alsace, Bavaria, New York, Tennessee, Mississippi, Indiana, and Louisiana. All had lived elsewhere in the United States and were acculturated to American life. Adventure and

opportunity brought them to the frontier town. Religion had little role in their lives. Yet, in a pattern replicated among Jews and other ethnic groups throughout the United States, they formed business partnerships and met and married one another's sons and daughters, creating a network of interlocking family and business ties.[9] The wives, mothers, and daughters in these pioneer Fort Worth Jewish families would all play a part in the city's women's-club movement.

Although Jews socialized mainly among themselves, they lived interspersed among their Christian neighbors. Anti-Semitism was minimal and rarely overt. The city's Bible Belt location engendered respect for Jews. Fundamentalist Christians acknowledged them as the "people of the book." Pioneer Baptist women, for example, felt an affinity with biblical Jewish women because of their subordinate role in the worship service and their exalted role in the home.[10] Furthermore, the frontier society (from the 1850s through the 1890s), with its embrace of pluralism, encouraged integration, participation, and assimilation. Among Jewish women, however, the pull of their ethnic and religious heritage held them back, reflecting a degree of tension, timidity, and self-segregation. Their collective goal was participation, not assimilation. They wanted to acculturate enough to feel American without abandoning Judaism.[11] The Fort Worth Council of Jewish Women's early history demonstrates both its members' assertiveness as "new women" and their insecurity as Jews hesitant to pull away from their tribal group.

This book explores the journey of Jewish women in Fort Worth, Texas, from the constraints and contradictions of their religious tradition to the forefront of their community as representatives of the National Council of Jewish Women. Along the way, it examines whether Jewish women's patterns of emergence into public life were similar to those of Jewish men. Similarly, did Jewish women's paths to communal participation parallel the route of middle-class Protestant women? That is, what roles did gender and Judaism play in acculturating to the secular community? What roles did the Council play in Jewish women's collective and individual emergence into public activism? It is also relevant to examine women's roles historically within the Jewish community and to ask whether formation of the Fort Worth Council in 1901 altered the status of Jewish women. Did the organization empower women within, as well as beyond, the Jewish community? Was the Fort Worth Council an elitist group, more comfortable for Reform women than for Orthodox Jewish women, and more accommodating toward American-born women than to immigrants? Did the Council strengthen communal bonds among Jews or bring internal differences to the fore? How did it help build community within and beyond the Jewish population?

Studies of similar journeys taken by middle-class women—both Protestant

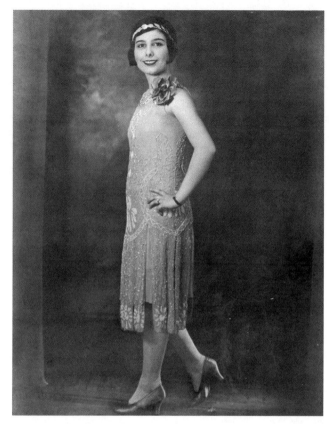

*Madam president. Charlotte Goldman passed along a legacy of
involvement to her daughter, Carol Minker, and her daughter-in-law,
Carol Goldman. All three served as presidents of the Fort Worth section.
Courtesy, Beth-El Congregation Archives, Fort Worth.*

and Jewish—in other geographic settings provide context to understand the
lives of Fort Worth Council members. In particular, four scholars have out-
lined and analyzed key applicable transitions. Women's historian Anne Firor
Scott sees gendered religious organizations as the embryonic threshold lead-
ing to women's public-reform efforts.[12] While some Texas scholars—notably
Judith N. McArthur—do not perceive these connections in the Lone Star state,
others, such as Elizabeth Hayes Turner, who studied Galveston clubwomen,
do.[13] American Jewish historians generally concur with Anne Firor Scott that
Jewish women's religious-based benevolent organizations served as a prelude
or springboard to civic involvement. This tendency among American Jewish
women appears to transcend region.[14]

Second- and third-generation leaders. Carol Goldman Minker, left, and Ellen Feinknopf Mack volunteered at the annual Book Fair and served as Council presidents. Minker's mother, Charlotte Goldman, was president in 1951. Mack's mother-in-law, Norma Harris Mack, was a president, as was Norma's mother-in-law, Polly Sachs Mack. Courtesy, Fort Worth Star-Telegram Photograph Collection, Special Collections, The University of Texas at Arlington Library, Arlington, Texas.

A second key element on women's collective journey toward civic importance involves their level of philanthropy, measured not only in dollars and cents but also in terms of time, advocacy, and institution building. Kathleen D. McCarthy places clubwomen's intangible gifts on a parallel plane with men's monetary outlays. She points out that women's groups created power structures

that resembled the business and political arenas of men. Philanthropic endeavors enabled American women to claim distinctive public roles through the nonprofit sphere.[15]

As the twentieth century progressed, the dynamics of feminism's first wave, which promoted women's right to vote, and its second wave, dubbed the *women's liberation movement*, had ramifications for all women. Sara M. Evans focuses her lens on these changes, subtle and profound.[16] Historian Beth S. Wenger describes American Jewish women as continually renegotiating their roles, vis-à-vis Jewish men, as they redefined gender constructs and reassigned communal responsibilities.[17] Wenger suggests that future studies explore the challenges that subsequent generations of Jewish clubwomen faced as the social-housekeeping rationale for volunteer work underwent devaluation and transformation. Fort Worth was no exception. Jewish clubwomen, who had previously followed in the footsteps of their mothers and mothers-in-law, developed a wider range of alternatives and preferences. Shifting cultural currents, linked to identity politics and the multiculturalism spawned by the civil rights movement, affected the way that women self-actualized in American society.

During most of the nineteenth century, the American woman's primary and preeminent role was motherhood. Victorian notions of "true womanhood" defined the female as a fragile emotional being limited to the domestic arena.[18] She was praised as a paragon of virtue, purity, piety, and self-sacrifice. The female sphere, an ideological construct based on gender and class notions, was intrinsically different from the male arena.[19] Men shielded women from unpleasant, unscrupulous practices that raged in the outside world. Women looked inward to their households, extended families, and faith-based groups. For socialization and for learning domestic skills, women depended on their networks with one another. Unless women were acquainted through blood, marriage, or religious ties, they often had little interaction with one another. Custom, convention, and restrictive laws limited their participation in the communal sphere, except for benevolent involvement in gendered religious institutions of their faith.[20] In the early part of the century, society permitted them to associate within the spiritual arena, where seeds were planted for women's growth and civic involvement in later decades, according to Anne Firor Scott.[21]

Among American Jewish women, this denominational activity first manifested itself in 1819 with the formation of Philadelphia's Female Hebrew Benevolent Society, which was created by the "ladies of the Hebrew Congregation . . . desirous of rendering themselves useful to their indigent sisters of the house of Israel."[22] Three of the founders—Miriam Simon Gratz (1750–1808) and her daughters Rebecca (1781–1869) and Richea (1774–1858)—had helped in 1801 to

start a similar, nonsectarian group for women.[23] From this experience, they became comfortable negotiating their way in the local social-service network. However, the Protestant volunteers with whom they worked tended to evangelize while giving aid to the poor, much to the discomfort of the Gratz women.

Some scholars of American Jewish history contend that the evangelical aims of Protestant women are what kept nineteenth-century Jewish women from rushing toward nonsectarian causes, including the abolitionist movement and the 1848 Seneca Falls women's-rights conference. Indeed, Elizabeth Cady Stanton (1815–1902), one of the Seneca Falls organizers, authored a *Woman's Bible* that criticized Judaism for setting patriarchal standards and codifying degrading attitudes and practices against females.[24]

The Gratz women responded to Christian evangelizing in 1819 by organizing with others a specifically Jewish charity, the Philadelphia Female Hebrew Benevolent Society.[25] The pattern of Jewish benevolency that the Gratz women set was replicated in New York and elsewhere. In 1838, the pioneering Rebecca Gratz launched for boys and girls a Jewish Sunday school, modeled after the Protestant Sunday school movement. Sunday schools were at odds with traditional Judaic norms in which men, rather than women, passed Hebrew scholarship to sons. Utilizing Sunday, rather than Saturday, for religious activity, was another adaptation. Breaking barriers in one realm led Jewish women to tread, however cautiously, into other arenas, such as cemetery societies and worship-service attendance, modeling their behavior after gender norms observed in the Protestant community.

The American Civil War accelerated these changes and widened the sphere of female benevolence. During wartime, women's roles expanded, as did their mobility, their contributions to public causes, and their exposure to newspapers and periodicals, which proliferated during the era. Anything that drew women out of their insular confines was bound to have a societal impact. In the postwar burst of altruism, Clara Barton (1821–1912) launched the American Red Cross, which visibly extended women's nurturing stereotype to society at large. The Red Cross serves as a prime example of *domestic feminism*, whereby women expanded the scope of their household roles into the civic arena.[26] Later feminist historians have described this broadening of women's work as *female consciousness* because women, for whom maternal aims were uppermost, attempted to solve societal problems in a nurturing way. Such thinking enlarged women's boundaries yet kept them within an accepted gendered domain.[27]

In the aftermath of the Civil War, a tide of fraternalism also emerged. Veterans' groups flourished. The fraternal movement, which had started before the Civil War, gathered momentum. Men from similar classes and economic strata banded together and bonded. Those who were excluded—meaning mar-

ginalized groups such as immigrants, working-class religious denominations, and women—replicated this fraternal model. Clubs flourished to such an extent that Henry Martyn Robert in 1879 authored the still-relevant *Robert's Rules of Order* to teach a generation of adults how to conduct a meeting without it degenerating into chaos.[28]

Women's clubs were initially organized for literary, musical, and other educational pursuits. Since it was unusual for women to gather for nonsectarian purposes, their clubs were lampooned and eyed with suspicion. As *The Ladies' Home Journal* editorialized, "Women decided to retaliate and have clubs for themselves, from which men should be excluded. . . . And what is the result? Men and women are, if anything, more widely separated than ever."[29] Despite such derision, the early women's-club movement proliferated. Nationally, the most visible clubs were the New England Woman's Club in Boston, founded in 1867, and Sorosis in New York.[30] Sorosis was formed in protest in 1868 after women journalists were excluded from a press dinner that they helped organize for British novelist Charles Dickens. Within two decades, there were around one hundred such women's clubs across the nation. Their proliferation was a sign that well-to-do females were concerned with injustice and gender discrimination. They were also thirsting for education and socialization among other women in their strata. In 1889, the Sorosis club celebrated its twenty-first anniversary by inviting to New York a representative of each club with which it was familiar. The women who attended agreed to reconvene the following year, at which time they chartered the General Federation of Women's Clubs (GFWC).[31] With that, middle-class women's clubs became a nationwide force.

At that time, Texas had a handful of women's literary clubs, but none were on the national radar. The state's early Shakespeare clubs tended toward discussions of female characters such as Lady MacBeth, Ophelia from *Hamlet*, and Kate from *The Taming of the Shrew*. After studying the Bard, many a Texas literary club moved to the plays of Henrik Ibsen, whose unconventional female protagonists foreshadowed feminists of later years.[32] "Discussions [of Ibsen] . . . allowed clubwomen to consider alternatives to motherhood," notes Anne Gere.[33] Once women started discussing possibilities beyond the household sphere, their thoughts and pursuits could not be so easily bound by convention. The clubs drew women into civic life.

With urbanization and industrialization, exposure of unsafe working conditions and child labor practices began to erode survival-of-the-fittest attitudes. The Progressive-era ethos extended a helping hand to less fortunate victims of industrialization.[34] Women's clubs expanded to encompass social involvement.[35] In Texas, literary clubwomen became acutely aware of illiteracy and the shortage of reading materials. They organized public libraries, and then they lobbied

for compulsory school-attendance laws. Anne Gere believes that their altruism was also a defensive response to the mockery that persisted in the press toward women's clubs. Many a women's group publicized its tree plantings and penny-lunch programs while downplaying the high teas and literary discussions that bonded members.[36] As Progressive-era ideals supplanted Victorian notions of class, it was no longer politic to stress the social or the frivolous, lest it seem self-ish. Missionary women, in particular, looked down on the self-culture movement as less than virtuous and declared that if women would only give as much time to church work as they did to the card game of whist, they would become a "power and inspiration."[37]

By 1893, the term *new woman* was being bandied about in the popular press with reference to clubwomen partaking in the world of ideas and pursuing goals beyond the home.[38] The term was initially popularized by novelist Henry James, whose fictional "new women" were young, unmarried American girls who scorned social conventions.[39] Spoken tongue-in-cheek, the expression evolved into an all-encompassing construct for women who were redefining their roles. Typically, the clubwoman who fit the new woman stereotype tried to dissociate herself from the confrontational suffragists. Even if she favored the right to vote, the clubwoman articulated her views softly and politely.[40] Later academicians termed the turn-of-the-century's new woman a *social feminist* because she subordinated female emancipation to general social reform when she lobbied for such issues as child labor laws, meat inspection, purification of water, and conservation of endangered birds.[41] She also conveyed what Nancy Woloch describes as an "enhanced sense of self, gender, and mission."[42] Elizabeth Enstam sees *new women* in step with changing times as they worked for legislation that changed the role of government and embraced Progressivism.[43]

The new woman worked in conjunction with others. Since most women's clubs—whether focusing on Shakespeare, music, gardening, or even sewing—were crafted from the same institutional model, they easily bridged, partnered, and affiliated with one another. This gave rise to coalitions and federations of organizations with national officers, nationwide agendas, and local chapters that fanned across the country. It was a network that could share ideas, set goals, advocate policy changes, and accomplish a high percentage of them.

Part of the stimulus to coalesce emerged from another development—the international exposition, which proved to be a catalyst in the formation of women's groups. World's fairs periodically showcased industrial and commercial advances in Western society. The first of these fairs was London's 1851 Crystal Palace, which included exhibits celebrating women's crafts such as needlepoint, china painting, and cookery. At subsequent expositions, women's achievements were housed in separate buildings. That gave rise to separate gov-

erning bodies, entrusting women with key administrative roles. At the 1876 Philadelphia Exposition, which commemorated the United States centennial, a woman's committee was part of the managerial structure, empowering women to set their own agenda. By 1893, Chicago's Columbian Exposition featured a Board of Lady Managers and a women's building designed by a female architect. In Chicago, women's entries were sometimes exhibited alongside men's accomplishments. John Cawelti hails the Chicago exposition as a "climactic moment" applauding the "new woman."[44]

It was during Chicago's 1893 Columbian Exposition that Jewish women emerged from the realm of *historical invisibility*.[45] A religious parliament was on the agenda. Chicago clubwoman Ellen M. Henrotin,[46] vice president of the World Congress Auxiliary, coordinated the women's branch of the General Committee on Religious Parliament. In that capacity, she appointed one representative from each major religious denomination, women who were nationally known or who had pulpit experience or seminary training. At that time, there were no female rabbis and no nationally visible Jewish suffragists.[47] To head the Jewish Women's division of the World Parliament of Religions, Henrotin turned to her Chicago friend, Hannah Greenebaum Solomon (1858–1942). Solomon and her older sister Henrietta G. Frank had been the first Jews recruited into the Chicago Women's Club, a powerful civic and social-reform group. Solomon, a self-proclaimed suffragist, had connections within and beyond the Jewish community. She was also active in the city's Jewish organizations, with relatives among the founders of five Chicago synagogues.[48]

Starting with her extended family and friends, Solomon contacted rabbis, Jewish clubwomen, and writers around the nation, asking for nominees to participate in the Jewish Women's Congress. As she slowly gathered cohorts, Solomon and her circle resolved that a byproduct of the Jewish Women's Congress would be a permanent, national Jewish women's organization.[49] Solomon's search for a geographic cross-section of Jewish delegates to the Chicago congress netted ninety-three female representatives from twenty-nine large cities.[50]

When the four-day Jewish Women's Congress convened on September 4, 1893, it was so successful that "the room originally intended for the sessions was found inadequate." Despite moving to a larger hall, an "overflow-meeting" had to be held. Jews and non-Jews attended. Topics included religious persecution, Jewish women in biblical and medieval times, women in the synagogue, women as wage-workers, Judaism in the home, charity according to the biblical code, women's place in charitable work, and mission work among unaffiliated Jews.[51] On the Congress's closing day, Chicago delegate Sadie American[52] (1862–1944), a charismatic "new woman" of her time, made a motion to create a permanent women's organization in which Judaic study would be one pillar and

Generation to generation. This 1954 brochure illustrates the changing face, dress, and perceptions of clubwomen. National Council of Jewish Women, Collections of the Manuscript Division, Library of Congress.

social service the other. Touting itself as the first national organization uniting Jewish women across denominational lines, the National Council of Jewish Women came into being on September 7, 1893 (although the word *national* was not generally used in its publications or its logo until 1923).[53]

Modeled after secular women's club federations, the NCJW's organizational framework and goals combined nineteenth-century women's clubs with social reform and a dash of religion. The founders of the Council of Jewish Women, like Rebecca Gratz and her followers decades before, "hoped to create an acculturated Judaism that, without abandoning the broad outlines of Jewish tradition, would still feel American."[54] The new group's glossary of institutional

PUT YOURSELF IN THIS PICTURE

The volunteer era. During the affluent post–WWII decade, the NCJW grew dramatically as stay-at-home women filled leisure hours with meetings and volunteer activities. This brochure, dated 1958, is titled "Join Council." National Council of Jewish Women, Collections of the Manuscript Division, Library of Congress.

terms reflected forward thinking. The Council of Jewish Women's founders called themselves *women*, not *ladies*, because the latter term was pregnant with class implications. Rather than being a *society*, the organization chose the word *council*, connoting representative democracy. Use of the word *Jewish* demonstrated the founders' pride in their distinct religious heritage. The group's local affiliates would be *sections*, rather than *affiliates* or *chapters*, indicating that each unit was an integral part of the whole.

To organize local sections, regional vice presidents were selected, including one from Texas—Ada Chapman, a rabbi's wife from Dallas, who was soon replaced by Jeannette Miriam Goldberg, a college-educated new woman from the East Texas city of Jefferson. These leaders, and others touched by Chicago's Columbian Exposition, returned home with a "strong sense of women's role in the world," concluded Ann Firor Scott.[55] Across Texas, Jewish and non-Jewish women felt ramifications from the Chicago World's Fair. Clubwomen, among them a small number of Jews, began talking about convening a Texas Women's Congress modeled after events in Chicago.[56]

In Jewish circles, women read with anticipation about their new national organization. When the Council's Texas organizer, Jeannette Miriam Goldberg, arrived in Fort Worth in the autumn of 1901, ripples from the Chicago world's fair had already altered the role of the city's key women's organizations. However, Fort Worth was a unique locale. To understand the contours of the founding of Fort Worth's Council of Jewish women, one must first examine the social history of the city itself.

Pioneer Women Get Organized

Fort Worth's Jewish community grew in the last decades of the nineteenth century, increasing from a handful of pioneer families to more than five hundred individuals. Through their business endeavors, the city's Jewish men easily mingled with the larger society and joined lodges and civic organizations. Local Jewish women—despite the growing prevalence of women's clubs and trends toward assimilation—seemed hesitant to integrate, possibly because they feared proselytization and anti-Semitism. A few local women participated in both the Jewish and non-Jewish spheres. However, not until one of those women, Sophia Brann, organized the Fort Worth Council of Jewish Women in 1901, eight years after the NCJW's inception, did the city's Jewish women pull together to express themselves in a fashion parallel to their non-Jewish counterparts. Their gradual involvement in municipal activities illustrates the Council of Jewish Women's role in raising the Jewish community's civic profile, as well as these women's collective self-esteem. In 1901, for example, the Council donated money to the new public library and, "as a result," wrote the group's secretary, "felt in closer touch with the community [as] a body and individually."[1] In 1902, the women appointed a representative to a municipal-charity council. In 1905, they hosted a brisket-and-strudel fundraiser at the annual Fat Stock Show, Fort Worth's signature communal event. Under the mantle of the Council of Jewish Women, they became involved in Fort Worth civic affairs while maintaining group boundaries. In Fort Worth, as elsewhere across the United States, single-gender volunteer groups redefined Jewish status and Jewish roles.[2]

Sixteen horse-drawn carriages—called phaetons because of their sleek, open-air design—pulled up at the Fort Worth home of May Hendricks Swayne on Wednesday, February 11, 1889.[3] Out stepped sixteen young married women clad in lace-up boots, ankle-length dresses, and broad-brimmed hats. The guests and their daytime gathering on "silk-stocking row" inside a house with stained-

glass windows and a rosewood grand piano caused a stir. News accounts in the *Fort Worth Weekly Gazette* described the "young matrons" as a "select circle of . . . the most distinguished, intellectual, fascinating ladies in Fort Worth."[4] Each hailed from a pioneer family that had come to Fort Worth during the Wild West era when the settlement, a mere outpost on the Trinity River, was a daylong stagecoach ride from Dallas. Now their hometown was a bustling county seat with a network of railroads and a population of twenty thousand. Elsewhere in Texas, a handful of cities boasted women's literary clubs. These leading ladies thought it high time that Fort Worth followed the trend. As they talked and drank tea in May Swayne's parlor, the women elected a secretary whose handwritten minutes described their gathering as the founding meeting of the Woman's Wednesday Club.[5] The group's aims would include "mutual improvement, promotion of friendship and . . . [discussion] of domestic problems that agitate the brain of the modern woman."[6]

Among these "modern" women was one Jew, Bertha Wadel Samuels (1850–1914), an accomplished pianist married to a Confederate veteran.[7] Her religious background had not barred her from club membership, demonstrating the egalitarianism of the frontier vis-à-vis Jews.[8]

Yet over the next decade, as additional women's clubs formed, only two Jewish women—Edith Mayer Gross (1875–1952) and Sophia Brann (1867–ca. 1940s)—followed Samuels's footsteps into the Fort Worth club arena. Edith Gross, like Bertha Samuels, was from a successful frontier family. She too had Civil War ties, but to the North. Her family had also settled in Fort Worth before the advent of the railroad in 1876 and before the consecration of a Hebrew cemetery in 1879. Both women had forged social ties when their hometown on an eastern branch of the Chisholm Trail was a rowdy backwater where saloons never closed and a person's mettle was of more consequence than religion. The third pioneer clubwoman, Sophia Brann, was a newlywed, the second wife of a widowed merchant. German-born and educated, she possessed the élan, education, and social graces that led others to look up to her. Because these three Jewish women were so well accepted, they could likely have sponsored their mothers, daughters, sisters, cousins, and Jewish friends into the club arena, yet that rarely occurred.

Pulled by contradictory forces to assimilate and to preserve their heritage, Jewish women were reluctant to enter the public sphere. "They faced conflicting impulses for integration and distinctiveness," historian Eric L. Goldstein has observed.[9] Despite overtures from the surrounding culture, fears of proselytization and warnings of assimilation held them back.[10] Not until 1901, when Sophia Brann organized the Fort Worth chapter of the NCJW, did the city's well-to-do Jewish women collectively, if tentatively, make their way into the larger arena.

When they did, they exerted a marked influence on civic reform and cultural growth, underscoring the impact of their emergence into the mainstream.[11]

The pattern of Jewish women's involvement in Fort Worth is similar to the progression that occurred elsewhere in Texas, specifically in El Paso and San Antonio. El Paso's Olga Bernstein Kohlberg (1864–1935), a German immigrant who arrived in the far west as a newlywed, co-founded her city's first women's study club in the early 1890s. By 1894, she had started the state's first public kindergarten. She was also instrumental in establishing a sanitarium for babies suffering from the desert heat. In 1898, she was among the founders of El Paso's first Jewish congregation, Temple Mount Sinai. In San Antonio, Anna Hertzberg (1862–1937) moved up the club ladder, from founding president of the city's Tuesday Musical Club in 1901 to the presidency of the Texas Federation of Women's Clubs from 1911 to 1913. She was later elected to the city's school board. Hertzberg and Kohlberg both served in 1905 on the board of the Texas Federation of Women's Clubs—an indication of the easy entrée into club work accorded to Jewish women of affluence and action. Meanwhile, most of Hertzberg and Kohlberg's Jewish sisters remained in the background until the creation of local Councils of Jewish Women—in San Antonio in 1907 and in El Paso in 1917.

Pioneer clubwomen like Kohlberg, Hertzberg, and—in Fort Worth—Edith Gross, Sophia Brann, and Bertha Samuels were the exceptions. Regardless of religion, all local women felt some degree of trepidation about venturing into the realm of women-only clubs. At the turn of the century, it was controversial for women to congregate for nonsectarian purposes. Their place was in the home, overseeing domestic concerns while men dominated the public sphere. As Fort Worth women's-club activist Mary Terrell, a member of the Woman's Wednesday Club, recounted in 1904, "The woman's clubs came to be referred to in the general press, most often as the butt of the funny edition."[12] President Grover Cleveland, reelected to the White House in 1893, declared, "Woman's best and safest club is in her home."[13]

Jewish publications also carried negative commentary. One of the leading rabbis in the West, San Francisco's Jacob Voorsanger, formerly of Houston, was quoted in the *American Jewess* assailing "these one-sex organizations" for their "tendency to widen the breach" between men and women. Voorsanger also declared, "The Jewess has no mission apart from the Jew."[14] And therein lay her dilemma.

The Jewish woman's traditional role was to preserve her religious heritage and to foster social ties within the Jewish community, not beyond it. Because American Jewish men mingled with Main Street merchants in the business world, Jewish women were perceived as indispensable guardians of the faith

within the home. Such gender segregation was evident not only in Fort Worth, but also in such places as Natchez, Los Angeles, and San Francisco, where Jewish men routinely joined Masonic lodges, glee clubs, and athletic clubs while their wives, mothers, sisters, and daughters restricted their club work to Hebrew benevolent organizations and Jewish burial societies.[15]

By contrast, in Europe, Jewish women had often, due to economic necessity, engaged in business and interacted in the marketplace because the ideal husband was a full-time scholar. In America, norms were different. Middle-class Jewish women lost their marketplace niche to men. When the women's-club movement emerged, Jewish women were ironically in a narrower space than they had occupied in the Old Country. Their desire to be both American and Jewish restricted their activities to the home front. As the women's-club movement dawned, they watched with ambivalence as American feminists questioned the confines of the women's sphere.[16] And so, during the late nineteenth century in Fort Worth, all but three Jewish women watched from the sidelines as their Protestant counterparts began participating in the growing local women's-club movement.

The Pathfinders

Fort Worth's first such study club, the Woman's Wednesday Club, with Bertha Samuels on its roster, was on the cusp of change. "Timid ones that had waited to see the trend of the movement hastened to seek affiliation," recalled Mary Terrell.[17] Because the club roster was limited to thirty married women and because election to membership required a majority vote from among three nominees, many an applicant was rejected.[18] In 1896, another cluster of elite women began a musical group, the Euterpean Club, named for the Greek goddess of music. Its founders included Edith Mayer Gross, whose extended family had moved to Fort Worth from Indiana when she was an infant.[19] At least four more local women's clubs had formed by the turn of the century.[20]

Among them was the Fort Worth Kindergarten Association. Its early roster included German-born Sophia Brann, who was familiar with the *Kindergarten* movement in her homeland. In 1896, the Mothers' Study Club evolved into the Fort Worth Kindergarten Association, an organization that would become a major player in Fort Worth civic affairs. Kindergartens were part of a burgeoning child-development movement fostered in large part by middle-class women's clubs.[21] Sophia Brann and other German-educated women like Olga Kohlberg in El Paso were perceived as bringing particular insight to the imported institution. The *Club Woman's Argosy*, a turn-of-the-century Texas magazine, featured

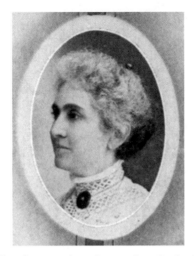

Sophia Brann, founding president. German-born Sophia Brann married a
well-to-do Fort Worth widower and became active in the city's Kindergarten Association.
Secular club work led her to launch the Fort Worth Council of Jewish Women
in 1901. In 1913 she became founding president of the Beth-El Congregation Sisterhood.
Courtesy, Sallie Capps Collection, Special Collections,
The University of Texas at Arlington Library, Arlington, Texas.

Brann's cameo photograph in an illustration that spotlighted nine "prominent members" of the Fort Worth Kindergarten Association.[22]

The Fort Worth Kindergarten Association became a model for cities across Texas. In 1900 it opened a two-year teacher-training school, the first in the state. The Kindergarten College, as it was called, annually enrolled six to twelve women who graduated as kindergarten teachers, a self-supporting profession. (Two local Jewish women, Sarah V. Carb and Ida Brown, graduated from the program in 1906 and became principals of north Fort Worth kindergartens.[23]) The Fort Worth Kindergarten Association expanded to include an alumnae association with dozens of benefactors. For a decade, the organization lobbied the state legislature and helped draft a bill, which passed in 1907, authorizing school districts to use public funds to operate kindergartens. As clubwomen joined forces to construct a public library and establish state and city federations of woman's clubs, the association remained a vital network in Fort Worth.[24]

Sophia Brann's interest in Progressive-era organizations extended to the religious sphere. Her husband, Herman Brann, was among the founders in 1902 of Beth-El Congregation, the Reform synagogue. Her daughter was a student in one of the congregation's earliest confirmation classes, and in 1913 Sophia

Brann became the founding president of the congregation's women's auxiliary, called the Sisterhood.

Fort Worth's two other pioneer Jewish clubwomen—Bertha Wadel Samuels, a native of Summit, Mississippi, and Edith Mayer Gross—had arrived in Fort Worth shortly after the Reconstruction era, but via different routes and circumstances. Each acculturated to the surroundings to varying degrees, ranging from partial integration to near-total assimilation.

Bertha Samuels's husband, Warsaw-born Jacob Samuels, had settled in Fort Worth in 1857 and opened one of the village's first dry-goods stores. When Texas seceded from the Union, Jacob Samuels enlisted in a Confederate cavalry regiment mustered on Main Street. Samuels returned in 1866 and opened a general store. A confidential credit report from R. G. Dun & Co. dated 1866 describes Jacob Samuels and his business partner as "slippery Jews."[25] The pejorative reference was offset by a disclosure that E.M. Daggett, a leading civic figure, was a silent partner in the business venture. The epithet in the credit report reveals an undercurrent of prejudice and stereotyping in a region with few Jews, few churches, and an ethos of frontier egalitarianism. Other local merchants with risky business ventures were not tarred with epithets related to religion.

The various paths and careers of the Samuels offspring reflect Texas's open society and their own ambivalence toward Judaism. Sidney Samuels, for example, graduated from the University of Texas Law School in 1890 and became the attorney for the *Fort Worth Star-Telegram*. He married a Presbyterian and tried to rewrite his past, telling journalists that his father was American born and that his mother came from a family of Methodist ministers.[26] The older Samuels daughter, Annye, married a local editor, Archer Dawson, a non-Jew, in a civil ceremony.[27] Brother Bertrand went into banking, donated money to Zionist causes, and married Mollie Harris, who joined the Fort Worth Council.[28] The Samuels women were fine pianists and vocalists. Youngest daughter, May, who was tapped in 1903 for the city's prestigious Monday Book Club,[29] studied at the New England Conservatory of Music. Her mother honored her in 1904 with a lavish "musical entertainment" for several hundred guests at the Worth Hotel. Of the twenty young ladies who greeted guests and performed that evening, none except for Annye and May was Jewish.[30] May married a Jewish man, Lester Gunst, and moved to Corpus Christi, where both are buried in a Jewish cemetery.[31]

Family patriarch Jacob Samuels was a charter member of the local Knights of Pythias lodge. Jacob was a proud owner of a family plot at Emanuel Hebrew Rest Cemetery; his tombstone, among the largest in the cemetery, is etched with a Confederate battle flag, evidence of his dual identity as a Southerner and a Jew.

Edith Mayer Gross's extended family offers a contrast. Her father, Joseph Mayer, was a Union veteran from Indiana. After the war, his business in Indianapolis failed. He and his brothers, Jacques and Edgar, moved to Texas for a fresh start when Edith (1875–1952) was an infant. Her brother, Max Kaufman Mayer (1877–1955), was the first Jewish child born in Fort Worth.[32] Members of the Mayer extended family were involved in several attempts to start a local Sabbath school, important among Jews in remote regions as a way to instill their children with a sense of Jewish identity and continuity.[33] As a youngster, Edith took music lessons that nurtured her fine contralto voice and led to her membership in the Euterpean Club—where she turned down the presidency but held every other position.

In 1899, Edith married Leon Gross, who had moved from Memphis to Fort Worth in the 1880s to work with relatives operating Fort Worth's two premier men's clothing stores, Washer Brothers Clothier and A. & L. August. Leon Gross was among the few Jews later tapped for membership in River Crest Country Club and the Fort Worth Club.

Edith became an early member of the Fort Worth Council, of which her aunt, Blanche Mayer, and sister-in-law, Berenice Gans Mayer, were charter members.[34] The Mayer men, along with Edith's husband (and Sophia Brann's spouse), were among the forty-three founders of the city's second Jewish congregation, Beth-El, the Reform synagogue organized in 1902.[35] Edith was also active in the secular women's club movement and endorsed a short-lived attempt to harness the club network for Progressive-era reforms. Edith and Leon Gross, through their participation in Jewish and non-Jewish social spheres, comfortably balanced their dual identities.

Fort Worth and the Women's Club Movement

Women's Clubs proliferated in Fort Worth and across the state. Inspired by Chicago's 1893 Columbian Exposition, the Lone Star State's clubwomen arranged to hold a Texas Women's Congress the following year in conjunction with the state fair in Dallas. But the very word *congress*, pregnant with political meaning, proved controversial because women did not have the vote. Therefore, when the clubwomen gathered in Dallas the following year, in 1894, they changed their collective name to the State *Council* of Women of Texas. With "timid flutterings" and a "quickened pulse," at least a dozen women from Fort Worth summoned the courage to attend and speak at the gathering, according to the official history of the Texas Federation of Women's Clubs (TFWC). "As no thunderbolts fell from the skies . . . the dear women . . . gained courage from

each other." Among the speakers from Fort Worth was Mary Terrell, representing the Woman's Wednesday Club. This Texas State Council of Women did not reconvene after 1896. However, Mary Terrell, a veritable general with "the brain and the nerve to guide," issued a call to create a "Texas Federation of Literary Clubs."[36]

In 1897, the Waco Woman's Club seized Terrell's idea and called a statewide conference of women who represented twenty-two clubs in fourteen cities. Many of the clubs were at least ten years old, and one had been meeting for two decades. The Waco gathering, attended by delegates from Fort Worth's Woman's Wednesday Club and '93 Club, culminated with incorporation of the Texas Federation of Women's Literary Clubs. Seventeen of the clubs opted to join.[37] At the group's next conference, held in Tyler in 1898, the word *Literary* was dropped from its name. "Literary culture was the raison d'être of the individual club," Terrell explained, ". . . but it was felt that . . . an organization of women . . . must stand for some united effort for social advancement in Texas."[38] At the Tyler meeting, the women zeroed in on the need for female leadership in civic reform. The mere act of forming a *federation* had helped these clubwomen redefine themselves as an altruistic coalition moving into the public sphere. In one year's time, they had grown from a literary league into a federation focused on the need for public libraries, child labor laws, and conservation of wild life. It was a turning point. In the words of historian Megan Seaholm, "This is the new woman emerging from the cult of true womanhood."[39]

By dint of its early call for confederation, Fort Worth's Woman's Wednesday Club earned the moniker "Mother Club" of Texas. In 1897, Fort Worth was also among the first four Texas cities—along with Waco, Tyler, and Greenville—to unite its disparate women's clubs into a city federation of women's clubs, and local clubwomen enjoyed being looked up to as pioneers. Furthermore, Fort Worth's Euterpean Club and Kindergarten Association, which had not sent representatives to Waco or Tyler, affiliated with the Texas Federation of Women's Clubs shortly after its establishment. One federation reinforced another. In 1898, when the nationwide General Federation of Women's Clubs (GFWC) published its hefty *History of the Woman's Club Movement in America*, the chapter on Texas mentioned by name thirty-seven different clubs from twenty-five cities.[40] It featured detailed write-ups of eleven Texas clubs, including Fort Worth's Woman's Wednesday Club, the Dallas Shakespeare Club, and Tyler's Quid Nunc, a literary circle that required members to answer roll call with a quotation from Shakespeare, Tennyson, Yeats, or whatever poet was being studied. These women's-club coalitions stimulated the exchange of ideas and moved clubwomen beyond preoccupations with sociability and self-improvement into public life.[41]

The first priority of both the TFWC and the Fort Worth Federation of Women's Clubs (FWFWC) was to establish public libraries. "Get Mr. Carnegie's money to Texas," Mary Terrell urged a convention of clubwomen, referring to Pittsburgh philanthropist Andrew Carnegie. Carnegie agreed to underwrite library buildings if the hometown pledged an annual subsidy equal to 10 percent of the construction costs.[42] Fort Worth women had been agitating for a public library since 1892, when twenty matrons had formed a Fort Worth Library and Art Association. Among that group's charter members was one Jewish woman, Belle Washer. The library association languished until the late 1890s, when momentum from the statewide movement prompted all the city's clubwomen to pour their combined organizational skills into establishing a public library. With determination, they raised money, fanned enthusiasm, secured a site, received backing from city hall, and acquired eight thousand books. Their crowning accomplishment came on October 17, 1901, when the brand new Carnegie Public Library opened its doors to 250 first-day patrons.[43]

The same month that the Carnegie Library was completed, twenty-five Jewish women gathered at a downtown hotel to organize the Fort Worth section of the Council of Jewish Women. These were not the only efforts coming to fruition.

City in Transition

The timing was propitious. Fort Worth was celebrating its impending transition from a rural county seat into the meat-processing capital of the South and Southwest. Swift and Armour, the two giant Chicago meatpacking companies, had just agreed—thanks to a $100,000 local subsidy—to construct multistory slaughterhouses two miles north of the county courthouse. These plants would employ thousands of workers and make Fort Worth the destination of ranchers and railroads bringing livestock to market. Completed in 1902, the packinghouses gave the city its first major industry, as well as a proud sense of continuity with its cattle-driving past.[44]

As Fort Worth prospered—adding gas-lit street lamps in March of 1877, a telephone line in May of 1877, and swelling to 6,600 residents in 1880—dozens of Jewish entrepreneurs arrived by rail to launch retail shops and wholesale ventures.[45] These merchants tended to sell dry goods, men's clothing, hard liquor, hand-rolled cigars, and groceries. Notable among these Jewish entrepreneurs were the Dahlman brothers—Isaac, Harry, and Aaron—the first haberdashers in the county to advertise custom-tailored gentlemen's suits.[46] (Later, in 1889, they attempted to ship refrigerated Texas beef to England, but

the ice melted en route, spoiling the meat and bankrupting the Dahlman Dressed Beef Company.[47]) Jewish merchants rapidly integrated into the city's economic life. Along the unpaved streets and alleys branching out from the courthouse sprouted a multitude of Jewish-owned businesses: Rosenfield Hides, Wool & Grain; Eichenbaum Cigar Co.; Wolfe Rosenthal House & Sign Painter; M. Rosenthal Furniture; Gernsbacher Kitchen Supply; M. Alexander Haberdasher and Hatter; Mayer Liquors; and Drescher Bros. Clothing.[48]

Parallel with the rest of Fort Worth, Jewish residents seemed off to a promising communal start. But the early 1880s brought typhoid fever, then smallpox, to the city. Drought diminished commerce.[49] The B'nai B'rith lodge disintegrated in the early 1880s. A Hebrew cemetery, deeded to the "Israelites" in 1879 by civic figure John Peter Smith, was not regularly tended.[50] Jews remained, but Hebrew institutions did not again take root until the early 1890s, when a new wave of immigrants began trickling into town.

This new wave had its impetus half a world away with a calamity, the 1881 assassination of Russia's Czar Alexander II. His successor enacted oppressive decrees against Jews. Over the next twenty years, more than 750,000 Jews fleeing persecution escaped to the United States.[51] About one hundred of them ended up in Fort Worth. They arrived in a chain-migration pattern whereby a relative, a friend, or a landsman (someone from their native village) who had already settled in the Trinity River town beckoned them to follow. Unlike previous Jewish settlers to Fort Worth, survival as Hebrew people, rather than wanderlust, fueled their journeys. In Europe, they had lived in *shtetls*, insulated Jewish enclaves, practicing tradition-steeped Judaism that they expected to transplant to the New World. They were accustomed to prayer shawls and skullcaps, worship garb that most acculturated Texas Jews had abandoned. They clung to dietary laws that banned pork, shellfish, and hunters' bounties such as deer, antelope, and bear. They spoke Yiddish, a mix of Slavic and Germanic languages written with Hebrew characters. The men wore dark jackets, black bowlers, and beards—decidedly foreign dress for the frontier. Most arrived penniless. They borrowed money from fellow Jews in Fort Worth and went to work peddling fruits, vegetables, and junk in the countryside and on city street corners. Some of the new arrivals—enterprising scrap-metal dealer Louis F. Shanblum of Poland, for example—courted and married local American-born Jewish girls.

In 1892, Shanblum and six other Eastern European immigrants chartered the city's first Jewish congregation, Ahavath Sholom, Hebrew for "love of peace." Within a year, the membership at the Orthodox Jewish institution had grown to thirty-two men. Several of Fort Worth's long-established Jews, who hailed from Russia and Poland and who understood Yiddish, joined Ahavath Sholom. Jacob Samuels is listed on the synagogue's 1893 roster. Ice manufacturer David Brown, who had worked in Mississippi and Tyler, became synagogue president

in 1899. Felix Bath, a wealthy immigrant cotton factor who classified himself a "free thinker," would not join the congregation but donated money for its support.[52] The Branns did not affiliate. Nor did the Mayers, although Max K. Mayer was hired to do legal work for the congregation. To the Branns, the Mayers, and other well-integrated American Jews with German roots, the fledgling congregation was too foreign, too much of a throwback to the Old Country, with worship services entirely in Hebrew and minutes recorded in Yiddish. In many ways, the unaffiliated Jews regarded themselves as more sophisticated than the Eastern European immigrants. In other ways, they were reminded of their identity.[53] Still, it would be another ten years until these unaffiliated Jews formed a Reform Jewish congregation in which they felt comfortable.

Women's World

Female participation at the synagogue was limited to Rosh Hashanah and Yom Kippur, the Jewish High Holy Days in the fall, when the board of trustees rented three dozen extra chairs and passed a resolution that women would sit on the north side of the sanctuary and men on the south. With its Old World, male-centered orientation, Ahavath Sholom did little to foster formation of a Jewish women's community. It had no religious school for youngsters until 1903. It had no *mikvah*, or ritual bath, for women until 1904.[54] Its modest, wood-frame synagogue was off the beaten path at Jarvis and Hemphill streets, twenty blocks from the Tarrant County Courthouse, the neighborhood where most of the city's Jews clustered. Yet the congregation's mere existence and financial stability of the immigrants demonstrated the strength and cohesion of Fort Worth's ethnic Jewish network.

In the larger Jewish universe, new currents were stirring for women. In 1893, word spread throughout American Jewish communities about the creation of the Council of Jewish Women, the first open-membership national organization for Jewish females. The group was an outgrowth of the Chicago Columbian Exhibition's Jewish Women's Congress. One Texan—Ada Chapman—had delivered a speech at the Jewish Women's Congress. Chapman, the British-born spouse of Dallas Rabbi Edward Maurice Chapman, was appointed Council vice president for Texas, a position that entailed organizing *sections*, as they were dubbed, in the Lone Star State.[55] However, Chapman failed to extend the NCJW's reach. The reason may have been her husband's ill health, which was exacerbated by the "long and excessively heated Texas summer."[56] The Chapmans took a lengthy cruise in 1895 and a permanent leave of absence from Texas in 1896, leaving the state without a national representative from the Council of Jewish Women.

Meet Jeannette Miriam Goldberg

At the NCJW's first triennial in 1896, which was held in Philadelphia, the national board appointed native Texan Jeannette Miriam Goldberg (1868–1935) vice president for Texas and later field organizer for several states. A charismatic educator, Goldberg typified the turn-of-the-century new woman. Born in small-town America and educated at prestigious northeastern women's colleges, she developed a professional niche in the social service field as executive secretary of the national Jewish Chautauqua Society and became economically self-sufficient. She eschewed marriage, wielded power within her profession, and was the intellectual peer of the men with whom she worked.[57] In that era, marriage and a career were presumed to be mutually exclusive, according to scholars of the Progressive era's professional-woman phenomenon.[58] Role models like Jane Addams, Clara Barton, and Frances Willard (founder of the Woman's Christian Temperance Union) demonstrated how much a well-educated, unmarried woman might accomplish in new fields of social service. Jeannette Goldberg fit that category. She was free-spirited, autonomous, and politically astute.

Moreover, she was devoted to Judaism and eager to spread the gospel of the Council of Jewish Women. "We have had enough lullaby and slumber in religious life," she exhorted. "[W]e now need wakefulness and spirit, to revivify the dry bones of American Judaism."[59] Goldberg was a first-generation American whose volunteer work organizing sections for the Council of Jewish Women ultimately led to her career as field secretary, then executive secretary, of the Jewish Chautauqua Society. The Chautauqua Society, a national adult-education organization then headquartered in Philadelphia, popularized Jewish learning among Jews and non-Jews through reading circles and lectures.

The fourth of five siblings, Jeannette Miriam Goldberg was born in 1868 in the East Texas city of Jefferson, a thriving inland port that annually shipped 75,000 tons of cotton.[60] Her parents, Louis and Miriam Levy Goldberg, had emigrated from Russia to New Iberia, Louisiana, in 1860 with two young sons. Following the Civil War, they moved to Jefferson along with another family of Goldberg relatives. Jefferson was Texas's sixth largest town, with four thousand residents, and by 1873, 26 percent of the town's merchants were Jewish. That year they organized Hebrew Sinai Congregation, converting a former convent into a synagogue and constructing an addition. The Goldbergs were well known for their civic, sectarian, and cultural involvement. Jeannette was acclaimed the city's "high priestess" of Judaism[61] and praised as a "silver-tongued orator."[62] She mingled amiably among the non-Jewish population. In 1888, when a Jefferson debutante married a lad from Boston at Fort Worth's Methodist Church, twenty-year-old Jeannette was a bridesmaid.[63]

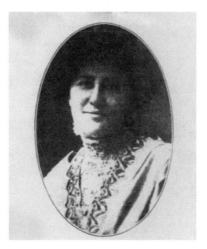

*Jeannette Miriam Goldberg, quintessential "new woman." In 1896, Jeannette
Goldberg, a charismatic speaker, was appointed the Council of Jewish
Women's vice president for Texas. Her volunteer work organizing Council
sections, coupled with love of Judaism and charismatic speeches, led to
a career as executive secretary of the Jewish Chautauqua Society. Photo from
American Hebrew, September 10, 1915, reproduced courtesy of The Jacob
Rader Marcus Center of the American Jewish Archives, Cincinnati.*

Goldberg traveled east for college and took classes in Vassar College's "prepa-
ratory division" during 1883 and 1884.[64] To complete her BA degree, she enrolled
in New York's Rutgers Female Institute, where she was class valedictorian.[65]
From New York, Goldberg moved back to New England for postgraduate in-
struction from the poet Oscar Fay Adams.[66] Following her formal studies, she
returned to Texas, working as Sabbath school superintendent in Jefferson and
in Houston in 1886 when Rabbi Max Heller, a leading Reform rabbi and Zion-
ist spokesman, had a pulpit there.[67]

As part of the "new generation of educated women," Goldberg was accus-
tomed to relative freedom and reluctant to settle down in her Texas hometown,
which by then had fallen into economic decline.[68] She taught literature at
schools in Dallas and in Birmingham, Alabama. She also taught at Waco Fe-
male College and North Texas Female College in Sherman, institutions that
served as finishing schools for girls.[69] Appointed education chairman of the
Texas Woman's Council, she wrote articles in the Texas press and thus was well
known among Texas women.[70] When the Texas Federation of Women's Clubs
met in Jefferson, she delivered a lecture on civics.[71]

Goldberg's passion for Judaism and proclivity for public speaking must have

been evident during her attendance at the Council of Jewish Women's first triennial in Philadelphia, where she was appointed vice president for Texas. In 1898, with a core group of seven women, Goldberg organized Texas's first NCJW section in the East Texas county seat of Tyler, which had an active club network. "Our Tyler Section, though small in number, is large in zeal and enthusiasm," she reported. "We have no passive members."[72] Later that year, she assisted Waco and Dallas women in forming NCJW sections.[73] (In Dallas, the organizing spark came from the city's new Reform rabbi, George Alexander Kohut, whose stepmother, educator Rebekah Kohut, was president of New York City's NCJW section.[74]) In the spring of 1901, Goldberg visited Beaumont, a boomtown gushing with oil, and launched a Council section there with twenty-seven women.[75]

Goldberg was eager to start a chapter in Fort Worth, but she held back. "I wanted the invitation to be spontaneous," she explained. "Fort Worth . . . stood foremost financially and socially, but religiously speaking they were dead. . . . I waited three years before I got an invitation to go to Fort Worth."[76] The invitation came from Sophia Brann. During the weeks preceding Goldberg's visit, Brann and her friend Sarah V. Carb mailed a postcard to each Jewish woman in the city—there were nearly a hundred—announcing a preliminary meeting to form a Council section:

> *Dear Madam—There is a movement on foot to organize in Fort Worth a*
> *section of the Jewish Women's Council. Miss Jeannette Miriam Goldberg*
> *of Jefferson has kindly offered to assist us in this move. You are invited*
> *to attend a preliminary meeting to be held on Monday, October 14, at*
> *3 p.m. at the parlor of the Delaware Hotel for the purpose of discussing*
> *the question.*
>
> <div align="right">*Mrs. H. Brann, Miss Sarah Carb, Committee.*[77]</div>

The society pages of the *Southwest Jewish Sentiment* and the *Fort Worth Register* also reported a "movement on foot to organize."[78]

The preliminary meeting, on October 14, drew twenty-two women. Two weeks later, Jeannette Goldberg arrived to "perfect" the organization, and twenty-five women "enrolled."[79] By the end of the year, forty women were involved, with Sophia Brann elected president and Sarah Carb treasurer.[80] Bertha Samuels, the lone Jewish member of the city's Woman's Wednesday Club, did not join, although her sister Regenia Lipstate, who lived in Tyler, had joined that city's Council of Jewish Women. Edith Mayer Gross—who was an officer in the Euterpean Club, the FWFWC, and the new, reform-minded Department Club—did not attend the founding meeting, although her sister-in-law, Berenice

Gans Mayer, and her aunt, Blanche Mayer, did. By the end of the Council's first year, Edith Gross and her mother, Amanda Mayer, were presumably involved in the section, because fifty years later Edith placed their names on a roster of charter members compiled for the section's golden anniversary.[81] The Council had flourished, and by then every Jewish woman in Fort Worth wanted to be a part of it.

The Council's early members represented the elite among the city's approximately five hundred Jews. All of the charter members, except for Sophia Brann, were American born or American raised. Many were cousins, mothers, daughters, and in-laws. None had college educations. Three were widowed, and four were single. All had successful merchant husbands, brothers, or sons. Ten had come to Fort Worth (and one to nearby Weatherford) before the railroad. Several others had pioneer roots in central Texas. Twelve were affiliated with Ahavath Sholom, the Orthodox congregation. Four had tried in vain to launch a Sabbath school. Many of the women socialized together in a Progress Whist Club in which card players competed for prizes, including crystal bowls and satin pincushions for the winners (and eggbeaters for the losers). Together, they celebrated birthdays and anniversaries. Although such soirées had no religious import, these well-to-do Jewish women clustered together socially, comfortable with their ethnic homogeneity.[82]

Formation of the Fort Worth section elevated gatherings among these women from a social to a serious plane. It injected into their get-togethers parliamentary procedure, committees, officers, money management, and goals beyond games and prizes. The Fort Worth Council of Jewish Women's first substantive act was to organize a Jewish Sabbath school that rapidly enrolled fifty children. For the women's own religious edification, the Council started a study circle focusing on aspects of Jewish history, with topics such as "The Jew in English Fiction," "Poems of Emma Lazarus," "Lady Magnus' Outlines of Jewish History," "The Immigrant Jews in America," and "The Reminiscences of Dr. Isaac M. Wise," founder of the American Reform movement among Jews.[83] To raise money, the women presented musical recitals featuring local vocalists and instrumentalists. In addition to earmarking a donation for the new library, the Council became a "patroness" supporting free kindergartens.[84] The section publicized its meetings in the newspapers, drawing notice to its existence.[85]

The Women Step into Reform

In September 1902, eleven months after the Fort Worth Council formed, forty-three men from among Fort Worth's pioneer Jewish families chartered a Reform

Congregation, called Beth-El, Hebrew for "house of God." As with many previous local religious efforts, the synagogue disintegrated after six months. This time, however, the women stepped into the vacuum. Utilizing their new assertiveness and national contacts, the local Council of Jewish Women summoned help from the Union of American Hebrew Congregations, the governing body of the Reform movement. Its circuit-riding rabbi, George Zepin, a cohort of Jeannette Goldberg, visited Fort Worth twice in the spring of 1904 to revive the congregation "from its state of lethargy."[86] At the women's urging, he arranged for Hebrew Union College to assign to Beth-El one of the few Reform rabbis ordained that year. The new rabbi, Joseph Jasin, rejuvenated the Sabbath school and reinstated weekly worship services. He mingled with the Orthodox members of Ahavath Sholom, for he shared their passion for Zionism. He was also prominent among the local clergy and was good-naturedly caricatured in a publication featuring the city's civic figures.[87] The Jewish community felt proud and united, and the Council received credit for that cohesion.

The revival of the Reform congregation and the success of its full-time rabbi signaled the Council of Jewish Women's importance as a vehicle to effect change within the Jewish community. Although these women could not serve on their synagogue's board of directors, they used their fundraising acumen and social connections to make their mark. They established a strong bond with the rabbi, for they paid his salary—a pattern common in small-town Texas congregations of all denominations. Especially on the frontier, where there had been indifference to worship and few to lead, women carved a place for themselves in traditionally patriarchal religions.[88]

Emboldened by their collective clout, the Fort Worth women "agitated" to construct a synagogue. A centrally located house of worship would convey "the presence of Jewish life . . . religious vitality [and] social acceptance."[89] The men governing Beth-El refused, not wanting to expend the funds or energy. Undeterred and with the backing of the rabbi, the Council in 1906 created a "temple sinking fund." To fatten the fund, they cooked their best dishes and served potluck dinners for three consecutive nights during the region's biggest annual event— the Fort Worth Fat Stock Show and Exposition. Their profits totaled $320. A Methodist minister who partook of the women's brisket and apple strudel sent a donation and a letter applauding their recipe for success. Soon thereafter, Beth-El Congregation's board of directors endorsed the proposed house of worship. A two-story synagogue of stucco and wood, replete with an office for the Fort Worth Council, opened in time for the High Holy Days of 1908.[90]

Until their public debut at the Fort Worth Fat Stock Show, Jewish women in Fort Worth had never mingled so openly with the larger local community. "This dinner . . . was the means of promoting sociability among our people and

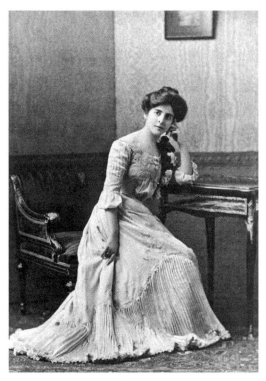

*Pauline "Polly" Mack, longtime NCJW president. Under Polly Mack's
leadership, the Fort Worth Council of Jewish Women revived Beth-El
Congregation after its 1903 collapse and opened a night school for
immigrants. Three generations of women in the Mack family served as
Council presidents. Courtesy, Beth-El Congregation Archives, Fort Worth.*

at the same time emphasized the fact that the Jewish women of Ft. Worth were
not afraid to work for their faith," Council President Pauline (Polly) Sachs
Mack wrote in her annual report. "In fact, . . . I know of no event that did more
to effectually proclaim to our community that the Jews of Ft. Worth were zeal-
ous in the cause of their religion."[91] Staying within the kitchen—the sphere of
women's work—the Council had challenged the men in a nonthreatening way
and expanded their collective role. The Council established itself as an ambi-
tious, high-profile group that created a sense of sorority and mission among
Jewish women while earning accolades and attention from the municipal scene.

The city's thriving Jewish community—with its two congregations, its suc-
cessful merchants, and its respectable women's club—reflected the forward
pulse of Fort Worth in the early years of the twentieth century. The meatpacking

industry brought jobs and prosperity to the area. The Interurban, an electric trolley, began hourly commuter service to Dallas in 1902, giving locals easy access to the larger, rival city to the east. Touting itself as the city "where the West begins," Fort Worth promoted itself as the supply center and staging area for vast reaches of the unsettled nation. Then, a series of front-page headlines prompted Jews and their neighbors to focus on Eastern Europe.

Eastern Europe Redux

On the last day of Passover in 1903, a date that coincided with Easter Sunday, a pogrom erupted in the Bessarabian city of Kishineff. During forty-eight hours of czarist-sanctioned terror, thousands of Jewish homes and businesses were looted, forty-nine Jews were slain, and more than five hundred were injured or raped. The brutality was page-one news around the world, including Texas, where the *Fort Worth Telegram* ran stories headlined "Terrible Scenes in Desolate Kishineff," "Horrible Atrocities," "Massacre of Jews," and "Anti-Semitic Feeling is Still Running High."[92] Jolted to action, the trustees at Congregation Ahavath Sholom called a "mass meeting" of Fort Worth Jewry and collected $234.25 for an international Kishineff Relief Fund. As outrage and headlines proliferated, they agreed to hold a meeting for the general public. Around the nation, thirty-eight cities registered public protests, through church sermons, editorials, public meetings, or resolutions. Fort Worth was among three Texas cities to do so.[93] The officers of Ahavath Sholom coordinated a public-protest meeting that convened on June 5 in the City Hall Auditorium.[94] The venue and the lineup of dignitaries demonstrate the degree to which the Jewish community had integrated into the mainstream. Attended by a crowd of three hundred, the forum began with an invocation from a minister. Speeches followed from the mayor, a judge, and a congressman. Three vocalists, accompanied by pianist Ida Goldstick, a Council charter member, rallied the crowd with such popular melodies as "Mighty Lak' a Rose," "Because of Thee," and "Esmeralda." An encore of "Dixie" was "enthusiastically applauded." So was an official resolution condemning "the inhuman and atrocious . . . uncivilized and un-Christian . . . cruelties perpetrated upon these people."[95]

The headlines, the public meetings, and grave worries about Jewish brethren living under the czar moved the Jewish community to further action. The local B'nai B'rith fraternal lodge, founded in August 1901, arranged to bring refugees to Fort Worth through the Industrial Removal Office, a New York agency that relocated Jews to inland cities. Within one month of the Kishineff massacre,

the Fort Worth Jewish community welcomed an immigrant couple with four sickly children. The next week, another destitute family arrived.[96]

The refugees' needs were obvious. The Fort Worth Council of Jewish women responded with a four-hundred-dollar contribution but no volunteers to assist with the refugees' adjustment. There was reluctance among most Council leaders to work one on one with their immigrant brethren. One Fort Worth Council member, Sarah Levy Shanblum (1874–1952), the wife of a Polish immigrant, responded by launching the Ladies Hebrew Relief Society (LHRS). This new women's voluntary association pledged to provide the refugees with "friendship and sociability," as well as "coal in winter and a cool rag on a feverish brow."[97] Fulfilling the proverbial role of women of valor, thirty women volunteered for the relief corps, most of them from the Orthodox Jewish community. Gradually, their ranks swelled to 130.

The rapidity with which Sarah Shanblum launched this new women's organization indicates dissension and tension within the ranks of the Fort Worth Council of Jewish Women. Class differences were certainly a catalyst for the creation of the LHRS. The Council of Jewish Women, criticized in the national Jewish press for elitism, proved unwilling to volunteer for hands-on care—perhaps because so few of its leaders spoke Yiddish or, more likely, because of the social distance between the affluent women and the refugees. The LHRS's one-on-one aid ironically mirrored what NCJW sections were doing in port cities around the nation—screening passenger manifests for Jewish refugees, helping immigrant women and children get situated with relatives, steering them clear of prostitution rings, and following up with home visits. Yet in Fort Worth, the Council of Jewish Women remained at arm's length. Council president Polly Mack's annual report covering this period asserts that there was no need for "settlement work" in Fort Worth because the city was in an "agricultural" region rather than a "squalid" urban area.[98] The creation of the Ladies Hebrew Benevolent Society would indicate otherwise.

Regardless of these differences, the Fort Worth NCJW's mere existence provided the blueprint for the new Jewish women's organization. The LHRS was, in many ways, a replica of the Council. It held regular meetings and solicited monthly dues. It raised funds through balls and picnics that attracted more members. The new group consulted out-of-state institutions, such as the Denver Hospital for Consumptives and the New Orleans Jewish Orphans Home, which the Council supported financially.

LHRS founder Sarah Shanblum was herself a bridge between cultures. Born in the neighboring county seat of Weatherford, she was the daughter of Polish immigrants, successful jewelers who had come to Texas by way of New

Sarah Levy Shanblum, Founder of Ladies Hebrew Relief Society. When the Council of Jewish Women balked in 1903 at administering one-on-one care to East European immigrants, Sarah Shanblum, a Council member, launched a separate women's organization, the Ladies Hebrew Relief Society. The LHRS was the forerunner of the Ladies Auxiliary to Ahavath Sholom. Shanblum's activism is the first evidence of a rift among the women's ranks. Family photo, courtesy of Sylvia Wexler, Fort Worth.

York. Her descendants recall her as a *balaboste*, a take-charge woman who could be both brusque and comforting.[99] She married Louis F. Shanblum, a Warsaw law student who, after following his brother to Texas, made a fortune in the scrap-metal business. (His brother, Moses Shanblum, is considered the founder of Ahavath Sholom.) When the Fort Worth Council organized in 1901, Texas-born Sarah Shanblum had the status and inclination to join. When her kinship group had needs, she had the self-confidence to respond. Sarah Shanblum remained a lifelong member of the Council but never assumed the presidency. She reserved her leadership for Jewish causes rather than secular concerns, priorities that would continue to divide the city's Jewish women.

What occurred in Fort Worth was similar to what was occurring among other ethnic groups dealing with new waves of immigrants.[100] Historian Nancy L. Hewitt writes about Latinas in turn-of-the-century Tampa, Florida, and the "complicated patchwork of conflicts and coalitions within the Latin community." Much like the Orthodox Jewish women in Fort Worth, Tampa's less acculturated Latina women formed associations that provided basic assistance to their cohorts. The more affluent and acculturated Latinas remained one step

removed. They formed a society that coordinated relief efforts delivered by others. Class and ethnicity again shaped the philanthropic response.[101]

Although nationally and locally the NCJW purported to embrace all Jewish women, those with Yiddish accents and Old World ways were more often candidates for charity than for leadership. Council members tended to be affiliated with Reform rather than traditional Orthodox synagogues. In Fort Worth and nationwide, the Council of Jewish Women attracted mainly affluent, acculturated women, those with longer lineage in America than the latest wave of immigrants. Members, hailing from middle-class and upper-class households, wore hats and gloves to meetings where they delivered committee reports with proper diction, not foreign accents. In this regard, the Council was like many Progressive-era women's clubs—altruistic in its programming, yet less than inclusive in its aura.[102]

National founder Hannah Solomon's vision of a broad-based women's organization that crossed denominational lines led to strains from top to bottom. Solomon herself was a secular Reform Jew. Orthodox women on the NCJW national board believed that their leader should consecrate the traditional Sabbath. Solomon's response was, "I do consecrate the Sabbath. I consecrate every day."[103] Such differences, rhetorical and religious, led to a gradual deemphasis on Judaic study, ironically the impetus for the national group's creation. Such differences led to a wider emphasis on *tzedakah*—the Jewish concept that combines charity, social service, and philanthropy.[104] Upwardly mobile Council women wanted only enough religion to remind them of their identity. Acculturation was their unstated goal.

Triumphs in the
Traditional Women's Sphere

As immigrants streamed into the United States, the metaphorical melting pot *became more than a casual phrase. Xenophobic Americans wanted foreigners to become Anglicized and to become good citizens. In 1907, the Fort Worth Council of Jewish Women announced a program that placed it at the forefront of the so-called Americanization movement and in the vanguard of immigrant aid. The Fort Worth Council opened an Americanization School—not just for Jewish immigrants but for all foreign-born Fort Worth residents, from Mexican refugees fleeing Pancho Villa to the Sisters of Saint Teresa who hailed from Rome. The success of the Americanization School positioned Jewish women on the cutting edge of the expanding female sphere. It established the Council as a dynamic group equiped to meet emerging community needs. The Fort Worth Council, as part of the middle-class women's network, helped resuscitate the Fort Worth Federation of Women's Clubs. Within the Federation, Council participants were recognized for their dedication to projects that beautified and benefited the commonweal. During wartime, the Council and the Federation supported the troops through war-bond rallies and sewing projects. Between the World Wars, they worked for peace. These joint activities led Council members to ascend to leadership posts in the broader community. Within the local Jewish community, the Fort Worth Council's example led to spin-off organizations, each with a specialized focus. Although there was a measure of competition, tension, and overlap among these various Jewish women's groups, the Fort Worth Council remained the largest, most visible, and most prestigious. However, not every Jewish woman felt at home there. The organization's ties to Reform Judaism were evident in 1913 when the Fort Worth Council helped establish the Sisterhood at Beth-El, the Reform congregation. The Council's members were mainly acculturated women who had lived in Fort Worth (or whose husbands had lived there) for decades. Immigrant women with accents*

and Old World ways did not feel as welcome, locally or nationally, within the NCJW.

The Americanization School's classes convened at night in the County Courthouse, reflecting the Council's political contacts and warm relationship with the larger community.[1] The curriculum included civics, etiquette, and hygiene, all as a prelude to socialization and naturalization. The pioneering school came to symbolize the Fort Worth Council of Jewish Women's status and its clout. As urbanization produced more complex social needs, the Council increasingly had a seat at the table and responded with creative solutions.

The Americanization School brought the women other, subtler, benefits. It reduced the outsider status projected on Jews due to their religion. It insulated Jews from nativist sentiments that increased after World War I. By transforming recent immigrants into Americans, the women demonstrated that they themselves had already completed the process.[2] With its broad enrollment and patriotic mission, the Americanization School was trendier and better suited to the Council than the one-on-one benevolence administered through the Council's rival, the Ladies Hebrew Relief Society.

Across the nation, Americanization was a flourishing movement endorsed by civic groups anxious that foreigners blend into the melting pot and absorb the Anglo-Saxon culture.[3] The penchant for Americanization stemmed, in part, from the 1886 publication of the Reverend Josiah Strong's *Our Country*, a bestseller during the pre–World War I decades. Written for the American Home Missionary Society, the book asserted the superiority of Northern European Anglo-Saxon Protestants, the immigrant stock that had settled much of the original thirteen colonies. As this line of reasoning went, perils faced the nation unless the latest wave of immigrants—who seemed prone to disease, deviance, and lassitude—reconceptualized themselves along the Anglo-Saxon-Protestant model.[4]

The women's-club movement, too, latched onto the Americanization trend. Women's clubs donated civics textbooks and sponsored patriotic speakers. Championing Americanization enabled middle-class clubwomen, who were also a marginalized class, to "assert their own cultural power," notes Anne Gere.[5]

The Fort Worth Council was ahead of the curve with its immigrant school. The school opened four years before national NCJW leaders added Americanization schools to their agenda. When the national office, in 1911, began encouraging such schools, the focus was on Jewish female immigrants, while the Fort Worth effort was nonsectarian and coeducational.[6] The stated goals of the Fort Worth Americanization School were to help immigrants "to master the English language [and] to assimilate American ideals." The teachers included three women from the Council and three men from the B'nai B'rith Lodge. Rabbi Joseph Jasin, who the Jewish women had brought to Beth-El Congrega-

tion, helped administer the new educational institution that enrolled "schol-
ars" from ages fourteen to forty-five.[7] The school became an institution highly
regarded throughout the larger community. It opened at a time when hundreds
of Greek, Polish, and Mexican immigrants were pouring into Fort Worth to
work in the expanding stockyards and meatpacking industries.

Six months after the Americanization School held its first evening class, the
Texas port at Galveston was officially opened to a new wave of Jewish immigra-
tion from Eastern Europe.[8] Between 1907 and 1914, ten thousand Jewish refugees
entered Texas through Galveston, with approximately eight immigrants per
month settling in Fort Worth, where the Americanization School served them.[9]

The Women's Club Network

The Fort Worth Library Association was also interested in uplift—cultural
uplift for all of the city's residents. In 1909, the association sealed the deal to
bring to the city its first major art show. The month-long exhibit opened on
December 20, 1909, and featured a "cross section of American art" on loan
from the New American Federation of Arts. The canvasses hung in the Car-
negie Public Library's upstairs art gallery. Because the exhibit of forty-nine
paintings required the presence of docents and hostesses, the Art Association
invited a different social, cultural, or religious group to sponsor each day. The
Council of Jewish Women was among those tapped. Other groups included
the Woman's Wednesday Club, the Monday Book Club, the Shakespeare Club,
the '93 Club, and the Cadmean Club—all members of the Fort Worth Feder-
ation of Women's Clubs.[10]

After coming into contact with these groups through the Carnegie Library
art show, the Fort Worth Council elected to join the Fort Worth Federation of
Women's Clubs (FWFWC).[11] Started in 1897, the Fort Worth Federation had
begun with a coalition of seven groups determined to improve the city's sanita-
tion, schools, parks, streets, and quality of life.[12] The Federation's influential
Civic Committee persuaded city aldermen to turn over to them the manage-
ment of public spaces such as Trinity Park and two city cemeteries—Pioneer
Rest and Oakwood. The women cleared the "grounds of weeds and rubbish"
and had gates placed at the entrance to each landmark.

The women also looked beyond the city limits. Following the catastrophic
Galveston hurricane of 1900, Federation members gathered in a public hall to
sew quilts and clothing for flood victims.[13] When out-of-town conventioneers
visited Fort Worth, the women "made it a special duty to look up and entertain
the visitors . . . scattered over the city in boarding houses."[14] The Federation's
City Streets and Alleys Committee tried to convince the city fathers to erect

street signs "with names and numbers . . . both durable and ornate." The city engineer allied with the clubwomen, drawing up a two-thousand-dollar plan to phase in street "placards." However, the women were rebuffed when "the aldermen refused to consider the matter."[15]

Amid mounting frustration toward city government, in May of 1902 the Federation's outgoing officers proposed turning their group—which consisted of twelve clubs with a combined membership of 250—into a progressive reform group called a *department club*, a "club of clubs" whose purpose was to spearhead "practical" civic improvements.[16] The Fort Worth Women's Department Club would be modeled after powerhouse organizations such as the Chicago Woman's Club—which had groomed the NCJW's Hannah Solomon for organization work. Harnessing their collective power through what Elizabeth Enstam calls *doctrines of domesticity and maternalism,* clubwomen in those cities had instituted manual training in the public schools, placed women on school boards, forced merchants to provide stools for saleswomen, and launched jail-house schools for imprisoned youths. They persuaded their cities to hire police matrons for female prisoners, erect hitching posts for horses, and install street signs and sidewalks for the general public.[17]

Laura B. Wynne, a FWFWC officer and reform activist, put forth a formal proposal in May 1902 that the city Federation transform itself into a department club with a broad-based membership to include working women, newcomers, and others generally excluded from the existing club network. "Co-operation is the trend of the times," she reasoned. "We dare not only to know but to grow." Because all but two of the Fort Worth Federation's affiliate clubs had limited membership, she lamented that "good women, helpful women, intellectual women are barred. . . . We should have a thousand women working together. . . . Let us open our doors to all women of our city."

Although no one spoke against expanding the FWFWC into a department club with an open-membership policy, Wynne sensed her audience's qualms. "This does not mean disintegration of study clubs," she assured her friends. It would mean that these middle-class matrons would mingle with people of different strata, something that she acknowledged could be uncomfortable because "we are all too fond of our own ways, our own style, our clothes, and our ideas. . . . We like to exchange the usual passwords and save ourselves the trouble of going any further for the development of higher ideals and nobler aims."

The vote to organize the Department Club passed overwhelmingly. Some women volunteered for committees. The city Federation established an interim board of directors to serve until October 1902, when the Department Club would replace it. The board's corresponding secretary was Edith Gross, one of a handful of Jewish women in the federated-club network.[18]

The Department Club never enrolled the large numbers anticipated. Over

the next month, only forty-seven women signed on, despite a newspaper announcement that declared, "Any woman in Tarrant County is eligible to membership, and any village or community in Tarrant County may organize and become a department of the club."[19] The reform effort never fulfilled its founders' dreams of awaking the city to the "crying needs" of the poor. Laura Wynne presided over a Philanthropic and Civic Department that organized a sewing class for fifty girls, started a Third Ward Boys Club that served seventy lads, and opened a kindergarten for the poor. Another department set up a Farmers Library that hung pictures on the "bare walls" of one-room rural schools. The Education Department persuaded the Fort Worth School Board to spend six hundred dollars to teach "domestic science" in the high schools.[20]

But by 1905, the Department Club was floundering. May Hendricks Swayne, the founder of the Woman's Wednesday Club, decided that it was time to reorganize the Fort Worth Federation of Women's Clubs. Response was lukewarm. "Attendance was small, and work was slow."[21] Most women preferred their limited-membership study clubs.

In 1910, the Council of Jewish Women joined the Fort Worth Federation of Women's Clubs, and its members received a warm welcome. Fort Worth Council president Nettie Lewis Stiefel was elected recording secretary. The Jewish women soon realized that the Federation was faltering. Its roster had dropped to nine clubs from twelve. The Kindergarten Association had dropped out, apparently due to a tiff with the executive board.[22] At the Federation's next meeting, ten of thirteen officers were absent. Two Fort Worth Council of Jewish Women members who did attend—Eva Potishman Brown and Lena Gordon—volunteered to chair the Federation's Entertainment Committee and the Humane Committee, respectively. (The latter investigated mistreatment of horses transported into the city.) When only ten women attended the Federation's June meeting to hear the director of United Charities describe his trip to a St. Louis conference, May Swayne resigned as president. Her friend Ida Jarvis, whose spouse was a local pioneer and among the founders of Fort Worth National Bank, agreed to assume the presidency. At the next general-membership meeting, attended by five people, the treasurer and the parliamentarian resigned. In the fall, so did Ida Jarvis.[23]

To the rescue came Ella Hall Galbreath, who "graciously took the chair." Unlike Ida Jarvis and the exasperated May Swayne, Ella Galbreath had a conciliatory attitude and a plan to rebuild. She "opened by words of encouragement and hopefulness toward a greater success." She scheduled a Federation meeting at the mayor's office, and it drew a crowd. She began visiting women's-club leaders and appointed other members to do the same in order to "get unaffiliated clubs to join the ranks."[24]

Jewish women aided the effort. They invited Ella Galbreath to speak at a Council meeting that was attended by Sophia Brann, Sarah Carb, and Ida Brown, stalwarts in the Kindergarten Association.[25] Shortly after Galbreath's speech to the Jewish women's Council, the Kindergarten Association rejoined the Federation. The Thursday Thimble Club, a neighborhood group at Interurban Stop 6, became the "first social club" to affiliate. With the addition of the Cadmeans and the Thursday Literary Club, the Federation's roster grew to thirteen. In the spring, the Tarrant County Humane Society joined. Individual memberships, an innovation proposed by Ella Galbreath, also increased.[26] The next year, the Fort Worth Federation joined the Texas Federation of Women's Clubs, and in 1912 it affiliated nationally with the General Federation of Women's Clubs.[27] The Jewish women were proud of their role in rebuilding the organization.

The Fort Worth Federation's list of city projects was unending. To encourage sanitation throughout the city, the women staged beautification contests, awarding prizes to children for the "best kept" school grounds. According to the minutes, "The Negro Schools . . . had asked permission to enter" and were welcomed. The African American community also approached the Federation for advice about cleaning up its cemetery and keeping "plots in order." Ella Galbreath lent her "personal effort in the cause" and arranged a meeting with the "colored cemetery" representatives. The Federation also worked in African American neighborhoods to help launch a boys club and a girls club to keep the children "off the streets and interested in beneficial occupations" such as needlework in after-school sewing clubs.[28]

Constantly on the Federation's agenda was the "crying need" to upgrade the Boys' Shelter Home. To raise money, the Federation held a December bazaar at which each club filled a table with salable items. "The Council of Jewish Women and chairman of its bazaar table, Mrs. Jac [Blanche] Mayer, received a rising note of thanks for working so faithfully to raise more than one-third of the total receipts from the bazaar, from which $459.15 were gleaned."[29] Basking in praise, Council president Ida Goldgraber wrote in her 1920 annual report:

> *Each year our Council has not only collected as much as any other club, but invariably has doubled the amount of any other affiliated Club. We are always in demand when there is real work to be done. . . . I am happy to report that our women are always "on the job."*[30]

The conscientious Fort Worth Council's women were also proud of their annual recognition for "perfect attendance." Member clubs were supposed to send five representatives to each monthly Federation meeting. The Council was among the few clubs to comply. The annual attendance prize was a five- or

ten-dollar check, which the Council of Jewish Women donated to a Federation charity. "I feel a just pride," Polly Mack, who was the recording secretary, later wrote, ". . . that we have responded to every worthy call."[31]

The Federation's most talked-about fundraiser was an "auto ride." Cars were still a novelty in 1911. Automobiles shared the streets with horse-drawn carriages and mule-drawn wagons. The clubwomen compiled a list of local automobile owners—among them Eugenia Seligman, a charter Council member who drove an electric auto with a transparent, glass-and-chrome chassis.[32] Clubwomen contacted car owners, asking them to participate in a caravan that would transport paying passengers on a guided tour of city sites. Seventy-three "machines" were promised. The starting point was City Hall, with the "ride to the finish" along Main Street. The fare of fifty cents per person led to a handsome donation to the Boys' Shelter.[33]

Throughout the decade, the Fort Worth Council worked hand in hand with the city Federation of Women's Clubs. Both gained stature and credibility. The Federation's Social Service Committee visited the city jail, the poor farm, the orphans' home, and the city-county hospital to help those in management positions solve problems. The women conducted a "social survey of the city" to assist Parent Teacher Associations. They furnished part of the city food inspector's salary. When their housing survey turned up the need for a "competent visiting nurse" to assist the poor and the sick, the proper authorities hired one. The Federation secured playground space for youngsters and evaluated the new Lake Worth dam and reservoir as a source of both clean city water and wholesome recreation. Concerned with moral rectitude, the women voted to prohibit "Sunday picture-shows in Fort Worth" and endorsed "federal censorship of picture films." The Federation's lecture committee scheduled a talk by Sarah Carb's nephew, David Carb, who had become a New York playwright and drama critic. Also on the speaking program in 1911 was Beth-El's rabbi, G. George Fox, son-in-law of the Federation's recording secretary, Nettie Stiefel.[34]

Expanding the Maternal Role

One of the Federation's most far-reaching projects was the creation and construction of the Fort Worth Free Baby Hospital, the forerunner of a present-day medical complex for children. The Baby Hospital, located at 2400 Winton Terrace West on two-and-a-half acres overlooking the Trinity River, opened its doors to twenty-two infants in March 1918.[35]

There are two stories about the origins of the Free Baby Hospital, one told in the secular community and one nurtured within the ranks of the Council of

Jewish Women. Among that group, Polly Mack is credited with spearheading creation of the hospital. The energetic and elegant Mack (1873–1939) had moved to Fort Worth in the fall of 1902, shortly after her marriage to Theo Mack, who had practiced law in Texas for some time. Both were Cincinnati natives, descendants of families influential in public affairs and in Reform Jewish circles. During Polly Mack's first pregnancy in 1903, she returned to Cincinnati because Fort Worth had no infant-care facilities. When she came back to Texas as a young mother with an eight-week-old son, so the story goes, she was determined to raise the level of hospital care for children.[36] It is possible that Polly Mack's experience during her first pregnancy motivated her to get involved, with heart and soul, in the local hospital project. Her volunteer work on behalf of the institution was ceaseless. However, the record shows that she did not originate the project but was, rather, part of a broad coalition of determined women.[37]

The official story about the Free Baby Hospital's origins begins in a local physician's office. A young doctor found a sick baby girl abandoned in his waiting room. Not knowing what else to do, he decided to take the infant home. While he and the malnourished baby waited in the rain for a streetcar, city postmistress Ida L. Turner asked what he was doing, cradling an ailing, ill-clad infant in the cold. On hearing the tale, she searched for an agency to tend the child and found none. "All Saints Hospital . . . made room for the foundling, gave it the best of care and nurtured it back to chubby baby health." Turner's friends raised money for food and clothing. When the baby was nine months old, a childless couple adopted the girl.[38]

Over the next several years, Ida Turner, in league with the City Federation of Woman's Clubs' Social Service Committee, investigated the city's "alarmingly" high rate of infant mortality. In a crusading spirit, she persuaded land developer Ben L. Waggoman to donate acreage west of Forest Park in the future Park Hill Addition. Architects at Sanguinett and Staats, a prominent local firm, drew plans for a twenty-two-bed facility and later supervised construction, without charge. Contributions — in small amounts of ten dollars and under — poured in from across the region. During hospital construction, Polly Mack and many other Council volunteers brought homemade sandwiches to construction workers at lunchtime. When the hospital opened, Polly Mack was appointed to the board of managers.[39] In her 1918 president's report to the Council of Jewish Women, Mack related:

> *The Free Baby Hospital, to which our Council contributed $25 . . . is completed and ready for your inspection. . . . Let me thank each and every one of you who worked so hard and faithfully . . . for this worthy cause. I heard many compliments on all sides for the splendid work done*

by those of our Council ladies who assisted. . . . And now let me ask every one of you to come out to see the hospital. It will be one of the proudest moments of your lives. When going through this building you see the attention given those poor helpless babies, and I feel assured that you will always rejoice that you have had the privilege and honor of making this hospital possible. I want you to know that this is your hospital.[40]

Making Inroads

Jewish women, through their involvement with the City Federation of Women's Clubs, increased and intensified their face-to-face contacts with Protestant women. Gradually, Jews were invited to join and to lead special-interest clubs. In 1910, twenty-four-year-old Ida Simon, who had immigrated to New York from Russia as an eleven-year-old and moved to Fort Worth as a young mother, was among thirty people to sign the constitution of the Fort Worth Art Association.[41]

Music proved to be the most frequently traveled bridge between Jewish and Christian women. Both the Euterpean Club and the Harmony Club recruited the talented Eva Potishman Brown (1886–1979), the American-born daughter of an immigrant liveryman. When the Texas Federation of Women's Clubs staged its annual convention in Fort Worth in 1915, Eva Brown led the audience in singing "The Star-Spangled Banner."[42] The Harmony Club also tapped contralto Lilli Bogen Morris, whose husband was managing editor of the *Jewish Monitor*, an Anglo-Jewish weekly launched in 1913. Lilli Bogen Morris was elected Council president in 1916 and Harmony Club president a decade later.

The Southern Association of University Women, chartered in Fort Worth in 1913 with fifteen college graduates on its roster, initially had but one Jew—Celia "Chick" Kassell, a Fort Worth Council member who gave popular annual reports on Broadway plays. During the 1920s, additional Jewish women graduated from college and into this club, which became an Affiliate of the American Association of University Women (AAUW). Members included University of Texas alumnae Pearl Gans, Alta Roddy, and Millie Rosenstein. Rosenstein's mother was a founding member of the Fort Worth Council. Jeannette Ginsberg, another young Jewish woman, became an AAUW member after earning a degree from Texas Christian University.[43] More and more second-generation Jewish women were attending and completing college, a reflection of their parents' upward mobility and material success.

The Fort Worth Council of Jewish Women continued broadening the avenue between the Jewish and non-Jewish communities. In the summer of 1919, Lilli Bogen Morris started a Miriam Club for young, single Jewish women.

Within two years, the Miriam Club affiliated with the Fort Worth Federation of Women's Clubs. The Council was creating entrée for others.

Still, many Jewish women, particularly those belonging to the Orthodox synagogue, felt estranged from Gentile society and chose not to cross that bridge. Many thought that the Fort Worth Council was "too assimilationist."[44] They preferred the Ladies Hebrew Relief Society. They contended that Jewish people should help themselves, because history had shown that no one else would. They preferred to raise money for Jewish causes such as B'nai B'rith's National Jewish Hospital for Consumptives, located in Denver, the New Orleans Jewish Children's Home, and for immigrants arriving through the port of Galveston. There seemed to be an invisible curtain separating women at the more traditional Ahavath Sholom from women at Reform Beth-El, with the former more inclined to raise money for Jewish causes and the latter more prone to engage in civic endeavors.

When Jewish immigration ebbed with the outbreak of World War I and the curtailment of the Galveston Movement, Sarah Shanblum disbanded the LHRS. In its place, in 1915 she helped create the Ladies Auxiliary to the Hebrew Institute.[45] The Hebrew Institute, housed in the building next door to the Orthodox congregation, was the educational and recreational arm of Ahavath Sholom. The new Jewish women's auxiliary decorated classrooms and community rooms, cooked for special events, and raised money for Jewish causes abroad. In 1922, a circle within the Ladies Auxiliary formed a chapter of Hadassah, the women's Zionist organization. Hadassah had been started nationally in 1912 by Henrietta Szold, a woman present at the founding of the NCJW.

At the local and national levels, the NCJW served as a blueprint for emerging Jewish women's groups, spin-off organizations that focused on special areas. For example, in 1913, a subgroup within the Fort Worth Council organized the Beth-El Sisterhood, which focused on the Reform congregation's needs. Sophia Brann was its first president. The Sisterhood freed the Council to concentrate on projects within the secular community. The rosters of each Jewish women's club overlapped, a phenomenon common in small Jewish communities.[46] Each organization reserved a different Tuesday of the month to host its business luncheons, at which the ladies cooked and served. Presidents received reciprocal membership in their sister Jewish organizations and were ceremoniously introduced at the lunchtime gatherings. Many of the same women attended each luncheon, and many served on multiple boards. Some years, the Jewish women's clubs coalesced for a joint luncheon, bridging but not dissolving the separate networks of Reform and traditional Judaism.[47]

In future decades, the overlapping membership and "fuzzy distinctions between"[48] volunteer groups would lead to quiet competition among organi-

zations to snare leaders. However, in the early decades, these spin-off groups strengthened the Jewish women's network. With the creation of the Auxiliary, Hadassah, and the Sisterhood, more women became involved in philanthropic work, more women were exposed to parliamentary procedure, more women had opportunities for leadership, and more women became role models to the next generation. Sociologist Robert Putnam observes that participation in overlapping, faith-based organizations reinforces a sense of community and reciprocity. In Fort Worth, as volunteers of the same religious faith assisted one another in a wider array of projects, internal communal ties strengthened.[49]

Integrating into the Mainstream and Hanging Back

In 1923, leaders of the city's secular women's clubs announced fulfillment of a dream. A wealthy donor, impressed with the civic and cultural improvements accomplished through the club movement, deeded to the city's clubwomen a mansion to serve as a landmark clubhouse. Inside the premises on Pennsylvania Avenue, each club would be able to meet, store books and sheet music, and enjoy lunch or tea. Edith Mayer Gross was among the seven women who signed the charter for the new umbrella organization, The Fort Worth Woman's Club, which held the deed to the house.

The clubhouse deed restricted membership to "any . . . club of white women."[50] The restriction was typical, particularly in the early 1920s. Those were years of boisterous nativism, an era when the Ku Klux Klan became a political force across the South and Midwest. Klaverns sprouted in more than one hundred Texas cities.[51] The Klan, with its constitution that excluded "colored races" and "non-Christians," controlled politics in Fort Worth and Tarrant County.

Local Jewish response to the Klan, which had an estimated 6,500 members, was guarded.[52] Rabbi George Fox knew that the men behind the white robes and masks were prominent citizens, and he did not want to alienate them. "Among these false prophets are also some of my best friends," he wrote in a 1922 editorial in the *Jewish Monitor*.[53] He maintained, "The alleged prejudice against Jews in these organizations is exaggerated."[54] Nonetheless, attorney Theo Mack switched from trial work to appellate work because, with most every judge and juror in the county courthouse a Klansman, he could not hope to win a jury trial.[55]

Ironically, during this time of vigilantism and nativism, a period when Congress passed the nation's first immigrant-quota laws, Fort Worth Jewish women continued to gain acceptance. Their increasing membership in the

*An evening out. The Fort Worth Council hosted a regional conference
in 1924 at the Texas Hotel, one of the city's largest and most prestigious
venues. Courtesy, Beth-El Congregation Archives, Fort Worth.*

new Woman's Club demonstrated their steady integration into the mainstream.
Although the deed to the new Woman's Clubhouse mentioned race, it did not
specify religion. "Jews were, first of all, white or at least . . . could pass for
white," notes Eli N. Evans, a chronicler of the Southern Jewish experience.[56]
Fort Worth's successful Jews were perceived as white; thus, the women's club
door was open to them.

The Fort Worth section of the NCJW could have collectively joined the new
Woman's Club and convened its meetings there. It did not, although on occa-
sion, the Council utilized the Woman's Club's tearoom for banquets. In Fort
Worth, the local Council remained active in the City Federation of Women's
Clubs and in the Texas Federation of Women's Clubs. Perhaps the section
could not justify expending dues for yet another confederation. It already had
a place to meet—the Community Center in Beth-El Congregation's new build-
ing at 207 West Broadway Avenue. Also, the new nonsectarian Woman's Club
was more social and cultural than philanthropic. It featured departments for
music, art, literature, and writing, but not for social action and municipal re-
form. The emphasis was on self-improvement, fine arts, and leisure pursuits

MENU

—o—

Assorted Hors D'Oeuvres

CELERY SALTED ALMONDS MIXED OLIVES

TOMATO BISQUE

ROAST TURKEY, DRESSING, CRANBERRY SAUCE

POTATOES LAURETTE NEW PEAS

FROZEN FRUIT SALAD

BISQUIT TORTONI

ASSORTED CAKES DEMI TASSE

MARSHMALLOW MINTS

PROGRAM
—o—
Mrs. Theodore Mack, Toastmaster
—o—

Quartette from Rigoletto........................Verdi
 Florence Goetz Naugle, Soprano.
 Lilli Bogen Morris, Contralto.
 C. D. Baxstresser, Tenor.
 Sam S. Losh, Baritone.
 Wm. J. Marsh, Accompanist.

To Our Guests..........Mrs. Ida Goldgraber, Fort Worth

Women; "What Can Our Rabbis Do With 'Em or
 Without 'Em"..........Dr. David Lefkowitz, Dallas

Faith and Humanity, Miss Hannah Hirshberg, San Antonio

"Mrs. Gallagher and Mrs. Shean".................
 Miss Ruth Fridman, Mrs. Gertie Jacobs Riebach
 Fort Worth

Echoes from the Three-ringed Circus, the St. Louis
 Triennial..........Mrs. Maurice Goldman, Houston

"Council Knockers; What Shall We Do With Them"...
 Mrs. W. T. Andreas, Dallas

Songs, Selected.....................Mr. Sam S. Losh
 (Mr. Wm. J. Marsh, Accompanist)

To Our Families—"The Lord Let His Countenance
 Shine on Them," when Mother Goes a-Confer-
 encing.................Mrs. Harold Potash, El Paso

The Modern Woman...Rabbi Harry A. Merfeld, Ft. Worth

Act II. Scene 1 (The Gypsy) from Il Trovatore....Verdi
 Azucena—Lilli Bogen Morris
 Manrico—Oscar Webster

Violinists—Mrs. Wilbur Fogleman, Mrs. Bruce Galloway
Flutist—Mrs. Cullen Bailey
Pianist—Mr. Sam S. Losh

Let Me Entertain You. The NCJW's 1924 regional conference in Fort Worth featured Polly Mack as toastmaster at a banquet filled with roasts, classical music, and operatic singing. Courtesy, Beth-El Congregation Archives, Fort Worth.

for the individual, rather than civic affairs. Therefore, the Council of Jewish Women did not fit in as a member-institution.[57]

Many individual Jews did find the Woman's Club a good fit. Seven Jews are listed among the club's seven hundred charter members. Within two years, the Woman's Club grew to a thousand members. Among them were twenty-five Jews, including Amy Haas Merfeld, spouse of the city's new Reform rabbi. Those twenty-five women represented 12.5 percent of the Fort Worth Council's total membership of two hundred. These figures also demonstrate that mixing with the Gentiles was not a universal goal among Jewish women.[58] Within the NCJW—and other sectarian volunteer groups that it spawned—those who wished to remain segregated were sustained by what Elizabeth Enstam calls "a vibrant cohesive society of their own."[59] The comfort of being among their own kind, coupled with traditional fears of assimilation, apparently kept a majority of Jewish women from venturing out.[60]

Those women who did join this new group with its prestigious clubhouse represented what Beth Wenger calls "the leadership stratum of Jewish women's

organizations."[61] They participated in two cultures. These women included Polly Mack, Chic Kassel, and Eva Potishman Brown. If these women were not in the majority, they were in the vanguard as Jewish women joined Christian clubwomen who were determined to redirect women's nurturing roles into civic endeavors. They transformed their gender into a tool for shaping public policy and justifying a louder voice in the community.[62]

War and Peace

Every sacrifice we make—be it buy a Liberty Bond, devote our time to Red Cross work or observe . . . food conservation—all these will make us better women, more able to feel for and sympathize with the oppressed. This is truly woman's mission.[63]

The writer was Polly Mack. The time frame was World War I. The patriotic words bespoke the nurturing role of women. Once again, Mack was serving as president of the Fort Worth Council of Jewish Women; she had been recruited back to the helm in 1917, when section president Tillie Schloss became ill. Polly Mack had never left the upper ranks of the Council, serving in a host of positions. She was pleased to rally her troops for the war effort. Expressing "just pride," Mack described the "Xmas boxes for the soldiers stationed at Camp Bowie," illustrating the universal nature of the Council's deeds. She noted her group's fifty-dollar contribution for blankets when the "first cold spell came upon us [and] our soldiers were without heavy covering." Wartime brought out self-sacrifice and nurturing instincts among women. Mack's troops therefore "dispensed with all social features," except for a dance "for our Jewish soldier boys stationed at the local camps." The women directed their money, time, and home-baked pies to the Red Cross canteen for the "men in uniform."[64] By going outside the home to "perform a customary role," they applied "nurturance" to ease wartime conditions.[65]

Simultaneously, these women looked forward to the peace. Like many women's organizations, the National Council of Jewish Women endorsed President Woodrow Wilson's call for a League of Nations and its proposed World Court at The Hague. Nationwide, Council sections began marking Armistice Day with peace luncheons at which ideas for ameliorating and avoiding international disputes were set forth. The NCJW joined the Women's Joint Congressional Committee (WJCC), which formed in 1920 to lobby for a range of issues, including international peace.

Peace activism was nothing new for the NCJW. As early as 1898, when the

Spanish-American War was imminent, Hannah Solomon had signed a petition sent to President William McKinley opposing war against Spain. Solomon was a close friend of Jane Addams, whose pacifist beliefs and involvement in the Woman's Peace Party were widely known. In 1907, the New York City NCJW section supported at Carnegie Hall a Peace Congress at which Addams spoke. In 1908, the NCJW created a standing Committee on Peace and Arbitration and urged each local section to do likewise. These peace committees would "study international tensions, recommend corrective measures, and lend support of the efforts to organizations to promote world peace."[66] The NCJW committees were similar to peace departments established in many women's organizations around the turn of the century. Linking women to pacifist issues implied that females were purer and more peaceful than men.[67]

Once the United States entered the First World War, the NCJW suspended its peace efforts. Nonetheless, because the antiwar movement attracted Socialists, Communists, and other so-called political radicals, every woman's group affiliated with the peace movement came under suspicion during the postwar Red Scare. In 1923, the NCJW was among seventeen organizations listed on the War Department Chemical Warfare Bureau's infamous *spider-web chart*. The chart, cluttered with oblique lines connecting clubs and coalitions, purported to identify seventeen Socialist-Pacifist women's groups. Many were affiliated with the Women's Joint Congressional Committee—including the NCJW, the WCTU, the GFWC, and the League of Women Voters. The Secretary of War subsequently issued a written apology, but not before the anti-Semitic *Dearborn Independent* printed the chart under the headline "Are Women's Clubs Used by Bolshevists?"[68]

In Fort Worth, there are few extant Fort Worth Council records covering this period. The existing archival documents (consisting of annual reports from 1908, 1918, and 1919, a minutes book from 1916 to 1917, and yearbooks for 1910 to 1911 and 1923 to 1924) make no mention of peace activism.

However, when the paper trail resumes with a 1927 annual report, the peace movement is mentioned in significant fashion. A peace program, presented that year during the Council's November luncheon, was approvingly referred to as one of "our cultural programs."[69] The section's bylaws, printed in the 1928 yearbook, specify that a standing committee on peace and arbitration will "carry out the plans of the national Council's Committee on Peace and Arbitration." In 1928, the group's November calendar again includes a peace program. In 1930, Rabbi Harry Merfeld of Beth-El Congregation was applauded in the Council president's annual report for delivering a "most inspiring talk on World Peace" at the November luncheon.[70] The next fiscal year, in addition to a November peace luncheon, the section sponsored a visit by the nation's most

famous peace advocate, former Montana Congresswoman Jeanette Rankin. Rankin, who voted against the United States entry into WWI (and later into WWII), was on a nationwide speaking tour at the time. From the pulpit of Beth-El Congregation, she delivered the sermon one Sabbath eve in 1932.[71]

By then, Hitler was rising to power in Germany. American Jews worried about the impact of war on their overseas brethren. As war approached, cries for peace became more urgent. Nationally, the NCJW supported an economic boycott of Germany and called for the United States to boycott the Berlin Olympics.[72] By then, reports about atrocities against Jews had filtered out of Nazi Germany. Still the NCJW headquarters urged neutrality and measures to avert war. In November 1937, the Council participated in the city's Armistice Day parade, a first for the Jewish women. Three months later, in February 1938, Fort Worth hosted the Texas Convention on the Cause and Cure of War. Thirty-one Council women attended, paying their own registration fees. Norma Mack worked as chairman of general arrangements for the 1938 gathering.[73] "We thought we were doing noble work by working against the war," Mack recalled in a 2003 interview. "After the League of Nations failed . . . we still believed in One World. . . . Little did we know."[74] Her reference was to the Holocaust.

In Fort Worth, the Committee on Peace and Arbitration received in 1941 a new name — Peace and Public Affairs. November peace programs remained on the section's agenda. However, the local president's annual report had more rhetoric of war than peace. "Today we are confronted with the Central Europe refugees who are running away from Hitlerism," wrote Sophia Miller:

> *The Council is bringing children from that tortured land into our land of freedom and liberty and love. Our Council is helping place those adult refugees in cities where jobs can be found for them. . . . We cannot shrug our shoulders and say, let the New Yorkers and El Pasoans take care of it; it isn't a local problem, but one that belongs to each of us as humanitarians.*[75]

As emphasis shifted from peace to war, on November 11, 1942, the Fort Worth Council no longer called the holiday *Armistice Day* but rather *World Government Day*. The following year, the section no longer had a peace committee at all. Its World Government Day observance was "appropriately celebrated" on November 11 when, section president Tobia Miller Ellman noted, "we re-dedicated all our efforts toward an early and complete victory." She added, "This year has seen our peaceful world tumble about us, has seen drastic changes in our lives."[76] The Council yearbook describes a new "Emergency Program" with committees involved in the sale of war bonds, Red Cross canteen work, hospi-

tality for Jewish soldiers training in the region, and an enlarged sewing circle to stitch surgical bandages for America's allies.

A Stitch in Time

The Council's sewing circle started modestly in the years after World War I and gradually grew into one of the section's most prominent subgroups. Socially, it united Jewish women of different generations. Philanthropically, it linked them to the needs of the city. Needlework became part of the Council on November 17, 1919, when twenty-four women met to sew nightgowns for the city's "poor and orphaned children."[77] Soon, the Sewing Circle was working in league with the City Federation of Women's Clubs to stitch layettes and linens for the Free Baby Hospital. During the 1920s, the Sewing Circle met three Mondays per month. The purpose was as much social as charitable and utilitarian. Young women grew up with the adage "Idle fingers are the devil's work." From an early age, they busied their hands with thimbles and needles, cross-stitching samplers before progressing to crocheted afghans and patchwork quilts. Banding together under the mantle of the Council to sew for the city's poor gave women welcome company while they performed a common pastime for the greater good.[78]

By the 1930s, the Council's Sewing Circle was stitching clothes for children in the New Orleans Jewish Orphans Home. "A group of our younger matrons did the sewing," reported president Libby Ginsburg. One of those "younger matrons" was Bernice "Beanie" Weil (1906–2004), a newlywed who had moved from Wichita, Kansas, to Fort Worth in 1934, after marrying Marion Weil. He was the nephew of haberdasher Leon Gross and his clubwoman spouse Edith Mayer Gross. Marion Weil worked at his uncle's store, Washer Brothers Clothier. His wife stayed at home.

"Nobody worked," recalled Beanie Weil, referring to the Jewish women whom she met in her new hometown. Now that she was married and in new surroundings, she wanted more substance in her life. "I made up my mind; I wasn't going to spend my time playing bridge. I grew up with a deck of cards in my hand. It was so useless."[79] Two older women took the young bride under their wings and encouraged her to join the Fort Worth Council's sewing circle. "I said, 'I can't sew.' They said, 'Oh, we'll teach you.' I didn't even know how to hold a needle, but I remember these two women—Mrs. Archenhold and Mrs. Hart—so well because what little I learned, they taught me." In no time at all, Beanie Weil was proudly making "little nightgowns" and sewing buttonholes.

Because her mentors were among the "older generation," no one addressed

them by their given names. "It was always 'Mrs. Archenhold' and 'Mrs. Hart.'" (Their given names, respectively, were Ruby and Hildegard.) "Mrs. Hart was married to the flour mill owner." The Sewing Circle, with its intergenerational membership, fostered special relationships akin to traditional family bonds. "Alleviating the isolation of the home," Elizabeth Enstam observes, "these clubs provide[d] the companionship that former generations had taken for granted."[80]

For a time, Weil also volunteered at the city-county charity hospital. "I brought chicken pox home to my children, so I stopped," she explained. Her participation in the Sewing Circle continued for more than a decade—even when gas rationing in 1942 necessitated moving the sewing room from the Reform synagogue, which was several blocks south of downtown, to the more conveniently located Hebrew Institute, which was next door to the Orthodox shul. But the move did not represent a closer connection between these two arms of the faith. "We had no connection with the Hebrew Institute," Weil insisted. "There was a line right down the middle between the Reform and Orthodox Jews. That was the trend. We were anxious to be seen as American."[81]

As the winds of war grew fierce, the needlework of the Council women assumed added importance. During the first six months of 1940, the Sewing Circle completed 387 dresses and sun suits, 95 women's wool dresses, 20 women's cotton dresses, 34 dozen diapers, 23 convalescent robes, 24 woolen shirts, several hundred baby caps, and dresses and blankets for the Red Cross and for British relief. In addition, the ladies did "considerable knitting," again for the Red Cross and British relief.[82]

The following year, demand increased, and the Sewing Circle met twice weekly on Tuesdays and Thursdays, from 10 A.M. to 1 P.M. That year the need was for shirts and shorts for men, aprons for women, and cloth bags to hold the personal belongings of "the unfortunates who arrive at Ellis Island and other ports of entry." When the city's All Church Home for Children issued a plea for Easter clothes, the Council's Sewing Circle obliged. "We dressed a little girl for Easter," president Tobia Ellman reported, another indication of the ecumenical nature of the Jewish women's charitable work.[83]

Needs multiplied. During the next year, 1944, the Sewing Circle extended its hours from 9:30 A.M. to 2 P.M. and produced 220 "kit bags," 57 arm pads, 19 wheelchair robes "patterned and quilted," 32 baby gowns, and 18 wash rags. (The women also hemmed 21 tablecloths for the Hebrew Institute, which, besides housing Ahavath Sholom's religious school, also functioned as a Jewish community center for groups using its gymnasium and ballroom.) Even after war's end, requests poured in. The Sewing Circle began filling wish lists not only from the Red Cross and the local children's hospital but also from the United Jewish Appeal. Members held three quilting bees—one at Regina

Gernsbacher's home, one at Lillian Blanc Weiner's home, and a third at the Beth-El community center.

By 1948, forty volunteers worked "untiringly" on the Council Sewing Committee. The next year, termed a *banner year*, the B'nai B'rith Lodge donated sewing machines, enabling the seamstresses to complete 577 garments. Many were for the NCJW's Ship-a-Box program that sent parcels of clothing, school supplies, and toys to Jewish children in France, Holland, Belgium, Italy, Greece, Austria, Germany, Czechoslovakia, Hungary, Poland, and Romania.[84] Additional garments, Council president Norma Mack proudly reported, were earmarked for "our adopted orphanage in France."[85]

Differences Within

In 1950, Margot Rosenthal Schwartz (1922–2006), a German refugee who had supported herself as a seamstress, moved to Fort Worth with her American husband Paul, a veteran working with the Army Corps of Engineers. Similar to Beanie Weil's experience fifteen years before, Margot Schwartz began attending Council functions, looking for a niche in the organization. "I was not accepted," Schwartz recalled. She could sense that she was not American enough. She felt invisible. "At luncheons, it was a matter of, 'Margot, would you please pass the salt and pepper?'" But there was no further conversation. She asked to serve on several committees, but she was not tapped.

Confident of her ability with a needle and thread, she went to a Sewing Circle session. Unlike American-born Beanie Weil, who had married into a prominent Fort Worth family and was mentored by older women in the sewing circle, Margot Schwartz felt unwelcome. "I did not come up to their expectations," she said. Smarting from the Council's elitism, she remained a dues-paying member but found leadership opportunities elsewhere. She served as president of the Beth-El Congregation Sisterhood and became active in the Fort Worth Symphony League and in several engineers' wives' auxiliaries.[86]

In Fort Worth and nationwide, the NCJW drew the bulk of its members from affluent and acculturated Jewish women, those with longer lineage in America than the latest wave of immigrants.[87] In general, women's clubs of the period were altruistic in their programming, yet exclusive in their membership policies. Members wore fashionable hats and gloves to meetings, where they delivered committee reports with proper diction, not foreign accents. The Council of Jewish Women was no different than most other women's clubs, although it purported to be. Women with German accents, Yiddish inflections, or Old World ways were more often candidates for charity than for Council mem-

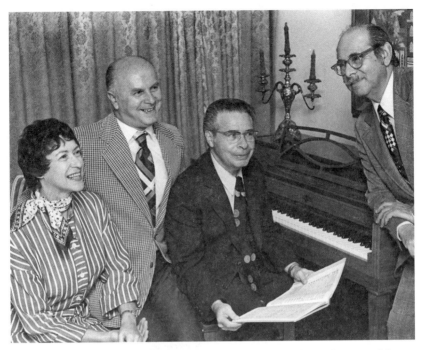

Margot Rosenthal Schwartz. A Holocaust-era refugee from Cologne, Germany, Margot Schwartz is pictured with her husband, Paul Schwartz, Michael Winesanker (at the piano), and Phil Ackin. Margot joined the NCJW Sewing Circle but received the cold shoulder from American-born members. Courtesy, Beth-El Congregation Archives, Fort Worth.

bership. As Beanie Weil had noted, Council members tended to be affiliated with Reform rather than traditional synagogues. Not until 1983 did the Fort Worth Council routinely elect presidents who had grown up attending Ahavath Sholom, the traditional synagogue.

Americanization School Redux

Amelia Levy Rosenstein (1897–1985) was a newcomer who fit the Council profile. A first-grade teacher from Houston, she grew up attending Texas's oldest synagogue, Beth Israel Congregation, where she taught Sunday school. In 1927, she married Fort Worth's Abe Rosenstein, moved to the city, and joined the Fort Worth Council. In that era, female teachers lost their classroom positions when they became pregnant. Teaching was Amelia's calling. Therefore, in Fort Worth she began to substitute in the Americanization School. Gradually, she became

*"Dean" of Americanization School. In this 1940 photo, Amelia Rosenstein stands at
a chalkboard at the Hebrew Institute, where she taught classes for immigrants.
Rosenstein directed the NCJW's Americanization School from the 1930s until her
retirement in 1973. Courtesy, Fort Worth Star-Telegram Photograph Collection,
Special Collections, The University of Texas at Arlington Library, Arlington, Texas.*

its unofficial "dean."[88] A gifted educator with a personal touch and a penchant
for detail, Amelia Rosenstein invited foreign students into her home and helped
many resolve bureaucratic problems involving visas and immigration papers.
Among her students were three well-educated Arab men who had taken En-
glish classes at a Baptist church but subsequently quit. The teachers there had
tried to convert them to Christianity. At the Council school, there was no reli-
gious proselytization, only a push to Americanize. Another student, an elderly
Greek matron, had difficulty grasping the United States system of government
with its separation of powers. "She couldn't understand the three branches of
government," Rosenstein's son Bernard recalled. "So Momma compared the
three branches of government to a three-part stove. A stove boils water, broils
steaks, and bakes cakes." The student grasped that analogy.[89]

Rosenstein remained a student herself. She kept abreast of the changing maze of naturalization requirements by scouring U.S. Department of Labor bulletins, subscribing to a monthly NCJW newsletter called *The Immigrant,* and utilizing the NCJW's seventy-six-page citizenship booklet, *Making Americans.*[90]

Throughout the 1930s, the Americanization School received New Deal money funneled through the Fort Worth school district. On the eve of World War II, the school lost its government funding. Rosenstein remained at the helm, coordinating a corps of volunteers. The local Council of Jewish Women paid her a small stipend and underwrote court costs for "all new Americans" from the school who applied for naturalization.[91] After the surrender, the school filled with war brides from Germany, Japan, and the Philippines.

Also enrolling postwar were Holocaust survivors whose status as students and fellow Jews complicated their relationship with the well-meaning ladies in

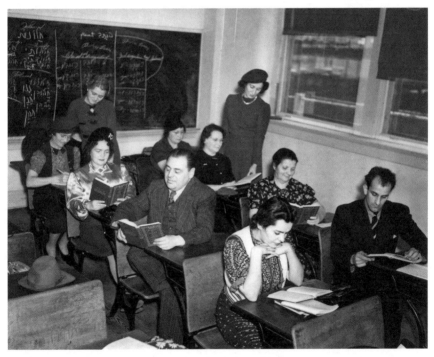

Night School, 1940. Amelia Rosenstein, standing, left, and Janet Teter assist a class full of immigrants. The students are, first row, front to back: Theresa Zulouf, Erwin Wolf, Mrs. T. Bergman, Annie Rutlader. Second row: Erwin Richker, Rosa Snofsky, Mrs. A. Haller, Ida Star. Courtesy, Fort Worth Star-Telegram *Photograph Collection, Special Collections, The University of Texas at Arlington Library, Arlington, Texas.*

Surrounded. Americanization School alumnae surprised longtime teacher
Amelia Rosenstein, seated center, with a party in December 1968. Photo by Norman
Bradford. Courtesy, Fort Worth Star-Telegram Photograph Collection, Special
Collections, The University of Texas at Arlington Library, Arlington, Texas.

the Council of Jewish Women. These proud newcomers, eager to get back on their feet, were often uncomfortable accepting charity from their social equals. Although they had developed a warm rapport with Amelia Rosenstein, they detected a level of condescension from other volunteers.

Among the new crop of students was Livia Schreiber, a teen survivor of the Auschwitz death camp. She arrived in Fort Worth in 1945 and moved in with her distant cousin, prominent local physician Eugene Steinberger, who sponsored her immigration to America. Pretty and animated, the twenty-year-old refugee picked up English with a lilting Czech accent. The Council nominated her as its candidate for Presentation, the Jewish debutante ball held at Thanksgiving. Within a few years, Livia married Texan Sam Levine and decided that she was ready to enroll in the Americanization School and apply for U.S. citizenship. On June 19, 1950, Livia Levine stood before a federal district judge, renounced allegiance to any "prince or potentate," and recited the oath of American citizenship.[92]

As a graduate of the Americanization School, Levine was entitled to a year's

free membership in the Council of Jewish Women. Amelia Rosenstein invited her to a monthly meeting. After introductions were made, Levine was asked to describe her wartime ordeal, from her 1939 deportation to her seven-year nightmare at Auschwitz and Bergen-Belsen. "My English was so bad, I am afraid I hit it off wrong with the women," Levine recalled fifty years later. Some of the women were skeptical of her narrative. "One of the ladies said, 'You know we had it hard, too. We had to have special coupons for gasoline and tires for a car.' . . . I was talking to them about bread. . . . Some of these women really and truly did not know what had gone on under the Nazis. I was so hurt." Levine

Livia Levine's debut. Livia Schreiber Levine, a survivor of the Auschwitz Concentration Camp, was the Council's 1947 nominee for Presentation, the annual Jewish debutante ball. Her date was Louis Weltman. Courtesy, Beth-El Congregation Archives, Fort Worth.

never became active in the Fort Worth Council, becoming involved instead in Hadassah and the Beth-El Congregation Sisterhood. She concluded, "Council was for the elite."[93]

The Council's triumphs in the traditional women's sphere—teaching, sewing, advocating peace, coalescing with other clubs, and performing motherly, nurturing work—had brought it stature and recognition across Fort Worth. These accomplishments also revealed strains within the Jewish community. Those with closer ties to the European experience favored one-on-one charity and old-fashioned frontier neighborliness. The urban climate, however, made such "deeds of loving kindness," as the ancient rabbis called them, seem obsolete, a throwback to a more naïve time. In the words of Beanie Weil, "We wanted to be seen as American." The Council's agenda was pointed toward the future, not the past. Council members marched in coalition with other leading women's organizations, embracing larger roles for women, roles ironically couched in the metaphors of the past.

Of Book Sales and Social Change

Triumphs Beyond Women's Traditional Sphere

The triumphant end to World War II spurred a transition in the role of women's clubs. The Fort Worth Council of Jewish Women gradually stepped away from cake raffles and Red Cross canteen work. Teacups and bobbins became symbols of the past. Section members collectively moved into ventures involving mercantile skills and policymaking, becoming agents of change. Domesticity and femininity still largely defined these women, who disavowed feminism and identified themselves by their husbands' given names rather than their own. But their fashion-show luncheons were increasingly paired with weighty speakers and causes such as combating juvenile delinquency. They financed cutting-edge pilot programs, such as downtown day care for low-income working women. Eventually, they even reclaimed their names. The Council initiated one of its most successful and enduring Fort Worth fundraising projects—the Annual NCJW Book Fair. The connection between books, Jewish women, and controversial social programs began there and would last many years. The Fort Worth Council of Jewish Women was entering its heyday, moving from the society page to the front page. But, being from the "lady-producing south," these women took a traditional stance and refused to ally with the militant feminist movement. Although other feminists in Fort Worth called the Council gutsy, its disassociation from the Women's Liberation Movement cost it credibility among newcomers and among young Jewish women coming of age. Also, the Council's coalitions with community organizations such as the prestigious Junior League would rob it of leaders, as Jewish women were invited to join clubs previously closed to them.

The postwar period brought defense contracts and prosperity to Fort Worth. Veterans poured into the region, filling jobs at Chance-Voight, locally known as the *bomber plant*, and at Bell Helicopter, which opened in 1949. The Fort Worth Air Field was enlarged and renamed Carswell Air Force Base, bringing

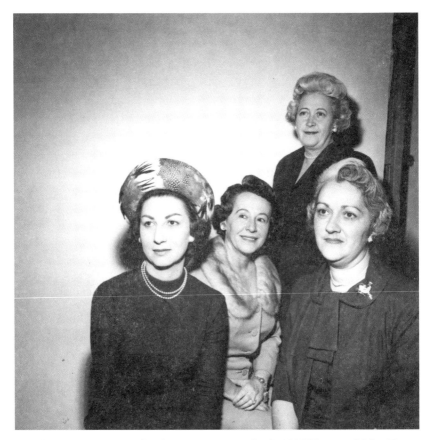

Silver Tea Committee. The planning committee for the NCJW's annual Silver Tea met in February of 1961 for what turned out to be the Council's last such fundraiser. Ruth Hamill, left, is grouped with Marguerite Rashti, Maxine Goldstein, and Minette Herman. Courtesy, Fort Worth Star-Telegram Photograph Collection, Special Collections, The University of Texas at Arlington Library, Arlington, Texas.

more military personnel and more civilian jobs to the region. The city's population grew by more than 50 percent from 177,600 before the war to 278,000 by 1950. Mother nature put a damper on the growth on May 16, 1949, when the Trinity River flooded and water reached the third floor of the Montgomery Ward's department store. The Council of Jewish women responded by giving flood victims all the clothing in the Council's thrift shop.

Changes were afoot within the Fort Worth Council. The group's annual *silver tea* fundraiser, an elegant affair with a sterling silver tea service as the centerpiece, evolved into a *silver brunch* in 1952 and a *silver tour of homes* in

1961 before it disappeared from the Council calendar altogether.[1] Involvement in the Federated Women's Club network diminished, with the tie officially severed in 1978.

Part of the impetus for change within the Council came from two war brides who settled in Fort Worth—Lilaine "Lil" Goldman (1913–2000) of Chicago and Ruth Rapfogel of New York City. Both were eager to get involved in the community. Both brought new perspectives and leadership styles. Lil Goldman, Council president from 1953 to 1955, was a preschool educator with an advanced degree from New York's New School of Social Research. Ruth Rapfogel, a New York art student who had studied in France, followed Goldman as president. She became active in local Democratic Party politics and the civil rights movement, arenas in which she was often the lone Jewish woman. Both Goldman and Rapfogel had moved to Fort Worth at a time when the Council was, in Rapfogel's words, "getting inbred" during the ho-hum, postwar

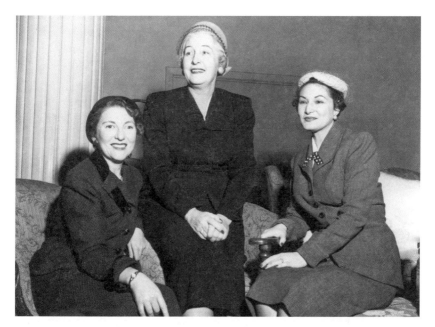

Lilaine "Lil" Goldman, educator. Goldman is pictured in 1954 with Florence Leonard, executive secretary of the Tarrant County branch of the National Foundation for Infantile Paralysis, and Florence Simon, NCJW March of Dimes co-chairman. Among Goldman's long-lasting achievements were the formation of the local day-care association and construction of the county's first supervised residence for juvenile delinquents. Courtesy, Fort Worth Star-Telegram Photograph Collection, Special Collections, The University of Texas at Arlington Library, Arlington, Texas.

Eisenhower era.[2] The two newcomers pumped fresh blood into a Council section in which members had grown accustomed to running a thrift shop and helping immigrants pass citizenship tests—worthy programs, to be sure, but no longer innovative.

Beginning in 1953, with Lil Goldman guiding the section, the Council of Jewish Women began publicly and relentlessly advocating an unpopular cause—a home for youths in trouble with the law. County voters had defeated by a three-to-one margin a bond issue to finance such a facility.[3] Yet, in the lexicon of the times, *juvenile delinquency* was a rising problem. Congress held hearings on possible causes, blaming television violence, comic books, and punitive parenting.[4] In Tarrant County alone, annual arrests of adolescent boys had more than doubled to 1,327 by 1954, compared with 550 in 1947.[5] During the first two months of 1955, 40 percent of the auto thefts, 40 percent of the rape cases, and 150 out of 175 burglaries cleared by police were attributed to youths aged ten to seventeen years.[6] Most offenders were locked up in the county jail, then shipped to the state reformatory, where they were likely to learn more about crime than rehabilitation. Those who claimed remorse were sent "back home where the trouble started."[7] A nearby residential youth facility, where delinquent boys could receive counseling, medical care, and schooling, seemed a saner alternative.

In 1955 the Council of Jewish Women teamed up for the first time with the Fort Worth Junior League, which had been founded in 1929. Together, they convened a public forum to draw support and raise money for the boys' facility. Two hundred citizens from all walks of life attended the forum, which was held at the Fort Worth Children's Museum and reported on page one of the morning and afternoon papers.[8] The most that the Jewish women could hope to do was educate the public—the most, that is, until a project came along that gave them the capital and clout to push through more extensive plans.

The Book Fair Business

During the summer of 1957, Pearl Joseph Rabinowitz, who had been the Fort Worth Council president ten years earlier, hit upon an enduring fundraiser. While visiting St. Louis, she attended a used-book fair. Residents donated old books; volunteers cataloged, priced, and shelved them; and thousands of bargain hunters purchased armloads of volumes at an annual sale that fostered reading and recycling. Little money was expended, because dozens of full-time homemakers donated their time. When Rabinowitz (1916–1978) returned to Fort Worth, she volunteered to coordinate a Fort Worth Book Fair for the

Pearl Rabinowitz, Book Fair founder. During a visit to St. Louis, Pearl Rabinowitz,
left, learned about the profitability of used-book sales. The Council replicated
the idea in Fort Worth, and it turned into a popular annual event that raised
the Council's profile. Here she is at a 1954 planning meeting. To her right are
Eleanor Gachman and Eva Greenspun, who is pouring coffee. Courtesy,
Fort Worth Star-Telegram *Photograph Collection, Special Collections,*
The University of Texas at Arlington Library, Arlington, Texas.

Council, with Norma Mack (1909–2006) as her co-chair. The board embraced
the idea. The membership voted to earmark profits to launch the controversial
home for youths in trouble with the law. During the winter of 1957 to 1958, as
plans for the Council Book Fair materialized, the Council trumpeted as its
motto "Buy a book, help a boy."[9]

The Council's community profile soared. Media coverage spilled onto the news pages and into the airwaves. Best-selling authors from around the nation donated autographed books. A Midwest traveler who read about the upcoming book fair during a layover at Fort Worth's Meacham Airport sent a package of books from Chicago, leading to another article in the daily press.[10]

By April, more than ten thousand books and hundreds of phonograph records had been cataloged and arranged on home-built shelves and tables in the Pioneer Palace, a hall constructed during the state's 1936 centennial. With a nod to religious tradition, the Book Fair opened at sundown on a Saturday night, at the close of the Jewish Sabbath. As the last rays of sunshine lit the roof of the Pioneer Palace, scores of people, some of whom had traveled from as far as Oklahoma, lined up for bargains. When the doors opened, bibliophiles swarmed in and grabbed supermarket shopping carts. Parents parked youngsters in the children's book nook, then moved on to browse for the evening. A convivial air pervaded the hall. Prices were so low—with most books priced from a nickel to fifty cents—that one customer purchased four hundred books "for a song," the *Fort Worth Star-Telegram* reported.[11] In one section, customers found higher-priced first editions. Among those treasures was a sixty-eight-volume set of Samuel Johnson's *The Works of the English Poets*, which the Fort Worth Public Library purchased. Also in this nook were the autographed bestsellers that the clubwomen had solicited from such luminaries as radio minister Norman Vincent Peale, a founder of the human-potential movement. Psychiatrist Corbett Thigpen, co-author of *The Three Faces of Eve*, which became an award-winning movie, inscribed his hardback: "We are glad to . . . help your project . . . for juvenile boys in trouble . . . One such home is worth a dozen mental . . . clinics."[12]

On opening night, the Jewish community was out in force. Many among the Council's four hundred members brought along spouses and children to help restock shelves and bag popcorn. Past presidents and their husbands vied to fill the most visible and prestigious positions at the checkout counters, where they chatted with customers and tallied purchases. By the end of the four-day fair, net profits totaled two thousand dollars. The Book Fair was the largest, most profitable public event that the Fort Worth Jewish community had ever staged. Volunteers swelled with pride over the fair's commercial success and the goodwill that it generated. The book fair reinforced friendships among Jews while fostering ties with the larger community. Over the next three decades, the book fair would turn into an annual event, gradually netting up to $35,000 a year. The Fort Worth Council had unwittingly launched a small business.

For the book fair's second year, Pearl Rabinowitz and Norma Mack again coordinated the event, gathering more books, doubling the profits for the youth center, and fine-tuning their merchandizing skills. "We learned a lot the first

Books galore. Mildred Gale, left, and Sarah Blum were overwhelmed
with donated books as they prepared for the 1957 Book Fair. Courtesy,
Fort Worth Star-Telegram *Photograph Collection, Special Collections,*
The University of Texas at Arlington Library, Arlington, Texas.

year," Mack recalled. "We learned that the prices were so cheap that second-hand dealers came and loaded wagons full of books. We learned that rare, important books should not be lying around. We looked in old book catalogs to better price the rare volumes."[13]

Librarian Marion Snyder, a non-Jew, volunteered her skills as a book appraiser to help boost profits. "They were charging a nickel and a dime for books," she recalled. "We upped prices so that we weren't giving them away any more. It was great fun. Every time a famous author died, like Ernest Hemingway, we marked up the writer's books . . . Book Fair was very close to my heart." While Snyder asked no salary, she required transportation. Volunteers dutifully chauffeured her to and from the workroom to prowl through the "rubble of donated books." Her appraisals paid off when rare books auctioned off during subsequent fairs sold for up to four hundred dollars.[14]

The Council women kept acquiring business expertise. During the 1960s, they began mailing letters to interior designers, realtors, and furniture-store

managers, suggesting that they shop at the Book Fair for handsome, though outdated, encyclopedia sets to fill bookshelves in commercial showrooms. The women notified federal prison officials to take advantage of bargain-basement prices on the fair's final day, when a shopping cart full of books sold for a set low price. The *Texas Jewish Post* reported each innovation.

Publicity abounded. Retailers inserted the fair's logo — Benji the Book Worm — into newspaper ads; bankers affixed the logo to monthly statements; and the city water department printed it on customers' bills. Local book editors donated review copies and plugged the event in the books section of the Sunday papers. Columnists chortled in print about love letters tucked into vintage volumes. In 1987, Pulitzer Prize–writer Larry McMurtry dropped in and purchased three thousand books that he loaded into a Lincoln Continental and transported to Archer City, his hometown, where, years later, he opened a used-book emporium. McMurtry's shopping spree resulted in a page-one column.[15]

The media embraced the book fair. In 1969, Meacham's, an upscale ladies department store, outfitted the Council officers in trendy spring fashions and featured the women and the book fair throughout *Meacham's Fashion News*, a monthly tabloid mailed to customers.[16] Council president Amy Scharff wore a white-cotton-brocade tunic pants suit, president-elect Sandra Freed modeled an above-the-knee geometric print, and administrative vice president Sonya Stenzler donned a striped blouse with a mini-skirt. The tabloid's cover story extolled the book fair, recapping Council history and listing a dozen nonprofits, from the Community Action Agency to the United Way, that drew on the Council's expertise through board representation.

Although the Book Fair initially lasted four days — and gradually expanded to nine — preparation was year round. Department stores and grocers set donation barrels outside their doors. Boy Scout troops and DeMolay, a service order for youths, were enlisted to empty the barrels and deliver the cargo to the basement or warehouse where the women were marking books prior to the sale. At first, books were stored at Pearl Rabinowitz's home and later in a warehouse belonging to a member's spouse.

In 1963, the city's only shopping mall, Seminary South, offered the Council an empty storefront for year-round storage and the mall's community center for the springtime sale. The arrangement, a boon to both, lasted until the fall of 1975. With two other Fort Worth shopping malls in the planning stages, the management at Seminary South opted to lease the space to a paying client. Book Fair was evicted. The women had thirty days to remove 100,000 volumes. The eviction turned into a page-one bonanza of publicity. "A bargain is hunting for a basement," declared the afternoon paper.[17] Two weeks later, another

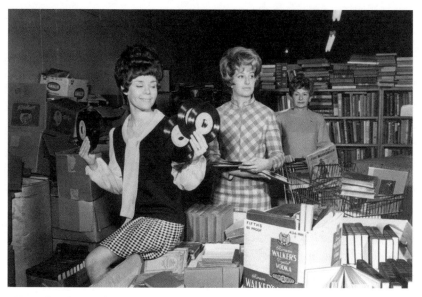

*'Round and 'Round in the 1970s. Bayla Simon sorts through a stack of 45-rpm records
donated to the annual Book Fair. Behind Simon are Sharon Finstein and Ida Glazer.
Courtesy,* Fort Worth Star-Telegram *Photograph Collection, Special Collections,
The University of Texas at Arlington Library, Arlington, Texas.*

front-page story informed a relieved populace, "Book Fair no longer is a home-
less orphan. The Lena Pope Home [a local orphanage] will take it in."[18]

"We had to get out of there soon," recalled Book Fair coordinator Carol
Minker, whose mother, Charlotte Max Goldman, had been Council president
two decades before. Alarmed at the logistics of moving 100,000 books, Minker
told reporters, "The organization does not want to spend money to hire profes-
sional movers because that would bite into book fair profits, all of which go to
local causes." To the rescue came Mayflower Moving & Storage with a donated
truck. A local carwash pitched in with manpower. Minker added, "There was
a lot of good will."[19]

Using Their Clout

As a direct result of the Book Fair's first two years' profits, a home for eighteen
delinquent youths was constructed in 1959 at Eagle Mountain Lake in the west-
ern reaches of the county. Funding came from the Council, the Junior League,

and the County Commissioners Court. The facility, called the Tarrant County Youth Center, proved so valuable that it evolved into the Lynn Ross Juvenile Detention Center, a still-viable, county-run facility for eighty-eight male and female juvenile defendants who receive medical care, counseling, and academic tutoring.[20]

The Youth Center was the first of many pilot programs started with seed money from the Council and taken over by a government entity. The boys' home was an example of a women's club program that served a wide-ranging, even professional, purpose. Historian Anne Firor Scott credits women's clubs with functioning as an "early warning system, recognizing emergent problems before the male-dominated political process identified them."[21] Historian Karen Blair, in her study of American clubwomen, notes that the progression from pilot program to community sponsorship attests to the value of middle-class women's clubs and their pioneering efforts.[22]

As the Fort Worth Council readied for its third annual Book Fair in 1960, the section turned its attention to the need for a downtown day-care center.[23] In coalition, once again, with the Junior League, the Council proposed turning a two-story building north of the Tarrant County Courthouse into the downtown area's first childcare center. The resulting publicity, coupled with a four-thousand-dollar check from the Council, led to the opening in 1960 of the Bluff Street Day Nursery. It enrolled up to ninety preschoolers. Along with Council funding came volunteers who participated at all levels, particularly on the board of directors, which shaped future policy. In 1961, the Bluff Street Day Nursery joined with eight other day-care centers to form the nonprofit Day Care Association of Fort Worth and Tarrant County. Lil Goldman is credited as its founder. The association received 89 percent of its $400,000 budget from the United Fund (the forerunner of the United Way) and the rest from tuition, which was based on a sliding scale.[24]

The Council partnered with other community groups besides the Junior League. Later in the 1960s, it worked with United Cerebral Palsy to create a sheltered workshop for the mentally and physically handicapped. Before allocating book fair money to this project, a Council committee of twenty-five women surveyed the city to assess the number of handicapped residents and their needs for rehabilitation and vocational training.

This grass-roots experience in canvassing the community, as well as the Council's interest in child care, led the section to participate in a nationwide day-care survey commissioned in 1970 by the U.S. Office of Economic Opportunity (OEO). The OEO had contracted with NCJW's national headquarters to publish *Windows on Day Care*, a 250-page paperback book, for an upcoming White House Conference on Children and Youth.[25] From among the NCJW's

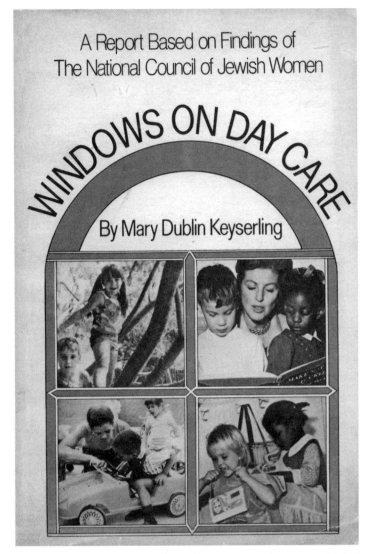

Windows on Day Care. This groundbreaking paperback volume, published in 1972, included research compiled by the Fort Worth Council of Jewish Women. Courtesy, Beth-El Congregation Archives, Fort Worth.

176 sections across the country, 77 volunteered to canvas their communities and compile detailed reports for inclusion in the publication. In Texas, Fort Worth was among five of the state's eleven NCJW sections to participate. The others were Dallas, El Paso, Houston, and San Antonio.[26]

Fort Worth's Ellen Feinknopf Mack, the third generation of Mack women to take a leadership role in the Council, coordinated the local child-care survey with a team of twelve eager volunteers. Their enthusiasm quickly turned into frustration. When volunteers attempted to visit day-care centers, "many doors were closed in their faces." Most facilities were unlicensed, yet the demand was so great that all had waiting lists. Even at licensed facilities, the surveyors detected "a feeling of fear from proprietors," fear that they would be reported for overcrowding, fear that they might not pass the next state inspection, fear that they would be faulted for inadequate first-aid equipment.[27]

Contacting parents with children enrolled in day care was another hurdle. Day care was a term spoken in whispers by those in need of child care. "People in these situations seemed to be 'scared,'" Mack reported. "If things are good, they are afraid they will be in jeopardy if they talk. If things are bad, they are afraid they will get into trouble." To gather names, addresses, and telephone numbers of day-care clients, Council members asked for assistance from their own "household help." One Jewish woman obtained from her manicurist a list of eighteen parents with children in day care. All were contacted. Few would talk about conditions inside their day-care centers, much less answer direct questions about cleanliness, staff-to-children ratios, and costs. Among the working poor, there was hesitancy to talk with uptown ladies about their child-care situations. Most parents who agreed to interviews insisted on anonymity.[28]

Despite these obstacles, the dogged survey team toured thirty-one child-care facilities—10 percent of the licensed centers in the county. They found some facilities "run down," others enrolling "too many children," many lacking "good medical provisions," and few providing educational enrichment. The Council's final report advocated revision of state standards for day-care facilities (because they were identical to the requirements for foster homes); uniform standards for commercial and nonprofit centers (because for-profit facilities had less stringent requirements); state funding (there was none at the time); and confederation of the county's thirty-four nonprofit day-care centers into the existing nine-member Day Care Association. "We feel, if these youngsters could be properly cared for now, some adolescent and teen-age problems might well be averted," the eighteen-page survey asserted. Bolstering these recommendations were demographic statistics, questionnaires, interviews, and photographs.[29]

Despite the professional expertise embodied in the report, its conclusions were prefaced with a disclaimer: "We are not Liberationists."[30] Leery of being

cast as feminists usurping gender roles by setting public policy and encouraging women to join the workforce, the Council opted for a moderate posture. Day care was becoming a divisive issue nationwide as more middle-class professional women actively sought employment. Many in the child-guidance community denounced the "communal approach to child rearing."[31] Politicians, including presidential candidate Richard Nixon, mistrusted the "family weakening implications" of day-care centers.[32] Therefore, the Jewish women involved in the Fort Worth survey felt it necessary to disavow involvement in the women's liberation movement and erect boundaries around their sphere. "We were wanting to change things for the women, but not adamantly, not militantly so," explained LaRue Glickman Glazer, section president from 1965 to 1967.[33]

She and the other women did not want to jeopardize their group's position as the key liaison between the Jewish and non-Jewish communities in Fort Worth. During the 1970s, the Jewish community totaled around five thousand people. The city was mushrooming to nearly half a million. The leaders of the Fort Worth Council basked in their disproportionate influence. They and their forebears had worked hard to reach this level of visibility, efficacy, and prominence. They sought to maintain it. They had representatives serving on the boards of more than a dozen community nonprofit organizations, from Easter Seals to the Area Agency on Aging. Through their cautious Progressive-era methods—mainly gathering facts, hosting public forums, working for legislative changes, and corralling volunteers—the Council's members had made many inroads. They could not risk their status by seeming to ally with radical social movements.

To shape public policy affecting the disadvantaged in Fort Worth, the Council had to strike a moderate, rather than demanding, posture. Historian Karen Blair views such tactics, prevalent among women's-club leaders, as a continuation of the social housekeeping mode that they had relied on for decades. Cushioning recommendations in self-effacing rather than assertive terms was apt to reap more success than would demanding language. "That was the climate of the times," observed Ruth Rapfogel. "Council did *service* things—not *political* things."[34]

In society at large, however, women were increasingly venturing into the political arena to demand equal pay and equal opportunity for themselves. Rhetoric over child care and other women's issues was growing insistent. Feminist groups such as the National Organization for Women (NOW), founded in 1966, were demanding changes in the workforce, decrying glass ceilings, and critiquing sexism in the media. NOW's president, author Betty Friedan, who was Jewish, had brought gender issues to the fore with her 1963 book, *The Feminine Mystique*.[35]

NOW: Feminism in Fort Worth

At the national level, Jewish women were in the vanguard of the National Or-
ganization for Women and women's-liberation politics. In Fort Worth, how-
ever, none were involved in the incipient feminist movement—although on
one occasion, the Council of Jewish Women invited a local NOW organizer to
speak at a meeting in a private home. Local Jewish women were intellectually
interested in feminist issues but wary of activism.

The feminist movement in Fort Worth first manifested itself in the late
1960s. The spark came from a woman who wrote to Betty Friedan, requesting
guidelines for organizing consciousness-raising groups. Friedan mailed her
back a two-page outline that served as a blueprint for a network of women to or-
ganize a cluster of consciousness-raising groups. Among the women attending
these initial consciousness-raising groups were Sally Armstrong, a Junior League
dropout who had married into a socially prominent family, and Katie Sherrod,
a *Star-Telegram* reporter. In the various consciousness-raising groups, the women
began pouring out their personal life stories and comparing notes. Anger erupted.
They had never before articulated their frustrations about submerged ambi-
tions, programmed roles, and stunted identities.[36]

Some women, uncomfortable with the anger, dropped out. "It scared
them off," Sherrod said. "In the South, anger and resentment [toward men]
doesn't play well for women who are supposed to know how to flirt when they
are born."[37] Those who did remain in the consciousness-raising groups joined
the Fort Worth chapter of the National Organization for Women, a cohesive
bloc of issue-oriented feminists that had started meeting in 1969 in the Tangle-
wood home of Dorothy DuBose, then-president of the local American Civil
Liberties Union (ACLU).

At NOW meetings, members studied feminist issues such as rape awareness
and abortion rights. Lawyer Sarah Weddington, who became renowned as the
lead attorney in the *Roe v. Wade* case that overturned the nation's anti-abortion
laws, was practicing in Fort Worth in 1970 and 1971, and she was part of the
NOW chapter. Together, the women drove to nearby Irving to hear Gloria
Steinem, a founding editor of *Ms.* magazine, speak. They applauded Demo-
crat Frances "Cissy" Farenthold, who spoke in Fort Worth just before announc-
ing her 1972 candidacy for governor.[38]

Talk turned to outrage, then to activism to combat discriminatory practices
across the county. One subgroup launched a rape-crisis program that was
staffed with volunteers who visited hospital emergency rooms to counsel vic-
tims of sexual assault. Another grass-roots group, which included Sally Arm-
strong, started the Women's Center, which helped indigent women find jobs,

learn rudimentary skills—such as taking a bus or talking on the telephone—
and access social-service agencies that could assist with their needs. Katie Sher-
rod wrote a newspaper series about battered women and shocked readers by
noting the victims' affluent addresses. Those articles led to creation of a shelter
called Women's Haven. New volunteers who were drawn to these programs
joined the cause. Dorothy DuBose persuaded the Star-Telegram's classified
advertising department to stop listing help-wanted ads by gender. Soon, other
women's issues—such as child support—became subjects of debate and con-
cern. As the feminists branched off to focus on solving hometown problems, the
NOW chapter dissipated.[39]

No Jews were involved in the initial phases of the Fort Worth feminist move-
ment. The Council did not earmark donations to the Women's Center of Tar-
rant County until 1981 or to Women's Haven of Tarrant County until 1982.
"They didn't come forward," said Sally Armstrong, whose children had many
Jewish friends among their classmates. She recalled the Jewish mothers as a
"solid mass" that "didn't mix with us," a cluster of well-dressed women who
made no overtures toward her and her friends. "I would say they stayed in their
own community. . . . They would never have been excluded, particularly be-
cause we activists were from all over."[40]

Dorothy DuBose was friendly with Jewish women who resided in her Tangle-
wood neighborhood. She recalled speaking at a small Council gathering "in
somebody's house." She said that her Jewish friends were "supportive" and
eager to hear about her activities, although none attended NOW meetings. It
puzzled her that Jewish women could be so vocal on the national level yet so
timid locally. Their rabbi was not that way.

She remembered Fort Worth's Reform Rabbi Bob Schur as an "enlightened
person" who was quick to embrace controversial causes. The rabbi was her
neighbor, and together they drove to an abortion debate. When the pro-choice
people in the audience were invited to stand up, she and the rabbi rose simul-
taneously. Yet the women in Rabbi Schur's congregation stayed in the shadows.
Schur's successor, Ralph D. Mecklenburger, the rabbi at Beth-El Congrega-
tion since 1984, has observed Fort Worth Jews to be "less passionate about fem-
inist issues than many other communities." Even the change to "gender-neutral
prayer language, a sacred cause in much of the country," did not concern many
among his congregation.[41]

In Fort Worth, change came gradually, through consensus rather than con-
frontation. According to a 1956 Life magazine article, Southern and South-
western cities "enjoy[ed] the famous 'cultural lag,'" meaning that they were
spared the social upheaval that women's-liberation groups brought to the East
and West Coasts. According to Life, "The Southwest is still closely enough

related to the South to share some of its traditions . . . [such as the] gentility . . . [that] makes a Southern girl want to grow up 'to be a lady.' That is, a lady who will preside graciously over her household."[42]

Yet, as hemlines and social consciousness rose during the counterculture era of the 1960s and 1970s, the Fort Worth Council left issues of women's equality to others. Although they donned a professional demeanor and developed professional skills, these women were more comfortable fighting for President Lyndon B. Johnson's War on Poverty than Betty Friedan's women's revolution. They used their book fair profits to launch grass-roots pilot programs for others. They were "handmaidens of reform."[43]

The Council opened the county's first Senior Citizen's Drop-In Center in 1969, in cooperation with the Governor's Commission on Aging. On behalf of the Edna Gladney Home for unwed mothers, the Council successfully lobbied the state legislature in 1964 to provide public schooling at such institutions. The Council also started adult-literacy classes, part of a statewide program initiated by the Dallas NCJW that was called Literacy Instruction for Texas (LIFT). Council volunteers also recruited young African Americans into Women in Community Service (WICS), a vocational-training program that channeled minority women into the Job Corps. This was a nationwide initiative that NCJW headquarters backed in concert with a coalition of national women's groups. Esther Winesanker, a WICS volunteer, recalled teaming up with an African American schoolteacher. Together, they went into poverty-stricken neighborhoods to visit potential clients and talk with families about the value of such job training. "It was eye-opening to see the conditions so many people lived in," Winesanker reflected. "We felt like we were in the vanguard of social change."[44]

Despite their absence from the city's more vocal feminist movement, the city's Jewish women were advocates for social change. Katie Sherrod perceived the Council as a "gutsy" organization. "They were a group of women who controlled a substantial amount of money. They alone made decisions about their money." That was a rarity. The Council's agenda was "feminist," even though its members protested that they were "not liberationists." "They had to raise issues in a way they could sell it to the powers that be," Sherrod said. "They were doing work that no one else was doing."[45]

The section had definitely developed a strategy for change and improvement in its hometown community. The book fair made it possible. Its philosophy of recycling books and utilizing profits for local programs had struck a responsive chord. The book fair not only proved financially profitable, it honed the women's business, administrative, and diplomatic skills. The publicity and profits from the Book Fair raised the section's profile and propelled its members to a new plateau of recognition and involvement.

Agencies lined up to lobby the Council board for seed money to jump-start pilot programs. The women evaluated cutting-edge proposals and critiqued bare-bones budgets. The Council was a full-fledged player in the civic life of the city and county. As Sara Evans has observed, "Traditional women's service organizations with their roots in nineteenth-century female culture could not provide a base from which to challenge the complexities of women's place in mid-twentieth-century America. Nevertheless, they continued to provide a training ground for leadership and to lay the groundwork for future change."[46]

Claiming Their Names

Within the internal ranks of the Council of Jewish Women, one issue addressed by the feminist movement had been simmering for years: How to identity themselves in their organization's yearbook. Should members designate themselves as *Mrs.*, *Miss*, or *Ms.*, or should they drop courtesy titles altogether? Clubwomen put a great deal of thought into such self-representation, for their membership directories were a reflection of how they viewed themselves and how they wanted others to see them. Sarah Evans Hughes argues that "language itself encodes . . . women at every turn" and that women "diminish" their significance when they identify themselves in their "roles as wife." What Evans terms "the language of sexism" was not a phrase that Fort Worth's Jewish clubwomen would have used. Yet their actions indicate that it was very much on their minds.[47]

Throughout the Fort Worth section's first quarter century, its membership roster identified married women as *Mrs.* followed by husbands' first and last names, as in *Mrs. Louis Morris*. Widows usually, but not always, reclaimed their first names, as in *Mrs. Lilli Bogen Morris*. Never-married women, such as *Miss Sarah V. Carb*, were so identified. In 1928, the yearbook dropped courtesy altogether. Edith Gross was listed as *Leon Gross*. Polly Mack was *Theodore Mack*. The women had literally disappeared! In 1943, *Mrs.* and *Miss* returned to the roster, adding a degree of clarity. Still there was apt to be confusion when contacting women from large extended families such as the Gernsbachers or the Gilberts. (The Gernsbachers were listed as *Mrs. A. Gernsbacher, Mrs. H. Gernsbacher, Mrs. J. Gernsbacher, Mrs. L. Gernsbacher,* and *Mrs. M. Gernsbacher.* The Gilberts were listed as *Mrs. A. Gilbert, Mrs. E. L. Gilbert, Mrs. J. M. Gilbert, Mrs. L. E. Gilbert, Mrs. Max Gilbert,* and *Mrs. Sam Gilbert.*) New-comers and even old-timers could be forgiven for directing mail or phone calls to the wrong relative's household.

In 1955, females' first names finally made it onto the printed page—typed inside parentheses and after their husbands,' as in *Gernsbacher, Mrs. H. (Helen),*

and *Gilbert, Mrs. L. E. (Carolyn)*. The alphabetical listings remained that way for the next twenty-five years.

The yearbooks' memorial pages, which list members who had died during the previous year, reveal signs of subtle disagreement among the leadership. Inconsistency prevailed. Some years, the dearly departed were identified familiarly by their given names, regardless of whether they were married or widowed, as with *Mrs. Nellie Greenwall* in 1928 and *Mrs. Blanche Mayer* in 1929. Other years, the "In Memoriam" page followed formal style. For example, during the mid-1930s last respects were paid to *Mrs. Alex Wolf* and *Mrs. M. Cohn*. For the next three decades, styles of address were mixed. In 1976, for example, members mourned both *Mrs. Yale Glazer* and *Mrs. Dorothy Hertzman*. Beginning in 1977, deceased women were no longer identified by their husbands' given names, although the courtesy titles *Mrs.* and *Miss* prefaced their identities. The membership was moving toward consensus.

Each president's annual report likewise reflected varying attitudes about women's appellations. Sophia Miller was the first to challenge convention in 1929, signing her annual report as *(Mrs. H. H.) Sophia Miller*. The next year's president simply typed *Rose Gilbert*. Then came a retreat. The next two presidents, *Mrs. S. J. Shaffran* and *Mrs. Harry Ginsburg*, used only their husbands' names. When Rose Gilbert served a second term as president in 1934, she reverted to *Mrs. Max Gilbert*. The next three presidents did likewise. However, when Sophia Miller was elected to a second term in 1939, she again boldly signed her name, this time as *Sophia (Mrs. H. H.) Miller*. The next six presidents assertively wrote their names as follows: *Sarah P. Horwitz; (Mrs. Benjamin E.) Tobia M. Ellman; (Mrs. Abe M.) Amelia Rosenstein; (Mrs. Bernard) Leonora W. Goldstone;* and *(Mrs. Maurice) Pearl J. Rabinowitz*. In 1948, Norma Mack reverted back, signing her name *Mrs. Henry Mack*. But after that blip, subsequent presidents included their given names as well as their spouses.'

Amy Scharff set a precedent in 1970 when her state-of-the-section report listed each officer by first and last name, with no allusion to marital status. For the next decade, her successors followed suit. However, on the alphabetical membership roster, these women's first names were still printed only parenthetically as *Freed, Mrs. I. L. (Sandra)* and *Minker, Mrs. Richard (Carol)*.

In 1973, the new title "Ms." appeared in the yearbook. A vice president, previously listed as *Lydick, Mrs. Larry (Nancy)*, divorced and requested that her name be printed as *Lydick, Ms. Nancy*. In 1974, Amy Scharff's divorce was reflected on two pages and in two different ways. On the alphabetical roster, the former *Mrs. Earl U. Scharff Jr.* was listed as *Scharff, Mrs. Amy Claire*. On the roll of past presidents, she was designated *Ms. Amy Claire Scharff*.

Nationwide, similar discussions over women's appellations were underway.

At NCJW's national headquarters, the transition from *Mrs.* to *Ms.* and from *chairman* to *chairperson* occurred in the early 1970s. In 1974, the national headquarters officially abandoned the term *chairman* in favor of either *chairperson* or *chairwoman*. In 1977, husbands' names and marital titles disappeared altogether from the national board minutes. Still, there was reluctance to use the word *feminism*, a term that Jonathan Sarna, a scholar of American Judaism, labeled the "f-word."[48]

In Fort Worth the following year, there was another telltale sign of consciousness-raising, this time regarding authorship of the Council Prayer. Since 1934, the yearbook had included an invocation penned by long-time president and role model *Mrs. Theodore Mack*.[49] The 1978 yearbook, for the first time, identified the prayer's author as *Pauline S. Mack*.[50] In her day, Polly Mack was an assertive woman who set the pace. She very likely would have approved. Two years later, in 1980, the Fort Worth Council did away with formal titles altogether. What's more, the women's names were removed from parentheses and the men's were bracketed instead—as in *Winston, Dorothy (Harold)*. The women had finally gained priority in print.

Building a Playground on Jewish Identity

Life magazine had identified one reason for the group's guarded posture vis-à-vis women's issues—the conservative, "lady"-producing region in which its members lived.[51] Another reason was self-consciousness stemming from their minority status as Jews. Despite all their civic involvement and success, the Council women remained alert to anti-Semitism. Each felt like a representative of her people. Ever since the Americanization School had opened in 1907, part of these women's unspoken agenda had been to dispel negative stereotypes about Jewish people. They knew that local preachers called Jews "Christ killers." "Working in Council, we believed that we were showing others, 'here's what Jewish people are,'" asserted Minker, who became Council president in the spring of 1977. "The way I looked at it, we represented Jewish people as a whole."[52] Dorothy Winston, a past president, concurred: "Our social service work got us into the front door of many institutions. . . . They found out what tremendous leaders and workers these Jewish women were. Stereotypes fell apart."[53]

Norma Mack recalled how significant the Council's work had seemed in the 1930s as Hitler was rising to power and slandering the Jews. "There were plenty of people that didn't like Jewish people at all or Catholics. We thought it was important that people read about good work that the Jewish people were doing."

Though never directly confronted with anti-Semitism, Mack detected covert signs. "Someone would collar you about the 'niggers.' You knew they were also talking about Jews." The Council of Jewish Women provided a platform from which to dispel negative stereotypes and help outsiders satisfy their curiosity about Jews. "We can never be equal until they know us," Winston said.[54]

Amy Stien (the former Amy Scharff) recalled how proud she was during her presidency to serve on the steering committee of Church Women United. At the start of one meeting, she was asked to deliver the invocation:

> They told me, 'We just happen to have your prayer book here. Will you lead us in the opening prayer?' I am no religious scholar. Many of the Christian women learn the Bible, chapter and verse, by heart. God was looking over me that day. I had a gut feeling that the appropriate prayer was on page 120. It was: 'Grant us Peace, our Most Precious Gift.' They were impressed. So was I.[55]

Dorothy Winston, Council president from 1971 to 1973, recalled with satisfaction how the Junior League invited her to participate in its docent-training program, which included a guided bus tour of city landmarks and civic institutions. To her, the invitation demonstrated growing acceptance of Jews. She remarked that the Council was like "a Jewish 'Junior League.'"[56]

In 1972, the Junior League of Fort Worth tapped its first Jewish member, Louise Kuehn Appleman, a Council officer. The prestigious League, founded in 1901 by a New York debutante, was under pressure from its national headquarters to adapt to the equal-opportunity era by relaxing admissions policies.[57] "The Council and the Junior League had partnered in so many things," Appleman recalled. Both donated money and volunteer hours to many of the same community projects. "Council was the most prestigious Jewish organization," Appleman continued. "It was the Jewish 'Junior League.' In those days that was the truth, although there wasn't an admissions process."[58]

It was, therefore, logical for the Junior League to tap Jewish women as it diversified. A succession of Jewish inductees, all of them active in the Council, followed. Within ten years, Louise Appleman was president of the League, followed several years later by another Jewish woman, Judie B. Greenman, who had distinguished herself as a Council and community volunteer.[59] The Council was proving itself a vehicle for acculturating and integrating Jewish women into the city's upper strata.

Not everyone within the Jewish community was impressed. Women who put Hadassah first among their extracurricular activities felt that the Council (and the Junior League) performed public service work that others could do.

Hadassah's efforts on behalf of Israel and the Jewish people were things that only Jews would do. "Many Jewish people resented the fact that Council did not confine itself to Jewish causes," Minker acknowledged. In the words of Pauline Wittenberg, Council president in the late 1950s, "Other Jewish groups look inward. The Fort Worth Council looked outward."[60]

In the early 1960s, the Council's numbers surpassed five hundred, with new members hailing from both the Orthodox and Reform communities. The popular book fair was a magnet for women from all branches of the religion. The Council maintained its position as the city's largest, highest-profile Jewish volunteer organization. Yet the Council was still perceived as a group primarily for Reform women more concerned with prophetic Judaism, which stressed good deeds, rather than traditional Judaism, which emphasized ritual. The Council's luncheons were not kosher. Its study groups focused on legislative action rather than spirituality. Council Sabbaths, in which members led the worship service just before the holiday of Purim, lapsed in 1961.[61] Until 1983, all but one of the section's presidents had hailed from Beth-El, the Reform congregation, although a number of lesser officers had been congregants at Ahavath Sholom. Membership still overlapped in each of the "Big Four"—the Council of Jewish Women, Hadassah, Beth-El Sisterhood, and Ladies Auxiliary to Ahavath Sholom. Each group had a different niche. Council got women involved in secular causes, Hadassah with international work for Israel. The Sisterhood raised money for the "Temple" (Beth-El) and the Auxiliary for the "Shul" (Ahavath Sholom).

To outsiders, distinctions among the groups were fuzzy.[62] As Pauline Wittenberg remarked, "The broader community didn't know which organization was which: Hadassah or Council or Sisterhood or B'nai B'rith Women (which began locally in the 1959). They didn't know one from the other."[63] In fact, a marquee that a retailer set up to promote the annual book fair called the event "The Jewish Ladies' Book Fair." What mattered most was that the impression was positive.

The book fair and the social-service programs that it spawned were so widely acclaimed that the Jewish community was stunned in 1977 when a new Council project, a neighborhood playground, sparked an undercurrent of anti-Semitism in its own backyard. The Council had wanted to fund play equipment, including swings, a sliding board, a sandbox, and some benches. The city-parks department informed the women that there were abundant government grants for recreational equipment in poor neighborhoods, but none for the affluent southwest side of town, where most of the city's Jews resided. In cooperation with the Park and Recreation Department, the Council appropriated three thousand dollars for a playground in a greenbelt area between Tangle-

wood Elementary School and the Trinity River. The women viewed the playground as a "gift" celebrating the American Bicentennial and their section's seventy-fifth anniversary.

Neighbors, however, looked this gift horse in the mouth. Petitions to block construction circulated. Residents feared that a playground subsidized by a liberal Jewish organization would become a magnet for "pot smokers," "hoodlums," and black children from high-crime neighborhoods. They hired an attorney and protested before the City Council. Jews received "threatening telephone calls containing anti-Semitic and racist remarks," according to the daily papers. "We were flabbergasted," Minker recalled. "There were such undertones of anti-Semitism. They said 'these Jewish women' would bring drug dealers into the neighborhood. They thought their maids would bring their children to the park." Church groups came out against the playground. Construction temporarily stopped. "Unpleasant" meetings followed. On March 26, 1977, the Council was again on the front page, this time with a banner headline declaring, "Tanglewood still torn over park dispute."[64] The next day, in a letter to the Council membership, section president Ruth Roper and her executive board wrote:

> There is no reason to feel threatened. On the contrary, from this experience we have gained many new friends. . . . A few remarks made in the heat of anger must be overlooked; and together, in understanding, we, as Jewish citizens and Council members, must continue to make positive contributions to Fort Worth.[65]

After all those years convincing themselves of their growing acceptance, the women felt bruised and disappointed, yet wiser. Ellen Mack, the designated spokesperson, told the press:

> We are living in a time when there is a latent undercurrent of anti-Semitism, which we tend to forget about until an issue makes it surface. Then when it does, it surprises everyone because we forget it has been there. Instead of being the real issue, it becomes a side thing that muddies the true facts.[66]

Playground construction continued to completion, and the park functioned without incident.

The "undercurrent of anti-Semitism" to which Mack referred had been growing since the advent of the Civil Rights Movement. Jewish leaders were visibly and disproportionately involved in efforts to integrate schools and public

accommodations. Jews had been among the founders of the National Association for the Advancement of Colored People. Rabbis were prominent among clergy from the North who descended upon the South to march with the Reverend Martin Luther King Jr. In Fort Worth, Rabbi Schur was the city's first white clergyman to march for black civil rights. While the Rabbi was publicly lauded, he and his co-religionists nationwide were linked with liberalism and forces of change.

As the Civil Rights Movement turned militant and separatist, Jews found themselves caught in a black backlash. A multitude of black organizations allied with people of color to denounce Zionism and the existence of Israel. Upwardly mobile American Jews, who had long championed African Americans, realized that they could not shed their identity as *other*. Mistrusted by white Protestants as too liberal and criticized by African Americans for being condescending, Jews began to face up to their distinct identity. In many American Jewish circles, these reactionary forces brought Jews together. "The communal agenda shifted in the late 1960s from universalistic concerns to a preoccupation with Jewish particularism," from civil rights to the Holocaust and Jewish survival, notes American Jewish historian Jonathan Sarna.[67]

In Fort Worth, the shift was evident at the city's two synagogues, where religious school curricula became more oriented toward Israel and the plight of Soviet Jews. The Jewish Federation of Fort Worth and Tarrant County welcomed Soviet immigrants to the city. Jewish youth groups stopped collecting money for UNICEF during Halloween because of the United Nations' 1975 vote equating Zionism with racism. The Council of Jewish Women, however, did not substantially alter its programming. Though shaken, it kept its focus local and secular.

Facing and Weathering New Directions

The shift in gender roles and perceptions had been underway for decades, since the very start of the Council in 1893. The Civil Rights era and publication of *The Feminine Mystique* accelerated the pace of change.[68] It altered the public conversation about gender issues.

Although most of Fort Worth's Jewish women chose to ignore the shift, social and economic changes were nonetheless occurring in their lives. Their volunteer experience and their leadership positions with the Fort Worth Council unwittingly equipped them for impending change.

Consider Fannette Bronstein Sonkin. When the national *Windows on Day Care* study was published in 1970, neither she nor any other woman in the Fort

Leadership duo, 1961. Fannette Sonkin, left, went to work after serving as Council president and became the top cosmetic buyer for a seven-store chain. Sonkin's successor, Roz Rosenthal, right, helped resuscitate her husband's business and later became well known for her philanthropy and leadership in the arts, social services, and Jewish causes. Courtesy, Fort Worth Star-Telegram Photograph Collection, Special Collections, The University of Texas at Arlington Library, Arlington, Texas.

Worth Council had first-hand experience with a child-care center, apart from their volunteer work. They saw day care as a War-on-Poverty issue unrelated to their daily lives. "We could afford to have help," recalled Sonkin, who served as Council president from 1959 to 1961.[69]

Sonkin's world was to change, and her role as Council president prepared her for the downturn. During her final months as Council president, her husband suffered business reversals, a nervous breakdown, and hospitalization.

"My life started falling apart," she recalled. It fell to her to close her husband's chain of drugstores and to work as a dollar-an-hour cosmetics clerk. Because her father lived with her family, "he kept the kids." Putting the children into day care would have been humiliating. It was demeaning enough to be employed. "I felt degraded. . . . You were Suzy homemaker, PTA mom. That's what we did. I didn't think I could do anything else. I got married young, out of high

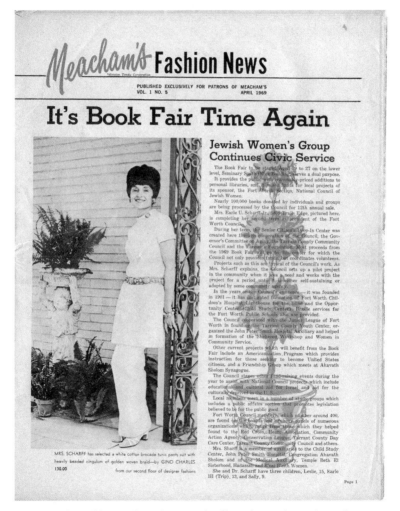

Fashionably presidential. Amy Scharff was featured in 1969 on the front page of Meacham Department Store's tabloid that promoted style and social service. Courtesy, Beth-El Congregation Archives, Fort Worth.

school, during the war." But being president of the Council, an organization of five hundred people, had given her the confidence to move into the workforce. She had served on agency boards and mingled with a cross section of the population. In the workplace, Sonkin rapidly rose to assistant buyer, then chief cosmetics buyer, for a seven-store chain. She became a role model to younger women then coming of age.

Sonkin's successor as Council president, Rosalyn (Roz) Gross Rosenthal, also thought herself lacking in work-a-day skills. When nominated as Council president in 1961, Rosenthal sought the counsel of Rabbi Schur. He compared her qualms to *The Little Engine That Could*, a children's book about a diminutive locomotive that succeeds by constantly telling itself that it is capable of traveling the road ahead. That story became the theme of Rosenthal's two-year presidency and a motif for the rest of her life. Initially, she had needed a man's permission to take on an executive position. In later years, she would not. When her husband's meat company tottered near bankruptcy in 1965, she went to work full time in the family business. With Roz as bookkeeper, the Rosenthal meat company grew into an international firm. She credits the skills acquired as Council president with giving her the confidence to mingle with all classes of people as she moved into the meat market. In later years, she would fill many leadership vacuums across the community.[70]

When Amy Claire Sharff—Council president after Rosenthal—found herself in divorce court, she started looking for work. Her only job experience was as a teenage secretary. She told prospective employers about her positions with the Council. That landed her a full-time job with the Jewish Federation of Fort Worth and Tarrant County as coordinator of volunteers and director of its women's division, tasks similar to work she had previously performed for no salary.[71] She subsequently remarried, took her husband's surname of Stien, and worked until the 1980s. During her Council presidency, she had told the membership, "Being president of Council gives one a chance to use her brain. After confining my reading to cookbooks and *Good Housekeeping* for many years, I wasn't sure mine would function. Well, I found that because it had to, it would!"[72]

For Amy Stien, Roz Rosenthal, Fannette Sonkin, and other war brides in the Fort Worth Council of Jewish Women, the world was changing. Their volunteer work with the Council had prepared them for the nation's economic, social, and demographic shifts. They still wore high heels to ladies' luncheons— if they could manage a long lunch break—but few donned hats and gloves, a sign that women were becoming more attuned to function than fashion. Because of the skills acquired through the Fort Worth Council of Jewish Women, the women were weathering changes and transitioning well.

Demise

The Downside of Success

The Fort Worth Council of Jewish Women prepared its members and clients for a changing world. It placed scores of women into powerful board positions across the city. Inadvertently, it trained dozens of members for managerial positions that opened in the wake of the women's liberation movement. Yet the Council's own institutional culture, locally and nationally, was not as attuned to change. The 1960s and 1970s brought what William Chafe calls a "seismic shift in the political and cultural landscape of America."[1] Identity politics, which celebrate race and ethnicity, gained adherents among Jews. Old and new Jewish organizations with a high degree of religion at their core, gathered strength and credence. The National Council's once-attractive secular image lost cachet. Membership in the Council of Jewish Women plunged nationwide. Dozens of sections disbanded. As more women joined the professional workforce, the NCJW maintained a message of motherhood and voluntarism and shunned the term feminism. Initially, it responded ambivalently to the Equal Rights Amendment, and it was the last Jewish women's organization to endorse ordination of female rabbis. Until 1985, it did not incorporate working women into its philosophy.[2] The Council still harbored the image of the nineteenth-century Lady Bountiful. Furthermore, in Fort Worth the Council was no longer the only bridge for Jewish women into positions of power. As the pool of local Jewish volunteers shrunk, the group relinquished the book fair in 1997 to the Friends of the Fort Worth Library, something that would have been unthinkable three decades before. As new membership applications diminished, the NCJW became more concerned with numbers than redesign. The century-old women's organization, both locally and nationally, was late to adapt.

In many respects, the Fort Worth Council was a microcosm of traditional Jewish women's associations nationwide. These clubs received a scathing critique in 1978 when *Lilith*, a two-year-old Jewish feminist magazine, published

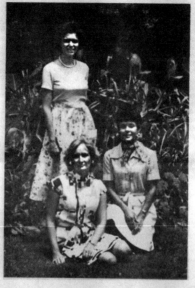

Opening Luncheon at Botanic Garden

September 18, 1975

Looking over the Botanic Garden for our first
meeting are: Ruth Roper, President, Elaine
Rubin, Program Chairman, and Bayla Simon,
Co-chairman.

*Success in the '70s. The Council, still the city's most visible Jewish women's
organization throughout the 1970s, held its September 1975 luncheon at the
Fort Worth Botanic Garden. The front page of the section's monthly newsletter
pictures president Ruth Roper, standing, with programming co-chairmen
Elaine Rubin (Griver) and Bayla Simon. Courtesy Fort Worth Jewish
Archives, Jewish Federation of Fort Worth and Tarrant County.*

a package of articles characterizing Jewish women's voluntary organizations
as "sheltered" workshops.[3] "Vanguard or Rear Guard?" asked the lead article
penned by Paula E. Hyman. Hyman, an assistant professor at Columbia Uni-
versity, went on to become a leading scholar of gender and Judaism.[4] She con-
tended that Jewish women's voluntary groups were more concerned with insti-
tutional self-preservation than the enhancement of individual members. The
magazine was especially scornful of the National Council of Jewish Women.[5]

Despite the NCJW's early involvement in War on Poverty social-service pro-
grams, the Council was ambivalent about the Equal Rights Amendment and

reticent on issues of gender equality in Judaism. The NCJW did not press for appointment of Jewish women to the boardrooms of synagogues, Judaic charities, Jewish colleges, or Israeli-American policy-making bodies. Historian Faith Rogow, who chronicled the NCJW's first century in *Gone to Another Meeting*, concluded, "They provided women with no direct means to gain power in the Jewish community."[6] The Council as a whole did not endorse ordination of female rabbis until the early 1970s, when this breakthrough was nearly a *fait accompli*. Yet, decades earlier, Rogow notes, a vocal minority among the Council's leadership believed that women "could and should be rabbis."[7] The Council, which had faced sexism at its inception in 1893, had forgotten its roots, *Lilith* charged.[8]

Feminist author and journalist Letty Cottin Pogrebin later caricatured Jewish women in traditional organizations as *Tante Tovahs*, Yiddish for "Aunt Goodies," a designation parallel to Harriet Beecher Stowe's "Uncle Toms." Pogrebin asserted that such women were frightened of change, fearful of losing their status as wives, and beholden to men and the imagery of God the father. She described these "don't-worry-about-me volunteers" as a dying breed.[9]

Downward Trends

Both Pogrebin's and *Lilith*'s assertions of the NCJW's growing irrelevance were borne out by plunging membership rolls, disappearing sections, and dwindling geographic representation.[10] The number of Council chapters peaked in the mid-1950s, with 245 sections in thirty-nine states and the District of Columbia. By 2007, the number had diminished to 104 sections in thirty-two states and the nation's capital, where the organization also maintained an advocacy office. Rather than founding new sections, the Council continued to lose and redefine chapters. For example, the San Antonio section, founded in 1907 by Anna Hertzberg, in 2006 became a "section-at-large" due to declining membership and "difficulty meeting . . . financial obligations locally and nationally."[11] The chapter's assets were placed in a joint-signature account shared with the national headquarters. A century ago, the Council of Jewish Women was San Antonio's premier Jewish women's organization. During its centennial year, it was trying to reorganize and reassert itself. That pattern was similar to the trajectory in Fort Worth and elsewhere. Other sections reorganized as "sections-at-large" included NCJW affiliates in Cincinnati, Indianapolis, Syracuse, and Maine.[12]

The Houston section, stable with 780 NCJW members, became proactive

in 2005 and began analyzing, from a position of strength, how to remain viable into the twenty-first century. Starting in 1975, the section had divided into "branches" based on geography, meeting times, age, and career tracks. Each branch had a president. The difficulty was finding an overall Houston section president. With input from focus groups and advice from an outside consultant, the Houston NCJW formed a thirteen person governing board representing the section's four branches. Eileen Silverman, the Houston section's immediate past co-president, concluded: "No one person wanted the responsibility of being president of Greater Houston Section. The job had grown too large. Members had other activities that demanded their time. It was a strain on leaders. We acknowledged that the world is changing."[13]

During the 1920s, the presidency of an NCJW section was considered a prestigious position, rather than a strain. At that time, forty-nine percent of the NCJW's 229 sections were in cities with less than one thousand Jews. For Jewish women, it was often the only game in town. Membership dipped during the Great Depression, reflecting a nationwide trend among clubs and organizations, and then surged after World War II. The number of dues-paying members crested in 1962 at 123,000.[14] With population shifts to the suburbs in the early 1960s, many rural and small-town sections disbanded. For example, when the NCJW marked its fiftieth anniversary in 1943, Oklahoma had five NCJW sections. By 1967, Oklahoma was down to three chapters; in 2007, it had none. Neighboring Arkansas, which had three sections in 1943, had none in 1967. Alabama, with three chapters as late as 2003, had none at the start of 2007. North Carolina, which boasted six sections in 1943 (in Asheville, Greensboro, High Point, Piedmont, Raleigh, and Winston-Salem), no longer has any, despite its status as one of the fastest-growing Jewish population centers in the country. Between the Council's fiftieth and seventy-fifth anniversaries, California dropped from thirteen sections to ten. New Jersey had twenty-three sections in 1943 and thirteen by the end of the century.

At national NCJW board workshops during 1967, membership retention was characterized as a "grave concern."[15] By the early 1970s, that grave concern had escalated into a "crisis."[16] Although a 1977 press release boasted NCJW membership of 100,000, national-board-meeting minutes throughout the 1970s indicate that totals were inflated in public pronouncements. Figures distributed at executive board meetings fixed NCJW membership at 84,000 in fiscal 1974–1975. The figure dropped to 76,500 in 1977.[17] In 1998, NCJW national President Nan Rich conceded to a reporter from the *Forward*, a national Jewish weekly, that the real membership figure had dropped to 70,000. In 2007, the total slipped to 48,590.[18]

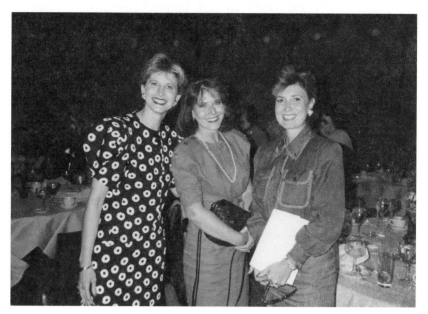

Lunchtime in the '80s. The Council's 1988 closing luncheon was downtown at the posh new Worthington Hotel. Among the crowd were these three stylishly dressed past executive officers: Joan Katz, Leslie Florsheim, and Harriet Anton. Courtesy Fort Worth Jewish Archives, Jewish Federation of Fort Worth and Tarrant County.

In Fort Worth, section membership fell from a peak of 522 women in 1960, when the book fair was young, to 403 in 1970. The roster dipped to 333 in 1980. Section leaders brainstormed over novel ways to entice members to midweek luncheons. They hosted a crêpe buffet at a trendy eatery and a poolside lunch at a wealthy member's new home. Many members and potential members were not available for any sort of lunch—they were working. One 1991 luncheon honored "Women in Power," with the honorees a city councilwoman and the Jewish community's own Louise Appleman, an elected trustee on the Tarrant County College board.[19]

The guests of honor were indicative of other shifts underway. As anthropologists Michelle Rosaldo and Louise Lamphere have observed, educated and affluent women tend to gravitate toward traditionally male positions, roles with more power, authority, visibility, and prestige than leadership roles within women's organizations like the Council, the General Federation of Women's Clubs, or the League of Women Voters.[20] The latter two groups were also losing vigor and volunteers. Trends toward gender equity and professional parity

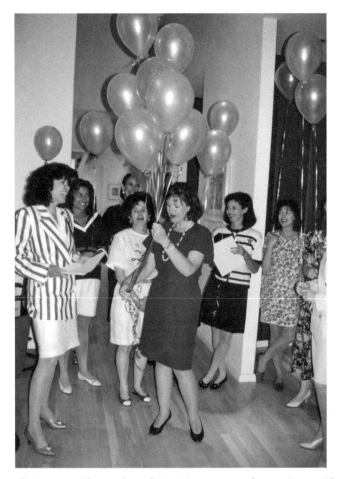

*Installation, 1992. The mood was festive May 14, 1992, when section president
Marilou Labovitz, left, installed her successor, Leslye Urbach, who holds
a balloon bouquet. Behind the two presidents stand Gail Prostok, Leslie Black,
Laurie Blum, Patricia Garsek, and Beth Clegg. Courtesy Fort Worth
Jewish Archives, Jewish Federation of Fort Worth and Tarrant County.*

were opening new avenues for women and devaluing their previous pursuits.
In addition, ripples from the civil rights movement were loosening discrimi-
natory barriers that had long restrained people of color and diverse creeds. In
Fort Worth and elsewhere, the Council was no longer a trailblazer setting the
agenda; neither was it the only avenue for Jewish women seeking access into
the larger universe.

In 1995, the last time that the Fort Worth section published a yearbook, the

roster included 237 members. That total is not a true gauge of retention, because 104 of those women were lifetime members who had purchased perpetual memberships during the previous decade.[21] Many of the veterans were passive members who were working full time or were energetically involved in other volunteer pursuits. Despite the 237 names on the roster, by 1996 it was impossible to staff the book fair. The Council joined forces with Friends of the Fort Worth Library, which eagerly co-sponsored the popular and profitable used-books sale. The following year, Friends of the Fort Worth Library took over the Council's flagship event.

Not only would few Fort Worth Council women volunteer for the book fair's year-round chores, but in 1996 no one among the Council's 237 members would assume the presidency.[22] In lieu of a president, a thirteen-member governing body attempted to coordinate and carry on the work of the section.

The leadership vacuum was not unique to Fort Worth. A 1977 national survey of 160 NCJW chapters described many local leaders as "lethargic," "unmotivating," "recycled," and "poor."[23] National NCJW leaders blamed falling numbers, failing sections, and lack of leadership on competition from new organizations, population shifts to the suburbs, and young working women who "do not understand [the] concept of giving of self without salary."[24] "Fewer women are willing to make Council a career," the national board concluded in 1972. "All have been touched by the women's revolution."[25]

More than a women's revolution was occurring. National leaders were slow to grasp the scope of societal change. Staff and board members were astonished in 1972 when some local sections suggested sponsoring Jewish parochial day schools. That contradicted the Council's historic push for pluralism and public schooling. The direction in which many young Jews wanted to move ran counter to the NCJW's purpose.

Also becoming a handicap was the Council's image as an affluent "elitist organization," more interested in the secular than the spiritual. Early in the twentieth century, the Yiddish press had depicted the NCJW as a "club of wealthy German women who, if they observed Judaism at all, practiced the bare minimum of ritual common among Reform Jews."[26] That image, similar to what was already perceived in the Fort Worth Council, would not abate. Unfortunately, that stereotype was at odds with the egalitarianism of the civil rights movement, the women's liberation movement, and the counterculture era.

The liberal, humanitarian causes that the NCJW championed should have had strong appeal among the group's potential membership pool. Yet young adults coming of age in the 1960s and 1970s were more apt to embrace single issues such as ecology, reproductive freedom, or animal rights, rather than the large menu of causes that the Council represented. The Council's image, in

addition to being elitist, was blurry and indistinct. The NCJW national board acknowledged in 1971 that the Council "lacks clear identity versus other national Jewish organizations."[27]

For many years, the Council had been Fort Worth's only intergenerational Jewish group offering public service, cultural programs, and issue-oriented forums. In the mid-1980s, that began to change. In Fort Worth, for example, the B'nai B'rith Women, which dated to 1959, started a popular evening chapter. Those who attended were mainly young mothers who could not afford to hire day-time sitters. The day-time and night-time chapters worked with the all-male B'nai B'rith lodge to spearhead construction in 1983 of a nonsectarian senior-citizen housing complex. Financed by the U.S. Department of Housing and Urban Development, the sixty-unit apartment complex was built in close proximity to the city's Jewish community center. It demonstrated that the Council was no longer the only Fort Worth Jewish organization capable of landmark public-service projects. Meanwhile, another new women's group, the Fort Worth chapter of Brandeis University Women (founded in 1977 by former Council president Ruth Rapfogel), drew older Jewish women tired of volunteer work and eager for cultural and intellectual programs. Hadassah was also gaining strength, especially after Israel's Six-Day War in 1967 captured the American imagination. Attuned to social change, in the early 1990s Hadassah headquarters instituted a social-service program, dubbed "Check It Out," at which volunteers taught high-school girls about breast-cancer self-examination.

Bowling Alone

The Council's gradual decline in membership and preeminence was not an isolated phenomenon confined to Fort Worth or to its parent organization. Sociologist Robert Putnam, author of *Bowling Alone*, notes that during the last third of the twentieth century, large, chapter-based associations with long histories were gradually replaced by single-purpose organizations. These were often "staff-led interest groups" that represented people's "narrower selves."[28] As early as 1945, Southern historian Margaret Nell Price observed a tendency among volunteer leaders to gravitate toward single-issue groups such as tuberculosis and cancer societies. In her study of leadership development through women's clubs, Price writes that many groups with Progressive-era roots ultimately turned into "endorsing and educating bodies" because newer, ad hoc groups seized the initiative on current concerns. "As other agencies have arisen to meet needs, the federations have lost their pioneer functions as pathfinders. . . . Where once the clubs might have been appealed to for the initial ac-

tion, they are now called upon to cooperate with the society formed to meet the specific need, helping publicize the matter . . . and perhaps even helping get legislation passed." The transformation that Price and Putnam discuss was happening to the Council.[29]

The decline of the Council is also evidence of larger societal trends that were drawing women into the professional ranks. Demographic patterns had drastically altered as a result of second-wave feminism and economic conditions that necessitated two-income families. Couples were marrying later. Single women, often with advanced graduate degrees, pursued careers throughout their twenties—the ages at which their mothers and grandmothers had joined the Council. After childbearing, women simultaneously raised their offspring and worked at full-time jobs. Women in the workforce made new connections. They became involved in professional and civic associations, such as the Rotary Club, which in earlier eras was male only. Professional parity and gender equality opened new options for volunteer activities. According to the Jewish Federation's 1990 National Jewish Population Survey, these tendencies were especially marked among Jewish women, who were at the "forefront of trends to become educated."[30]

"The movement of women out of the home and into the paid labor force is the most portentous social change of the last half century," sociologist Putnam declared. "The fraction of women who work outside the home doubled from fewer than one in three in the 1950s to nearly two in three in the 1990s."[31] Because of long days at work and lengthy commuting times, women—and men—became more selective about their volunteer activities. When career women volunteered, as they did in large numbers, they preferred to utilize their professional talents than spend hours addressing invitations, pricing used books, or engaging in what researcher Sylvia Barack Fishman terms "idle chitchat."[32] For example, a physician might be eager to lecture on the propensity for breast cancer among Jewish women. A writer might be flattered to lecture on Israeli authors.[33]

There are more options open to Jewish adults today than in the past when their venerable volunteer organizations were founded. The push since the 1960s for racial integration and multiculturalism has hastened the decline. As a legacy of the civil rights movement, many mainline organizations sought to diversify and become representative of the larger community. Talented Jews, blacks, and women were drafted into the ranks. "Religion no longer has an influence on a wide range of social behaviors," according to Moshe and Harriet Hartman's analysis of Jewish demographic data. "Even though it is clear that religion is not dead . . . the impact of religion on wider aspects of social life is minimized."[34] This more open attitude has drawn Jewish women away from

clubs like the NCJW that are more secular than spiritual.[35] Fishman concludes that discrimination that had once excluded Jews from leadership posts in civic affairs has virtually disappeared. Those seeking volunteer work are no longer compelled to seek an outlet in the Jewish communal world.[36]

Jewish Feminist Movement

Just as the civil rights movement gave rise to second-wave feminism and to an ethnic-identity movement among American Jews, within Judaism a distinct feminist movement emerged. It was called *Ezrat Nashim*, a Hebrew phrase with dual meaning—literally, "help for women," and colloquially, the segregated women's gallery in traditional Orthodox synagogues.[37] *Ezrat Nashim*'s appeal was initially among young Conservative Jewish women and academicians who were searching their faith for more meaningful rituals. It began in September 1971 as a study group within a New York City women's *chavurah. Chavurah* is an ancient term for a fellowship circle. The Jewish counterculture adopted the term to describe a "new model for serious Jewish study" similar to the consciousness-raising group.[38] The women in *Ezrat Nashim* searched for ways to implement gender equality within a traditional Jewish framework. Paula Hyman, who wrote the seminal article lambasting traditional Jewish women's organizations, was among those in *Ezrat Nashim* probing for new meanings:

> [P]ersonally affected by the renascence of feminism, we felt in our own lives a tension between our knowledge of Judaism and the limited spheres in which we could put that knowledge into practice in the synagogue and then in the community, and we found that many elements of the traditional Jewish attitude to women deeply offended our sensibilities.[39]

In March 1972, the feminists in *Ezrat Nashim* went public, confronting a national conference of Conservative rabbis with "demands for full acceptance of women as the religious equals of men."[40] The next year, in February 1973, the North American Jewish Students' Network convened a national Jewish women's conference that was attended by five hundred women from all walks of Jewish life. The conference gave rise to a proliferation of Jewish feminist groups bent on changing traditional ritual, practice, and thinking. In the summer of 1973, *Response: A Contemporary Jewish Review* devoted its quarterly issue to articles by participants in *Ezrat Nashim*. "The biological differences between men and women can no longer justify the outmoded and rigid sex-role division which the Jewish tradition prescribes," Hyman wrote in an essay titled "The Other

Half: Women in the Jewish Tradition."[41] Elsewhere in the journal, Judith Plaskow Goldenberg outlined how the "secular movement for the liberation of women" had made it "imperative" to raise specific Jewish issues:

> We are here because we will not let ourselves be defined as Jewish women in ways in which we cannot allow ourselves to be defined as women. This creates a conflict not just and not primarily because the women's movement is a secular movement whose principles we are attempting to apply to an ancient religious tradition, but because the women's movement is a different community around which we might center our lives.[42]

Another contributor to the journal, Jacqueline K. Levine, predicted an "exodus of Jewish women leaders" from Judaism's communal organizations because of exclusion from policy-making positions. "You may lose them if you don't include them," Levine warned. "Others can recognize their capabilities and accomplishments. At the top, we wish to share not glory but responsibility."[43] In a broadside that included the NCJW, Vivian Silver Salowitz lashed out at entrenched American Jewish organizations. She termed them "the single most important force in undermining Judaism" during the previous half-century. "They purport to be concerned with Jewish survival, but the conscious assimilationist trends run counter to their claims."[44]

The intellectual ferment stirred by *Ezrat Nashim* brought many well-educated Jewish women back to their religious roots. Susan Gubar, a woman's-studies scholar and English professor at Indiana University, analyzed the trend in *Critical Condition: Feminism at the Turn of the Century.* She recalled that Jews of her generation were largely raised as "secular, acculturated" people, as "Jewish non-Jews." Initially, they wanted nothing to do with a "sexist" and "patriarchal" religion that had bequeathed them with "a 'negative' identity of being 'set apart from a larger culture.'" However, by the 1990s, "after careers built on non-Jewish" areas of study, many Jewish academicians were "returning to ethnic sources."[45] Linking the Jewish women's movement to the civil rights movement, Gubar observed that James Baldwin's essays on African American identity helped reconceptualize racial and ethnic categories. "[I]dentity politics provided a vocabulary for Jewish women to take seriously their own hyphenated identities to speak as 'Jewish-American women.'"[46]

The Jewish feminist movement gradually exerted its impact on organizational life within American Judaism. Major Jewish institutions, such as the United Jewish Appeal (UJA), "once exclusively male," began tapping women for decision-making positions.[47] Jewish women were breaking the glass ceiling—or, to use a Jewish metaphor, parting the *mechitzah*, the curtain separat-

ing men from women at prayer. Although feminists did not seek to remove the *mechitzah* during Orthodox worship services, they argued that it need not curtain them off from decision-making roles or from reinterpreting ancient rituals and teachings. Weary of being "peripheral Jews," Pogrebin explained that "religious feminists target injustice in the synagogue and repair that world with new rituals and a new inclusiveness."[48]

The new inclusiveness came to Fort Worth in fits and spurts. In 1970, the Fort Worth Jewish Federation, the UJA's local fundraising and social-service agency, elected as its first woman president Madlyn Barnett, a stalwart in Hadassah who was also a longtime Council member. To applaud Barnett's service, the next year B'nai B'rith Men named her the "Jewish Man of the Year"—a sobriquet both ludicrous and prestigious, and an acknowledgment that a woman could penetrate what Pogrebin calls the "mystique of male authority."[49]

In Fort Worth, synagogues began naming women to executive-board positions (beyond the stereotypical recording secretary). In 1979, Sandra Freed became the first to serve as a synagogue vice president.[50] In 1987, Louise Appleman became Beth-El Congregation's first female president, followed in 1999 by Judie B. Greenman and in 2003 by Maddie Lesnick. None of the three female synagogue presidents had been president of a local Jewish women's organization. They climbed the communal-service ladder through other avenues in the civic and business world.[51] As the leaders of *Ezrat Nashim* had predicted, there was an "exodus of Jewish women leaders" into the secular sphere. There they gained the recognition and prestige that finally validated their talents to the rest of the Jewish community. If the path to power in the Jewish community was through outside organizations, then why should women with leadership potential invest their time and talents in the National Council of Jewish Women—or any Jewish women's organization?

As the ranks of Council volunteers thinned, the local chapter of Hadassah, the women's Zionist organization, grew. Hadassah did not promise integration into the larger community. It did guarantee a sense of Jewish identity and Jewish peoplehood. Because the older generation of women in Fort Worth and elsewhere remained dedicated to Hadassah's mission, it offered Jewish continuity. Madlyn Barnett, for example, spoke with her two daughters about some day following in the footsteps of their mother and grandmother by becoming Hadassah presidents. They eventually did. In addition, Hadassah's nationwide social-service program, Check It Out, strengthened intergenerational ties. Hadassah, more so than the Fort Worth Council of Jewish Women, understood that Jewish baby boomers wanted a sense of ethnic identity, a feeling of sisterhood, and meaningful interaction between the older and younger generations.

Yet, Hadassah would also suffer from a lack of leadership at the top. In 2006,

no one accepted the presidency. In 2007, three past presidents and the treasurer formed an executive committee to steer the chapter. Fort Worth Hadassah had 323 lifetime members and 66 annual-dues-paying members. It had no trouble fundraising. While its numbers looked strong, new leaders would not step up to the plate. It was falling prey to some of the same forces that had weakened the local NCJW.[52]

Redesign

Omitted from *Lilith*'s "Vanguard or Rear Guard" article was another Jewish organization, B'nai Brith Women (BBW). *Lilith* followed this group's ongoing struggles in its news columns. The organization's battle for survival involved what feminist theoretician Estelle Freedman would call "separatism," "female institution building," and a battle against the "integrationist approach."[53]

B'nai B'rith Women traces its origins to 1897, when women began establishing auxiliaries to lodges in the all-male Independent Order of B'nai B'rith (IOBB), a fraternal organization begun in 1843. The auxiliaries gradually developed an agenda of their own. They federated as chapters in 1940, dropping the term *auxiliaries*. They adopted the name B'nai B'rith Women in 1957 and became a distinct legal entity under the parent organization's constitution in 1962. BBW was termed a *parallel* organization to the all-male B'nai B'rith lodges. It considered itself a Jewish woman's advocacy and service association. In 1971, it became the first of the large Jewish voluntary associations to endorse the Equal Rights Amendment.[54]

BBW burgeoned in the 1970s as it introduced night chapters. However, its male counterpart, B'nai B'rith, like many lodges rooted in the nineteenth century, suffered membership losses. The men's roster plummeted from 200,000 in 1969 to 136,000 in 1987. To reverse the trend, in 1984 an IOBB resolution called for "full and equal membership for women."[55] The men said that one reason for the measure was to promote gender equality.

At that time, B'nai B'rith Women had a roster of 120,000 women in more than nine hundred chapters in North America. BBW's leadership argued against integration, fearing a "devaluation of women's culture" as the men raided their roster; the men's bid to become a "mixed institution" was tantamount to a brother robbing a sister. Nonetheless, B'nai B'rith lodges went coed in 1988. An estimated 20,000 to 25,000 members of B'nai B'rith Women opted for "assimilation" and the opportunity to work as equals in a mixed group.[56]

Fearing further hemorrhaging, B'nai B'rith Women developed a plan to "terminate" its relationship with its parent organization. In 1995, B'nai B'rith Women

disaffiliated from the well-known international organization. In leaving the fold, BBW relinquished its name. It reemerged as Jewish Women International (JWI).

Before reinventing their organization, JWI's leaders studied the sociology and pathology of voluntary organizations across the United States. They discerned that chapter-based associations were dying from irrelevance and attrition. "The demographics of life had changed so drastically," said JWI's executive director Loribeth Weinstein. Baby boomers who were working, completing graduate school, and postponing or rejecting marriage did not have the same need as their parents and grandparents to affiliate. The volunteer activities that post-feminist women gravitated to had to be "very close to home," usually something related to their immediate families. "This ran counter to the culture of the traditional Jewish woman's organization," Weinstein noted. Lady Bountiful helped others. Women in the 1990s wanted self-help tools.[57]

In North America, JWI is no longer strictly chapter based—although it has 125 chapters remaining from its B'nai B'rith days, including the one in Fort Worth. Weinstein and her colleagues, concurring with sociologist Putnam, concluded that contemporary Americans prefer advocacy organizations that do not require committee meetings or elected officers. Jewish women who used to join a handful of broad-based, overlapping organizations now limit membership to those with specific agendas that appeal to them. Bearing that in mind, JWI hosts seminars around the country on domestic violence and financial literacy. It creates task forces. It recommends unusual service projects—like sending Valentine's Day bouquets to battered-women's shelters. JWI tries to "think outside the brisket."[58]

In Fort Worth, the JWI chapter has a roster of 160 women. The average age ranges from sixty-five to seventy-five. Monthly meetings attract about thirty people. "For most of them, that's about the only activity for the month," former president Faye Berkowitz said in a 2004 interview. Most members bonded decades ago when BBW sponsored a weekly bowling league. After B'nai B'rith lodges went coed, these women preferred to maintain their "pocket of sisterhood." Despite the change in name and focus, the local JWI chapter has attracted few new participants. Members expect it to die of attrition. Said Berkowitz, who died in 2005, "It's a different world. It's just a different ballgame. We had our run. We accomplished."[59]

Success Breeds Decline

Fort Worth's JWI chapter is a fading remnant of the B'nai B'rith Women of the past; members acknowledge its slide. However, the demise of the Fort Worth

Council of Jewish Women caught people off guard. The general public was so attuned to the group's success that outsiders still register surprise that it disbanded in 2002. Many of the women placed on the Fort Worth Council's community boards still serve. Numerous past presidents hold high-profile positions in the community.

Ironically, the Fort Worth Council's triumphs led to its decline. The successful Book Fair put Jewish women on the front page and onto dozens of agency boards. Council members exported their expertise across the community. As more doors in Fort Worth opened to women and to minorities, leaders from the Council were among the first to gain entrée. Jewish women who had learned administrative and political skills through the Council moved beyond it to become presidents of human-service institutions, to launch small businesses, and to work in the private and public sectors. The Council's successes propelled members into diverse paths. In what Sara Evans calls a "paradox of modernity," success became a source of fragmentation. Success eroded the communal base of the women's organization.[60]

There are historical precedents for this pattern. When first-wave feminists secured voting rights in 1920, women's collective power became fragmented. With the passage of the Nineteenth Amendment, women lost their joint "sense of mission," says Estelle Freedman. Many abandoned single-sex organizations, convinced that their hard-won equality at the ballot box would prove a panacea to all social ills. They dared believe that they could reform society through the voting booth, without women's organizations to help them strategize. The general reputation of women's clubs became "mere recreational."[61]

Patricia R. Hill, who documents the American Women's foreign-mission movement during the first two decades of the twentieth century, notes that its leaders welcomed "social and material progress." This ultimately led to broader acceptance of secularization, which undermined their movement.[62]

When the National Council of Jewish Women was created in 1893, women's civic activism rested on the ideology of separate spheres. Only by stretching the boundaries of the domestic sphere could women participate in the larger world. When the public and private spheres of men and women began to merge, groups like the Fort Worth Council lost the major reason for their existence. As discriminatory barriers fell, women and Jews were among the first invited in. They flocked to the larger realm. This is what their organization had been aiming for all along — integration into the mainstream.

Throughout the first seven decades of the twentieth century, the Fort Worth Council of Jewish Women was the largest Jewish women's voluntary organization in the city. During its heyday, the Council helped women bridge the transition from home to social action. Similar to secular women's clubs, it gave

Jewish women a route to communal participation that paralleled the paths of middle-class Protestant women. Jewish men mingled more easily in the public arena because of their business ties and because the public sphere was also perceived as the male sphere of influence. Thus, gender and Judaism impacted Jewish women's entrance into the world beyond hearth and home. The Council became their vehicle for the transition.

The Council also helped Jewish women in Fort Worth succeed despite hidden anti-Semitism and limited opportunity to join other social clubs. It raised the status of all Jewish women in the community. They became associated with education, through the Council's Americanization School and later through the citywide book fair. The Council's leaders became empowered within the Jewish community and beyond it as they were increasingly tapped for roles within the local and state Federation of Women's Clubs, within the short-lived Department Club, and, later, with the Woman's Club of Fort Worth and ultimately The Junior League of Forth Worth. Each of these was a high-profile, high-status organization among the city's elite. That status rubbed off on the Jewish women.

The flip side of this secular involvement was the resentment that it bred among Jewish women who were less upwardly mobile. These were most often women with ties to the more traditional of the city's two synagogues. Although the Council strengthened communal pride among Jews through citywide efforts like the Book Fair, it also accentuated differences. Some factions in the Jewish community felt that volunteer time and fundraising efforts should be directed at in-group causes such as Zionism and immigrant aid for Jewish refugees resettling in Texas. The Council's reluctance to assist local immigrants early in the century and its cool demeanor toward Holocaust-era refugees are evidence of the elitism of which many detractors accused the NCJW at all levels. Yet from isolation to acculturation, the Council provided credibility for the city's Jews and a path to prominence for women in Fort Worth to follow. The Council's platform turned into a springboard for secular involvement. By the late twentieth century, Jewish women became successful in the non-Jewish world without the assistance of the Council. And, like many single-sex organizations, the Council seemed dated, even antiquated, to the baby boomers and gen-Xers.

In Fort Worth, the remnant of the Council that gathered in Roz Rosenthal's living room in 1999 tried for three years to revive the Fort Worth chapter. The women appealed to sentiment, for theirs was the oldest surviving section in Texas. They appealed to social conscience, organizing a Valentine's Day party at a domestic violence shelter and a school-clothing drive in conjunction with Catholic Charities. They canvassed community rosters for potential new members, received dues from recent arrivals, but never called a general meeting. A

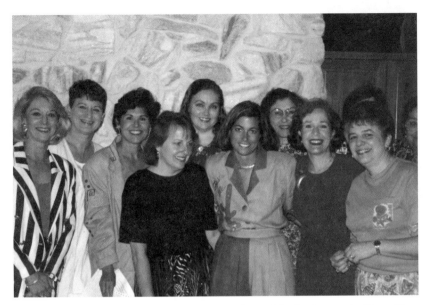

Closing Luncheon, 1993. Nine women pose in front of the fireplace at the Council's closing luncheon in the spring of 1993 at a private home. From left, are Robin Nagle; Debby Stein, who in 1994 became the section's last president; past president Marilou Labovitz; unidentified; Nancy Siegel, Gail Prostok; Marian Haber; Leslye Urbach, the incumbent president; and hostess Barbara Schuster. Courtesy Fort Worth Jewish Archives, Jewish Federation of Fort Worth and Tarrant County.

newcomer who had experienced the joys of the Council in another city seized the reins for a year, but she could not move the organization forward.

Acknowledging that the chapter was in its final days, Roz Rosenthal and her informal committee decided to distribute money left in the treasury to worthy local causes. Grant applications were publicized, and more than $50,000 were allocated to local agencies such as I Have a Dream, Habitat for Humanity, a camp for homeless youngsters, and Jewish Family Services. Meanwhile, the national headquarters pressed the section to pay delinquent dues, totaling $19,150, and threatened legal action if the dying section kept disbursing its assets locally.[63] In September 2002, the section disbanded, with the $30,000 left in the treasury going into the national coffers.[64] Members received letters from NCJW headquarters encouraging them to join the Dallas section, which had 1400 members then (and 1200 in 2007). None affiliated. They had lost the camaraderie fostered within their local Council.

Participating in the Council had always been about the local community, more so than the national agenda. Without the NCJW, local Jewish women

had an impact individually, but not collectively. "While it is good that we Jews are accepted, it is not good for the Jewish community's identity," lamented Ellen Mack. "We lost our collective role shaping the larger community. We are not as identifiable as Jews."[65]

The disintegration of the Fort Worth Council is evidence of societal and demographic trends integrating Jews into the secular community and drawing women into the professional workplace. Barriers that once excluded Jews and restricted them to the Jewish communal world have virtually disappeared. The community and the cultural values that created these organizations no longer exist. Volunteer organizations require new vision. The Fort Worth section of the National Council of Jewish Women did not adapt. It had fulfilled its mission. Back in 1901, it was the only outlet for Jewish women. At the dawn of the twenty-first century, having prepared its members for equal opportunity, it had become an anachronism. It had thrived for a century, however, and during that time, the Council served a vital purpose, assisting with the modernization of Fort Worth and the expansion of Jewish women's public roles.

Charter Members,
Fort Worth Council of Jewish Women

The *Fort Worth Register*'s club page of November 3, 1901, listed twenty-five women who attended the founding meeting of the Fort Worth Council of Jewish Women. On November 10, an article on the club page mentioned two additional members—Mrs. Marcus Alexander and Mrs. Alex Goldstein—who were serving on committees. The newspaper identified women with courtesy titles and with their husband's first names. This list attempts to fill in the women's first and maiden names.

1. Alexander, Pheenie (Mrs. Marcus)
2. Brann, Sophia (Mrs. Herman), president
3. Brown, Sarah Simon (Mrs. David)
4. Carb, Matilda "Tilly" (Mrs. Charles)
5. Carb, Hattie Baum (Mrs. Isidore)
6. Carb, Miss Sarah V., treasurer
7. Cohen, Anna L. (Mrs. Lee E.), secretary
8. Flesch, Sallie Weltman (Mrs. George)
9. Gernsbacher, Julia Falk (Mrs. Henry)
10. Goldstein, Mrs. Alex
11. Goldstick, Sarah (Mrs. Mike)
12. Gordon, Lena (Mrs. David)
13. Gronsky, Miss Adrienne
14. Gronsky, Miss Cecilia
15. Heninger, Rebecca (Mrs. Jake)
16. Keller, Mary (Mrs. August)
17. Mayer, Berenice Gans (Mrs. Max K.)
18. Mayer, Blanche (Mrs. Jacques)
19. Potishman, Miss Eva

20. Rosen, Betty Gordon (Mrs. Sam)
21. Rosenstein, Sarah (Mrs. Max)
22. Schloss, Tillie Angleman (Mrs. Aaron), vice president
23. Seligman, Eugenia Sanger (Mrs. Oscar)
24. Stiefel, Nettie Lewis (Mrs. Ike)
25. Washer, Rosa Rouff (Mrs. Jacob)
26. Weltman, Leah (Mrs. James)[+]
27. Weltman, Louisa (Mrs. Louis)

A fiftieth anniversary program listing thirty charter members of the Fort Worth Council includes fifteen women not on the original list. The program omits seventeen of the founders named in the 1901 articles. Newcomers to the list are noted with an asterisk (*).

1. Alexander, Pheenie (Mrs. Marcus)
2. August, Hattie Baum (Mrs. Alphonse)*
3. Brann, Sophia (Mrs. Herman)
4. Brown, Sarah Simon (Mrs. David)
5. Carb, Babette (Mrs. David)*
6. Carb, Matilda "Tilly" (Mrs. Charles)
7. Carb, Hattie Baum (Mrs. Isidore)
8. Cohen, Anna L. (Mrs. Lee E.)
9. Friend, Carrie (Mrs. A. M.)*
10. Gabert, Balbina (Mrs. Simon)*
11. Gernsbacher, Julia Falk (Mrs. Henry)
12. Gordon, Lena (Mrs. David)
13. Gross, Edith Mayer (Mrs. Leon)*
14. Jacobs, Mrs. S.*
15. Lederman, Hattie Schloss (Mrs. Herman)*
16. Levy, Addie (Mrs. Sam)*
17. Mayer, Amanda (Mrs. Joe)*
18. Mayer, Blanche (Mrs. Jac)
19. Mehl, Annie Jacobs (Mrs. I. N.)*
20. Miller, Mary (Mrs. Sam)*
21. Rosen, Betty Gordon (Mrs. Sam)
22. Rosenstein, Sarah (Mrs. Max)
23. Schenck, Mrs. L. G.*
24. Schloss, Tillie Angleman (Mrs. Aaron)
25. Seligman, Eugenia Sanger (Mrs. Oscar)

26. Shanblum, Sarah Levy (Mrs. L. F.)*
27. Simon, Hattie Weltman (Mrs. Uriah M.)*
28. Washer, Rosa Rouff (Mrs. Jacob)
29. Weltman, Bettie (Mrs. Henry)*+
30. Weltman, Louisa (Mrs. Louis)

+Leah Weltman (Mrs. James), whose name was printed in the 1901 newspaper article, should very likely have been listed instead of Bettie Weltman (Mrs. Henry).

Presidents, Fort Worth Section
National Council of Jewish Women

1901–03: Sophia Brann (Mrs. Herman)

1903–05: Pheenie Alexander (Mrs. Marcus)

1905–09: Pauline "Polly" Sachs Mack (Mrs. Theo)

1909–10: Tillie Angleman Schloss (Mrs. Aaron)

1910–14: Nettie Lewis Stiefel (Mrs. Ike)

1914–15: Lilli Bogen Morris (Mrs. Louis)

1916: Tillie Angleman Schloss (January to October); Lilli Bogen Morris (October thru December)

1917–19: Pauline "Polly" Sachs Mack (Mrs. Theo); Served as first vice president of State Conference for NCJW

1919–21: Julia Alltmont Pincus (Mrs. H. I.)

1921–23: Ida Goldgraber (Mrs. Joseph)

1923–25: Sophia Welsch (Mrs. C. S.)

1925–26: Ida Goldgraber (Mrs. Joseph)

1926–28: Sophia Winterman Miller (Mrs. Herman H.)

1928–30: Rose Gilbert (Mrs. Max) (first president from Ahavath Sholom)

1930–31: Beatrice W. Shaffran (Mrs. Simon J.)

1931–32: Libby Ginsburg (Mrs. Harry)

1932–34: Rose Gilbert (Mrs. Max)

1934–35: Amanda Colton (Mrs. David L.)

1935–37: Etta Brachman (Mrs. Sol); Served as Texas/Oklahoma regional president, 1941–1945; National Board of Directors, 1949–1952

1937–38: Lillian Adler (Mrs. Melvin)

1938–40: Sophia Miller (Mrs. H. H.)

1940–41: Sarah Papurt Horwitz (Mrs. I. E.)

1941–43: Tobia Miller Ellman (Mrs. Ben)

1943–45: Amelia Levy Rosenstein (Mrs. Abe)

1945–47: Leonora "Sweetie" Goldstone (Mrs. Bernard)

1947–49: Pearl Joseph Rabinowitz (Mrs. Maurice Rabinowitz, later Mrs. Max Whalen)

1949–51: Norma Harris Mack (Mrs. Henry); regional vice-chairman, 1949–51

1951–53: Charlotte Max Goldman (Mrs. M. M.)

1953–55: Lilaine "Lil" Goldman (Mrs. Bernard); regional president, 1960–62

1955–57: Ruth Rapfogel (Mrs. Irving)

1957–59: Pauline Landman Wittenberg (Mrs. Edwin)

1959–61: Fannette Bronstein Sonkin (Mrs. Norman)

1961–63: Rosalyn "Roz" Gross Rosenthal (Mrs. E. M.)

1963–65: Harriet Lopin (Mrs. Marcus)

1965–67: LaRue Glickman Glazer (Mrs. Louis)

1967–69: Amy Jacobs Scharff (Mrs. Earle U. Scharff, Jr., later Mrs. Robert Stien)

1969–71: Sandra Miron Freed (Mrs. I. L.)

1971–73: Dorothy Diamond Winston (Mrs. Harold)

1973–75: Ellen Feinknopf Mack (Mrs. Theodore)

1975–77: Ruth Roper (Mrs. Doug)

1977–79: Carol Goldman Minker (Mrs. Richard)

1979–81: Carol Goldman (Mrs. Ronald)

1981–83: Jane Oderberg (Mrs. Simon)

1983–84: Harriet Anton (Mrs. Larry) (second president from Ahavath Sholom)

1984–85: Cynthia Gilbert (Mrs. Burton)

1985–86: Joan Katz (Mrs. Howard): (third president from Ahavath Sholom)

1986–87: Barbara Herman (Mrs. Morton) (fourth president from Ahavath Sholom)

1987–88: Barbi Schwartz Eisenman (Mrs. Stanley) (fifth president from Ahavath Sholom)

1988–90: Co-presidents: Marcia Garoon (Mrs. Glenn) (sixth president from Ahavath Sholom); Sandy Hollander (Mrs. Ira)

1990–92: Marilou Labovitz (Mrs. Jack) (seventh president from Ahavath Sholom)

1992–94: Leslye Urbach (Mrs. Michael)

1994–96: Debby Stein (Mrs. Herb Gleitz)

1996–97: Governing body of 13 women, with rotating meeting leaders

Fall 1997–March 1998: Ellen Mack and Evelyn Siegel, co-coordinators

1999: Attempts to reorganize. Two national representatives visit Fort Worth, meet with 35 women at Roz Rosenthal's house.

January 2000: Beverly Ross, reorganization chairwoman; Karen Savitz,
 treasurer
November 2000–May 2002: Deborah Gould, interim president
September 2002: Section officially disbands

> *Presidents' list compiled from *Southwest Jewish Sentiment*, October 20, 1901, p. 9;
> Fort Worth NCJW section yearbooks; Fort Worth NCJW section minutes books,
> 1916–17, 1940–46; "50th Anniversary Dinner," booklet, October 24, 1951; Library
> of Congress, NCJW Collection, National Office, Series I, Box 101, Directories
> 1923–56; Series II, Box 30, Directories 1965–78; NCJW Proceedings of Triennials;
> Fort Worth NCJW Scrapbooks 1948–53, 1985–91, Fall 1991–April 1992; *Jewish Monitor*, September 10, 1915, and August 22, 1919. Dates of terms from 1903 to 1917 are
> tentative.

NCJW Sections in Texas, Status Report

Compiled from NCJW Triennial Proceedings, 1902–1967; national NCJW directories, 1920–1967; minutes of national board meetings; Fort Worth section yearbooks; San Antonio section newsletters, 2005–2006.

Austin

1919: Organized with 61 members

2007: Active with approximately 180 members, including 88 annual and 92 life members

Bay Area

1967: Organized

1972: Disbands; women invited to join Houston section

Beaumont

1901: Organized with 27 members

1905: "Out of existence"

1907: Reorganized; donates $6.25 to victims of San Francisco earthquake

1911: "Out of existence"

1918: Reorganized with 80 members; sends delegate to 1920 triennial

1965: Disbands

Brownsville

1942: Organized

1946: No longer in national directory

Corpus Christi

1946: Organized

1971: Still active

1975: No longer in national directory

Corsicana

1919: Organized with 16 to 30 members

1932: Disbands

1937: Tries to reorganize with Mrs. Harry Kaufman, president; effort unsuccessful

Dallas

1898: Organized by Rabbi George A. Kohut, Mrs. L.M. Guggenheim, Miss L. Wormser, and Miss Nora Wormser

1901: Juniors section organized

1902: Delegates attend triennial in Baltimore; Mr. Sanger and Mr. Kahn each donate $100 to become patrons of the triennial

1905: "Out of existence," according to *Triennial Convention Proceedings*

1913: Organized with 75 members by Sadie American, NCJW's executive secretary; 210 members by next triennial in 1914

1917: Dallas member Grace Goldstein becomes a national officer

2007: Active with approximately 1,200 members

El Paso

1917: Organized

2003: Disbands

Fort Worth

1901: Organized by Jeannette Miriam Goldberg with 25 charter members

1960s: More than 500 members

2002: Disbands

Gainesville

1904: Organized by Jeannette Miriam Goldberg with 11 women

1905: "Out of existence"

Galveston

1913: Organized by Sadie American with 80 members; 121 members by 1920

1965: Disbands

Houston

1913: Organized with 164 members by Sadie American; 354 members by 1920

2007: Active with 780 members; Greater Houston Section consists of Greater Houston Daytime Branch, Career Branch, West Houston Evening Branch, and Concerned Young Women Branch. Each branch has an executive board. Under a new strategic plan, a thirteen-person governing board is created to coordinate among the branches.

Palestine

1901: Mentioned in *Southwest Jewish Sentiment* as being organized by Jeannette Miriam Goldberg; never listed in national convention proceedings or in a national directory; possibly foundered from the start

Port Arthur

1920: Organized
1965: Disbands

Rio Grande Valley

1942: Organized
1965: Disbands

San Antonio

1907: Organized by Anna Hertzberg with 82 members, including women from Seguin, Tex., Freemont, Okla., and Mexico City; met at Menger Hotel
1914: Anna Hertzberg elected vice president of national NCJW
1920: Membership reaches 248
2005: Reorganized as "section at large" because of declining membership and inability to meet "financial obligations locally and nationally"; section's assets are held in a joint signature account with NCJW, Inc.; situation described as "serious but not terminal"
2007: Celebrates 100th anniversary at Menger Hotel, location of first section meeting

Seguin

1936: Organized
1971: Disbands

Sherman

1917: Organized
1919: "Reorganized" with 23 members
1937: Becomes Sherman-Denison section

1967: Classified as "very small section"; gets award for retaining 85% members
1971: Disbands some time after 1971

Temple

1936: Organized
1939: Disbands in May 1939
1946: Reorganizes
1955: Disbands in the mid-1950s

Tri-County

1936: Organized; includes Schulenburg, Hallettsville, Columbus
1969: Disbands

Tyler

1898: Organized in September 1898 by Jeannette Miriam Goldberg with seven members
1926: Section disbands
1935: Reorganizes
1941: Disbands; no longer listed in national directory of sections

Waco

1901: Section paid $7 dues to national in 1901
1905: "Out of existence," according to convention proceedings
1912: Organized as a "new section" with 56 members; by 1920, 118 members
1966: Disbands

Wichita Falls

1919: Organized and called "a flourishing young section" with 45 members
1935: Disbands

Major Women's Clubs in Fort Worth, 1889 to 1923

1989: Woman's Wednesday Club
1893: '93 Club
1896: Euterpean Club (called Derthick until 1900)
1896: Fort Worth Kindergarten Association
1896: Monday Book Club (daughters of Wednesday Club members)
1897: Symposium Club (called Penelope Club after 1901)
1897: Forth Worth Federation of Women's Clubs
1900: Current Literature Club
1900: New Century Club (for "lady teachers," meaning single women. By 1903, membership extended to non-teachers.)
1901: Council of Jewish Women (referred to as *National* Council of Jewish Women after 1923)
1902: Department Club (disbands by 1906)
1902: Harmony Club (unlimited membership)
1902: History Club (daughters, nieces, close friends of Wednesday Club members)
1903: Sorosis
1903: Ladies Hebrew Relief Society (evolves into Congregation Ahavath Sholom Ladies' Auxiliary)
1904: Tuesday Club
1905: Woman's Shakespeare Club
1906: Judith Shakespeare Club
1906: YWCA
1908: Cadmean Club (formed by the '93 Club for younger women)
1908: Cemetery Association
1912: Southern Association of College Women, Forth Worth Branch (becomes American Association of University Women)

1913: Sisterhood of Beth-El Congregation (affiliate of National Federation of Temple Sisterhoods)

1914: Thursday Afternoon Club

1919: Girls Protective Association (later called Girls Service League)

1919: Miriam Club (becomes Junior Council of Jewish Women)

1922: Hadassah (women's Zionist organization)

1923: The Woman's Club of Forth Worth

Notes

CHAPTER ONE

1. Form 990, Return of Organization Exempt From Income Tax, 1999, NCJW Box 5, Tax Returns folder, Fort Worth National Council of Jewish Women Collection, Beth-El Congregation Archives, Fort Worth, Texas (hereafter, FW/NCJW Collection, Beth-El Archives).

2. "Life Member Computer-Generated List," 1997, NCJW Box 5, Life Member folder, FW/NCJW Collection, Beth-El Archives.

3. For discussion of intergenerational ties of activism among Jewish clubwomen, see Sarah Wilkerson-Freeman, "Two Generations of Jewish Women: North Carolina, 1880–1970," *Southern Jewish Historical Society Newsletter*, July 1989, 3–6.

4. "Notes, meeting with national representatives," NCJW Box 1, 1999 Meetings folder, FW/NCJW Collection, Beth-El Archives, Fort Worth.

5. Joan Katz, a former NCJW president, and Rozanne Krumholz Rosenthal, the daughter-in-law of Rosalyn G. Rosenthal, launched Fort Worth's Race for the Cure in 1992.

6. "Modernity brought gains and losses, eroding the female community that had flourished," writes Sara Evans with reference to feminism's first wave. The statement applies to the second wave as well. Sara M. Evans, *Born for Liberty: A History of Women in America* (New York: The Free Press, 1989), 173.

7. NCJW membership and section figures compiled by author from various sources, including proceedings of national triennial and biennial conventions; NCJW, National Office Collection, Library of Congress, Series I, Box 3, National Board 1926 folder and Series I, Box 102, Fact Sheets Years of Progress folder; Bernice Graziani, *Where There's a Woman, 75 Years of History as Lived by the National Council of Jewish Women* (New York: McCall Corporation, 1967), 124–125; Monroe Campbell Jr. and Willem Wirtz, *The First Fifty Years: A History of the NCJW 1893–1943* (New York: NCJW, 1943), 88–91; "NCJW in Your Community," accessed March 13, 2004, available from http://www.ncjw .org/html/AboutNCJW/NCJWInYourCommunity; Internet.http://www.ncjw.org/html/ AboutNCJW/NCJWInYourCommunity/.

8. Ibid., 51–58.

9. The Yiddish phrase for this phenomenon is *geknippt und gebinden,* meaning tied and tethered, interrelated at so many levels that family trees intersect at multiple points. Hollace Ava Weiner, "Tied and Tethered ('Geknippt und Gebinden'): Jews in Early Fort Worth," *Southwestern Historical Quarterly* 107 (January 2004): 403; For discussion of interrelationships within "Jewish crowds" in the American West, see Robert E. Levinson, "The Use of Genealogy in Western Jewish Historical Research," Klau Library, Hebrew Union College, F 870, J5L4.8; The same pattern is evident in North Carolina, according to Leonard Rogoff, *Homelands: Southern Jewish Identity in Durham and Chapel Hill, North Carolina* (Tuscaloosa: University of Alabama Press, 2001), 34.

10. Patricia Summerlin Martin, "Hidden Work: Baptist Women in Texas, 1880–1920" (Ph.D. diss., Rice University, 1982).

11. Karla Goldman, *Beyond the Synagogue Gallery: Finding a Place for Women in American Judaism* (Cambridge: Harvard University Press, 2000), 10–11; For a fuller discussion, see Eric L. Goldstein, *The Price of Whiteness: Jews, Race, and American Identity* (Princeton: Princeton University Press, 2006), 12–16.

12. "The power of association had its own inner dynamic, which carried many women to points they had not, in the beginning, been able to envision," concludes Anne Firor Scott, *The Southern Lady: From Pedestal to Politics, 1830–1930* (Chicago: University of Chicago Press, 1970), 106; Scott, "On Seeing and Not Seeing: A Case of Historical Invisibility," *Journal of American History,* 71 (June 1984): 7–21; Scott, "Women, Religion, and Social Change in the South, 1830–1930," in *Religion and the Solid South,* ed. Samuel S. Hill Jr. (Nashville: Abingdon Press, 1972), 144–48; Scott, *Making the Invisible Woman Visible* (Urbana: University of Illinois Press, 1984); Scott, *Natural Allies: Women's Associations in American History* (Urbana and Chicago: University of Illinois Press, 1991); Scott, "Most Invisible of All: Black Women's Voluntary Organizations," *Journal of Southern History* 56 (February 1990): 12–20.

13. Judith N. McArthur contends that Texas did not have a female "tradition of religious activism but rather, a network of secular voluntary associations dating from the 1890s that pulled southern women out of their cultural isolation and into Progressivism." She writes that the General Federation of Women's Clubs and the National Congress of Mothers "proved far more effective than the Women's Christian Temperance Union in encouraging Texas women to public activity." Judith N. McArthur, *Creating the New Woman: The Rise of Southern Women's Progressive Culture in Texas, 1893–1918* (Urbana and Chicago: University of Illinois Press, 1998), 3; Jean E. Friedman contends that the development of reform-minded women's clubs came much later in the South than in the North because Southern churches were dominated by patriarchal-kinship networks. "Sex-segregation as a pre-condition for reform never materialized in the South because . . . the primary association was with kin." Quilting bees and church suppers were "ephemeral meetings" that never "developed into consistent, stable patterns of association that held the potential for a reform network." Friedman, *The Enclosed Garden,* xi–xii. Supporting Anne Firor Scott's contention that women's clubs grew out of religious associations is Elizabeth Hayes Turner, whose examination of Galveston demonstrates how the local

women's-club movement rested on women's church societies. "Their pattern of emergence into public activism followed a trajectory that began in the home and led to eventual evolvement from church to relief society to benevolent institution to women's club to civic activism." She adds that "for Jewish women living in Galveston, the pattern of evolution into public civic life was similar to that of elite Protestant women." Elizabeth Hayes Turner, *Women, Culture, and Community: Religion and Reform in Galveston, 1880–1920* (Oxford: Oxford University Press, 1997), 9–10.

14. Regionalism versus ethnicity has been an ongoing topic of discussion among American Jewish historians. Many patterns persist nationwide among Jews in the Diaspora. Patterns among Jewish clubwomen are examined in Mark K. Bauman, "Southern Jewish Women and Their Social Service Organizations," *Journal of American Ethnic History* 22 (Spring 2003): 35–36. He notes that Jewish women "expanded their domains particularly through the medium of voluntary benevolent organizations" that emanated from their congregations. "The societies . . . offered opportunities to learn parliamentary procedure, raise and invest money, speak, and hold office, clear breaks from European Jewish tradition. In these ways, the women gained agency in male-dominated Jewish and secular societies"; See also William Toll's *Women, Men and Ethnicity: Essays on the Structure and Thought of American Jewry* (Lanham, MD: University Press of America, 1991), vii, in which he observes that organizations like the Council of Jewish Women "enabled Jews to . . . present their communal interests to the new pluralistic American polity. . . . Jews collectively learned to move freely in American philanthropic and civic circles."

15. Kathleen D. McCarthy, "Parallel Power Structures: Women and the Voluntary Sphere," in *Lady Bountiful Revisited: Women, Philanthropy, and Power*, ed. Kathleen D. McCarthy (New Brunswick: Rutgers University Press, 1990), 1–34; McCarthy, *Women, Philosophy and Civil Society* (Bloomington: Indiana University Press, 2001); McCarthy, *Women's Culture: American Philanthropy and Art, 1830–1930* (Chicago: University of Chicago Press, 1993).

16. Sara M. Evans and Harry C. Boyte, *Free Spaces: The Sources of Democratic Change in America* 1992 ed. (Chicago and London: University of Chicago Press, 1986); Sara M. Evans, *Born for Liberty: A History of Women in America* (New York: The Free Press, 1989); Evans, ed., *Journeys that Opened up the World: Women, Student Christian Movements, and Social Justice, 1855–1975* (New Brunswick: Rutgers University Press, 2003).

17. Beth S. Wenger, "Jewish Women and Voluntarism: Beyond the Myth of Enablers," *American Jewish History* 79 (Autumn 1989): 16–36; Wenger, "Jewish Women of the Club": The Changing Public Role of Atlanta's Jewish Women (1870–1930), *American Jewish History* 76 (March 1987): 311–33; Mark K. Bauman, "Introduction," *American Jewish History* 79 (Autumn 1989): 5–15.

18. Barbara Welter, "The Cult of True Womanhood, 1820–1860," *American Quarterly* (Summer 1966): 151–174; Walter E. Houghton, *The Victorian Frame of Mind, 1830–1870* (New Haven: Yale University Press, 1957), 349; Paula Hyman equates "True Womanhood" with the Jewish notion of "Mother in Israel." Paula E. Hyman, *Gender and Assimilation in Modern Jewish History: The Roles and Representations of Women* (Seattle

and London: University of Washington Press, 1995), 28; Diane Ashton, "Grace Aguilar and the Matriarchal Theme in Jewish Women's Spirituality," in *Active Voices: Women in Jewish Culture*, ed. Maurie Sacks (Urbana and Chicago: University of Illinois Press, 1995), 79–93.

19. Anne Gere and Amanda Vickery have called "into question the systematic use of 'separate spheres' as the organizing concept in the history of middle-class women. The two-sphere analogy seems too neat to be an accurate reflection of life in a dynamic nation." Amanda Vickery, "Historiographical Review: Golden Age to Separate Spheres? A Review of the Categories and Chronology of English Women's History," *Historical Journal* 2 (1993): 383–414, cited by Anne Ruggles Gere, *Intimate Practices: Literacy and Cultural Work in U.S. Women's Clubs, 1880–1920* (Urbana and Chicago: University of Illinois Press, 1997), 277 fn47. Gere further argues that sociological study of clubwomen does not reflect separate, gendered spheres, but rather "interpenetrating" constructs involved in a multifaceted public sphere. Gere, *Intimate Practices*, 13. Beth Wenger, who explores role theory, also disputes the static separate spheres model vis-à-vis Jewish women. She sees endless elasticity and flexibility in these boundaries and maintains that talk of women's orb "masked subtle revisions in gender norms and expectations" within the Jewish community. "As a metaphor, woman's sphere became the axis for negotiation of gender roles within the Jewish community . . . to justify or condemn, but most often to obscure significant modifications in female behavior." Although the debate often was couched in dichotomies—"public/private or professional/volunteer"—a "redefinition" and "reassignment of gender roles" was constantly in negotiation. "Within the Jewish community, both men and women continually rebuilt, redefined, and battled over the boundaries of woman's sphere as they negotiated gender ideals and communal responsibility. By constantly reinventing woman's sphere, Jewish men and women sustained the cherished ideal of Jewish womanhood during a period of rapid social change." She adds, "The changes in Jewish women's roles were less the expansion of a sphere than a tireless battle over the framing of new boundaries." Wenger, "Jewish Women and Voluntarism," 22, 26–27, 29, 31–32.

20. "Essentially, women . . . created institutions for in-group assistance," writes Mark K. Bauman in "Southern Jewish Women and Their Social Service Organizations," 34–78. Nineteenth-century women did not always live the separate-sphere model. Mary P. Ryan discusses ways that women had of breaching rigid social organization and of "circumventing the cash nexus to provide for the public welfare." Moreover, with the rise of industrialization at mid-century, cracks occurred in the female sphere. As the workplace moved outside of the home or the city, women managed boarders, a new slice of the economy. Women also made inroads as classroom teachers and garment-factory workers. Still, the model of the gendered spheres prevailed as the accepted ideal and supposed norm. Mary P. Ryan, *Cradle of the Middle Class: The Family in Oneida County, New York, 1790–1865* (Cambridge: Cambridge University Press, 1981), 204, 216–17, 225, 231.

21. Scott, "On Seeing and Not Seeing," 10; Jean E. Friedman, *The Enclosed Garden: Women and Community in the Evangelical South, 1830–1900* (Chapel Hill: University of North Carolina Press, 1985), xi–xii.

22. Karla Goldman, *Beyond the Synagogue Gallery*, 60; Jacob Rader Marcus, *The American Jewish Woman: A Documentary History* (New York: KTAV Publishing, 1981), 89.

23. Dianne Ashton, "Gratz, Rebecca," in *Jewish Women in America: An Historical Encyclopedia* Vol. I, eds. Paula E. Hyman and Deborah Dash Moore (New York and London: Routledge, 1997), 547–50.

24. Both Deborah Grand Golomb and Faith Rogow discuss reasons why Jewish women did not become leaders in the women's suffrage movement. A recurring theme is suffragists' denigration of Judaism for proliferating degrading images of women. Deborah Grand Golomb, "The 1893 Congress of Jewish Women: Evolution or Revolution in American Jewish Women's History?" *American Jewish History* 70 (September 1980), 55–56; Faith Rogow, *Gone to Another Meeting: The National Council of Jewish Women, 1893–1993* (Tuscaloosa, University of Alabama Press, 1993), 11–12; Elizabeth Cady Stanton and the Revising Committee, *The Woman's Bible* (Seattle: Coalition Task Force on Women and Religion, 1974). Cornelia Wilhelm writes that in the 1840s, the "Christian spirit of female missionary and social service activists prevented Jewish women from joining hands with their non-Jewish sisters in the emerging Protestant-dominated women's movement." Cornelia Wilhelm, "Independent Order of True Sisters: Friendship, Fraternity, and a Model of Modernity for Nineteenth Century American Jewish Womanhood," *American Jewish Archives* 54, no.1 (2002): 39.

25. Rebecca Gratz also founded the nation's first Jewish Foster Home in Philadelphia in 1855. Dianne Ashton, "Gratz, Rebecca," in *Jewish Women in America: An Historical Encyclopedia* Vol. I, 547–50.

26. Karen J. Blair writes that "domestic feminism" occurs when "women challenge male prerogatives by consistently applying the standards of the lady to the larger society." Karen J. Blair, *The Clubwoman as Feminist: True Womanhood Redefined, 1868–1914* (New York: Holmes and Meier, 1980), 8.

27. Estelle B. Freedman dislikes applying the word *feminism* to middle-class clubwomen because in that era the term implied a movement for the equality of men and women, which they did not favor. Freedman uses the phrase *female consciousness* to describe women who "accept gender hierarchy but attempt to solve specific problems by making moral claims as mothers." Estelle B. Freedman, *No Turning Back: The History of Feminism and the Future of Women* (New York: Ballantine Books, 2002), 328–29; Wenger, "Jewish Women and Voluntarism," 18.

28. Robert D. Putnam, *Bowling Alone: The Collapse and Revival of American Community* (New York: Simon & Schuster, 2000), 383.

29. Men "know that they possess the powers and capabilities that the world needs and appreciates," wrote Edward Bok, "Editorial," *The Ladies Home Journal* (September 1898), 14.

30. The New England Woman's Club in Boston included composer Julia Ward Howe.

31. Mrs. Jennie Cunningham (Jenny June) Croly, *The History of the Woman's Club Movement in America* (New York: Henry G. Allen & Co., 1898), 88, 1098–1100; Margaret Nell Price, "The Development of Leadership by Southern Women through Clubs and Organizations" (Ph.D. diss., University of North Carolina, Chapel Hill, N.C., 1945), 129.

32. Megan Seaholm, "Earnest Women: The White Woman's Club Movement in Progressive Era Texas, 1880–1920" (Ph.D. diss., Rice University, 1988), 237–46.

33. Gere, *Intimate Practices*, 149.

34. Frederick Cople Jaher, ed., *The Age of Industrialism in America: Essays in Social Structure and Cultural Values* (New York: The Free Press, 1968); Andrew Carnegie expounded on this philosophy of philanthropy in his essay "The Gospel of Wealth," *North American Review* (June 1889): 653–64, accessed August 15, 2004, available online from <http://www.fordham.edu/halsall/mod/1889carnegie.html>.

35. Seaholm, "Earnest Women," 7, 258.

36. Gere, *Intimate Practices*, 47.

37. Jessie W. Radcliffe, "Ask Somebody Else," *Woman's Work* 13 (July 1898): 188, quoted in Patricia Hill, *The World Their Household: The American Woman's Foreign Mission Movement and Cultural Transformation, 1870–1920* (Ann Arbor: University of Michigan Press, 1985), 55–56.

38. Seaholm, "Earnest Women," 8 fn32; Scott, *Southern Lady: From Pedestal to Politics*, 212–31; June Sochen, *The New Woman: Feminism in Greenwich Village, 1910–1920* (New York: Quadrangle Books, 1972), 31; Gere calls the phrase "new woman" a "journalistic encapsulation of changes in women's views and expectations." Gere, *Intimate Practices*, 141.

39. Henry James's "new woman" protagonists include the title character in *Daisy Miller* (New York: Harper & Brothers, 1879) and Isabel Archer in *Portrait of a Lady* (London: Macmillan and Co., 1881). For discussion of the term's origin and connotations, see Carroll Smith-Rosenberg, *Disorderly Conduct: Visions of Gender in Victorian America* (New York: Alfred A. Knopf, 1985), 176–77, 245–96.

40. Nancy Woloch, *Women and the American Experience*, 2nd ed. (New York: McGraw-Hill, Inc., 1994), 269–307.

41. J. Stanley Lemons, *The Woman Citizen: Social Feminism in the 1920s* (Urbana: University of Illinois Press, 1975), viii; Blair, *Clubwoman as Feminist*, 117, 119.

42. Woloch, *Women and the American Experience*, 269.

43. Elizabeth York Enstam, *Women and the Creation of Urban Life: Dallas, Texas, 1843–1920* (College Station: Texas A&M University Press, 1998), 97; Evans, *Free Spaces*, 92.

44. "The fairs were a meeting ground of the first order, and a number of organizations were actually founded at the fairs . . . Others met in national convention, or had special commemorative 'days' during the fairs," writes Darlene Rebecca Roth, *Matronage: Patterns in Women's Organizations, Atlanta, Georgia, 1890–1940* (Brooklyn: Carlson Publishing Inc., 1994), 13, 34–36; Gere, *Intimate Practices*, 154–58; John Cawelti, "America on Display: The World's Fairs of 1876, 1893, and 1933," in *The Age of Industrialism in America*, ed. Jaher, 339–40.

45. Scott, "On Seeing and Not Seeing," 10.

46. Ellen Martin Henrotin (1847–1922), a banker's widow, was the 1894 president of the National Federation of Women's Clubs. Blair, *The Clubwoman as Feminist*, 61, 95, 102–104.

47. There were no *ordained* female rabbis, although Rachel (Ray) Frank (1861–1948) was hailed as the "girl rabbi" of the "Golden West." Frank, a teacher, journalist, and "itinerant pulpiteer," attended classes at Hebrew Union College for one semester in 1893. She was a delegate to the Jewish Women's Congress, where she delivered the opening prayer and an address on "Woman in the Synagogue." She never represented herself as a rabbi, although the media did. Reva Clar and William M. Kramer, "Ray Frank: The Girl Rabbi of the Golden West, 1861–1948, Her Adventurous Life in Nevada, California and the Northwest," *Western States Jewish History* 35, no. 3–4 (2003): 55–98; Golomb, "The 1893 Congress of Jewish Women," 55–56; Rogow, *Gone to Another Meeting*, 11–12. Golomb and Rogow state that there were no nationally visible Jewish suffragists. They do not mention the late Ernestine Rose (1810–1892), a Polish immigrant dubbed America's "first Jewish feminist." From 1850 to 1869, Rose lectured on women's rights and women's suffrage in New York, Michigan, and across the South, often touring with Susan B. Anthony. She also worked with Elizabeth Cady Stanton and Sojourner Truth. Rose successfully lobbied for New York laws that allowed married women to retain property and have equal guardianship of children. She spent the final years of her life in England. Janet Freedman, "Rose, Ernestine," in *Jewish Women in America* Vol. II, 1163–1165.

48. Maureen A. Flanagan, *Seeing with Their Hearts: Chicago Women and the Vision of the Good City, 1871–1933* (Princeton and Oxford: Princeton University Press, 2002), 31–32, 208; Rogow, in *American Jewish Women's History: A Reader*, ed. Pamela S. Nadell (New York: New York University Press, 2003), 64–65.

49. Golomb, "The 1893 Congress," 52–67; Rogow, *Gone to Another Meeting*, 9–33; Hannah G. Solomon, *Fabric of My Life: The Autobiography of Hannah G. Solomon* (New York: NCJW and Bloch Publishing Co.: 1946), 79–81; Solomon, *A Sheaf of Leaves*, 50.

50. Graziani, *Where There's a Woman*, 20.

51. *Papers of the Jewish Women's Congress* (Philadelphia: Jewish Publication Society of America, 1896), 4, 6–7.

52. Elizabeth M. Holland, "American, Sadie," in *Women Building Chicago*, 35–38.

53. Mrs. Henry Solomon, "Beginnings of the Council of Jewish Women," *American Hebrew*, April 12, 1912, p. 725, quoted by Rogow, "Gone to Another Meeting," in *American Jewish Women's History: A Reader*, 71; Some would argue that the first national organization for Jewish women was the United Order of True Sisters *(Unabhängiger Orden Treuer Schwestern)*, a women's lodge that dates from 1846. Hannah Solomon's mother, Sarah Greenebaum, was a member. Members were largely spouses of B'nai B'rith men who belonged to Reform congregations. Hannah Solomon stated that the Council and the Sisters shared "cousinly" feelings. Cornelia Wilhelm, "The Independent Order of True Sisters: Friendship, Fraternity, and a Model of Modernity for Nineteenth Century American Jewish Womanhood," *American Jewish Archives*, 54, no. 1 (2002): 37–62. Golomb concedes that the True Sisters "might be called the first national as well as the first fraternal Jewish women's organization in the U.S." Golomb says that the True Sisters were an "organization of Jewish women," while the NCJW was a "Jewish women's organization." Golomb, "The 1893 Congress of Jewish Women," 53–54.

54. Goldman, *Beyond the Synagogue Gallery*, 10–11.

55. Scott, *From Pedestal to Politics*, 106.

56. Stella (Mrs. Wm.) Christian, *The History of the Texas Federation of Women's Clubs* (Houston: Texas Federation of Women's Clubs, 1919), 4–7, 11, 23, 28, 132, 138.

CHAPTER TWO

1. Polly Mack, "Fort Worth," Proceedings of the Council of Jewish Women, Fourth Triennial Convention, Chicago, Illinois, December 5 to 12, 1905, pp. 149, 351.

2. "Their commitment to transmitting their heritage to their children under less-than-ideal conditions demonstrates how women in small-town America ensured the maintenance of Jewish continuity." Deborah R. Weiner (no relation to author), "Jewish Women in the Central Appalachian Coal Fields, 1890–1960: From Breadwinners to Community Builders," *American Jewish Archives* 52 no. 1–2 (2000): 12, 25; *See also* William Toll, "The Quiet Revolution: Jewish Women's Clubs and the Widening Female Sphere, 1870–1920," *American Jewish Archives Journal* 41 (Spring/Summer 1989): 16; Beth S. Wenger, "Jewish Women of the Club," *American Jewish History* 76, (March 1987): 311.

3. May Swayne lived at 503 East First Street. Her father, George Harrison Hendricks, was a pioneer lawyer who came to Fort Worth after the Civil War and donated much of the right of way for the railroad. May Swayne attended a Kentucky school for girls. Her husband, John F. Swayne, was Fort Worth's first city secretary, appointed in 1873, and was Tarrant County clerk from 1880 to 1888. May Swayne was first president of the Fort Worth Federation of Women's Clubs, which had its founding meeting in 1897 in her living room, and the first president of the Oakwood Cemetery Association, formed in 1907. Edith Alderman Guedry, "Club Stories Will Date Back to Time Women Rode around in Phaetons," *Fort Worth Press*, December 9, 1932, p. 18; "Mrs. J. F. Swayne, 84 years old," *Fort Worth Press*, July 14, 1940, in Woman's Wednesday Club, Fort Worth, Texas, Scrapbook 1 (hereafter, WWClub Scrapbook #1), Texas Library, The Fort Worth Woman's Club; United States Census (1870, 1880, 1900, 1930); Pioneer Rest Cemetery Records; *History of Texas, Together with a Biographical History of Tarrant and Parker Counties* (St. Louis: The Lewis Publishing Company, 1895); discussions with Ruth Karbach, notes in possession of author.

4. *Fort Worth Weekly Gazette*, June 6, 1889, p. 2, typewritten copy of article in WWClub Scrapbook #1.

5. "Wednesday Club is City's Oldest Literary Group," *Fort Worth Press*, December 16, 1932, p. 18.

6. Woman's Wednesday Club minutes, February 27, 1889, in WWClub Scrapbook #1. A retrospective written for the club's fortieth anniversary described the founders as "young matrons earnestly desiring to further educate themselves and mitigate the prosaic tasks of housekeeping and child-rearing." *Texas Federation News*, n.d. 1900, p. 6, in WWClub Scrapbook #2.

7. "Wednesday Club Is City's Oldest Literary Group," *FW Press*, December 16, 1932, p. 18.

8. For examples, see Deborah R. Weiner, "Jewish Women in the Central Appalachian Coal Fields," 10–33; William Toll, "From Domestic Judaism to Public Ritual," in *Women and American Judaism: Historical Perspectives*, eds. Pamela S. Nadell and Jonathan D. Sarna (Hanover: Brandeis University Press/University Press of New England, 2001), 128–181; Toll, "The Quiet Revolution," 7–26.

9. Eric L. Goldstein, "Between Race and Religion: Jewish Women and Self-Definition in Late Nineteenth Century America," in *Women and American Judaism: Historical Perspectives*, 182–200.

10. See discussion in introduction that sites Golomb, Rogow, and Wilhelm's research. Discomfort with proselytizing women is a likely ingredient in what Sarah Wilkerson-Freeman describes as a "fundamental tension" between Jewish and Protestant clubwomen. "On many levels, their lives were separate from those of their gentile neighbors. . . . [They could not] share community rituals of the evangelical, charismatic Christian movements. . . . [Their] faith also kept them outside such powerful organizations as the Women's Christian Temperance Union and the Young Women's Christian Association, but common social agendas led them to form coalitions with these same groups." Wilkerson-Freeman, "Two Generations of Jewish Women," 3–6.

11. Joyce Antler, *The Journey Home: How Jewish Women Shaped Modern America* (New York: Schocken Books, 1997), 62.

12. Mrs. Joseph C. (Mary) Terrell, "The Texas Federation of Woman's Clubs," *Bohemian Worlds Fair Edition, Texas Past Present, Fort Worth, Texas*, 1904, p. 125.

13. Bernice Graziani, *Where There's a Woman: 75 years of History as Lived by the National Council of Jewish Women* (New York: NCJW and the McCall Corporation, 1967), 17.

14. *American Jewess*, April 1896, p. 380; Rabbi Kaufmann Kohler, a leading Reform Jewish leader who championed egalitarian worship, chastised Jewish women's clubs for their "morbid craving after non-Jewish speakers." *Southwestern* [Dallas] *Jewish Sentiment* (hereafter, SW *Jewish Sentiment*), October 18, 1901, p. 1.

15. "They couldn't become so comfortable as to completely assimilate into the surrounding culture," observes Deborah Weiner, "Jewish Women in the Central Appalachian Coal Fields," 13; "The role of gender segregation in maintaining social distinctions between Jews and non-Jews lasted well into the twentieth century," observes Goldstein in "Between Race and Religion," 186; See also Eric L. Goldstein, *The Price of Whiteness: Jews, Race, and American Identity* (Princeton and Oxford: Princeton University Press, 2006), 12–16.

16. Goldstein, "Between Race and Religion," 186–187, 198 fn10; In Chicago during the 1870s, German immigrants of all religions mixed in the mercantile world but not in recreational circles. This implies that Jewish women would have been even more isolated from interaction with non-Jews than were Jewish men. Avraham Barkai, *Branching Out: German-Jewish Immigration to the United States, 1820–1914* (New York: Holmes and Meier, 1994), 178; "Certainly the Jewish tradition of female entrepreneurship ran up against the modern middle-class notion that a woman's place was in the home. East

European Jews in America soon adopted middle-class norms that restricted married women to the domestic sphere." Deborah R. Weiner, *Coalfield Jews: An Appalachian History* (Urbana and Chicago: University of Illinois Press, 2006), 75–76.

17. Terrell, "The Texas Federation of Women's Clubs," *Bohemian Worlds Fair Edition*, p. 125; Mary P.Y. Terrell (1846–1920), born in Arkansas and raised in Marshall, taught for twenty-three years in East Texas public schools until 1887, when she married Joseph Christopher Terrell, a Fort Worth attorney and widower with five children. She was president of the TFWC from 1899–1901, a charter member of the Texas State Library Association, and was appointed to the first Texas State Library and Historical Commission. Handbook of Texas Online, s.v. Terrell, Mary Peters Young; accessed July 24, 2004, available online from <http://www.tsha.utexas.edu/handbook/online/articles/view/>.

18. By 1903, membership had expanded to fifty (a limit that remained in 2004). A two-thirds majority was initially needed for admission. By 1930, a three-fourths majority was required. Article IV of the club bylaws outlines a Byzantine system of balloting. "Should there be fewer than three names on the waiting list, no election shall be held. . . . [Should there be more,] the three receiving the greatest number of votes shall be declared the nominees. . . . Three-fourths of the votes [then cast by ballot] shall be necessary for election." Several rounds of balloting follow, with one candidate dropped after each round until but one name remains. "For the final round of balloting, members write 'yes' or 'no.' The nominee must receive three-fourths of the vote to be welcomed into the club." *Woman's Wednesday Club* minutes February 27, 1889; *Woman's Wednesday Club Year Book*, 1903–1904, 1907–1908, 1934–1935, 1997–1998; Karen J. Blair writes that the earliest woman's clubs were "selective in membership, with applications, screenings, and . . . even blackballs." The "exclusivity clearly smacked of social snobbery. . . . There was an aura of gentility and snobbery coupled with a commitment to serious study." Karen J. Blair, "Introduction" in *The Woman's Club of El Paso: Its First Thirty Years*, Mary S. Cunningham (El Paso: Texas Western Press, University of Texas at El Paso, 1978), xii.

19. "Mrs. Leon Gross is the only charter member still active in the club today and is the only honary [sic] life member." Chas. R. Fuller, "Music," 27, in Works Progress Administration (WPA) Papers, Federal Writers Project, Fort Worth, 1941, AR 316-3-7, University of Texas at Arlington Special Collections (hereafter, UTA Special Collections); "She had held every office except the presidency which she repeatedly declined." Frances Wallace, "Euterpean Club," in *A History of the Woman's Club of Fort Worth, 1923–1973*, ed. Marion Day Mullins (Fort Worth: The Woman's Club, 1973), 114–116; Families series, Leon and Edith Mayer Gross folder, Beth-El Congregation Archives (hereafter, Beth-El Archives), Fort Worth, Texas.

20. Dozens of social clubs proliferated, according to the society pages of the *Fort Worth Register*. Only clubs that joined the federated networks or that endured for a century are mentioned here. The Monday Book Club, for "single girls," formed in 1896. Fort Worth Clubs Yearbooks, Box 11, Monday Book Club folder, Genealogy and Local History Unit, Fort Worth Public Library (hereafter FWPL); "History of the Monday Book Club, Fort Worth, Texas, 1896–1946," loose-leaf binder, FWPL; The Penelope

Club (called Symposium Club until 1901) began in 1897. The Penelope had an annual Bible Day each December, which may explain why there are no Jewish women listed in its yearbooks from 1897 to the present. Fort Worth Clubs Yearbooks, Box 16, Penelope folder, FWPL; The Fort Worth Library Association formed April 25, 1892 with twenty women. A "Kooking Klub," evidence of interest in "domestic sciences," is mentioned in Risa Oglesby, "History of the Fort Worth Art Association" (M.A. thesis, Texas State College for Women, 1950), 2–3; The Bohemian Club, begun in 1898 to study Southern literature and creative writing, had no Jews among its staff or writers. Its 1904 World's Fair edition included separate profiles on Jewish haberdashers Nate and Jacob Washer. Nate's wife, Belle, was involved in early efforts to construct a public library. Jacob's wife, Rosa was a charter member of the Council of Jewish Women. "History of the Bohemian Club," *Bohemian Worlds Fair Edition*, pp. 181–83.

21. Proliferation of mothers' clubs and interest in child development led to creation in 1897 of the National Congress of Mothers, forerunner of the Parent Teacher Association.

22. McArthur, *Creating the New Woman* 55–56, 63; "Club Histories of First District, Texas Federation Women's Clubs: The Fort Worth Kindergarten Association, Fort Worth, Texas," *The Club Woman's Argosy*, vol. II, no. 3 (October 1908): 9, Sallie B. Capps Papers, GA 196, Folder 8, Printed Material, Correspondence, 1908–1924, UTA Special Collections.

23. Sarah V. Carb (1862–1920) taught in both public and Jewish religious schools. She became principal of the North Fort Worth Kindergarten and director of the Denver Avenue practice kindergarten. Ida Brown (1885–1967) was director of a practice kindergarten at Rosen Heights Elementary. Brown's father, David Brown, and Carb's brothers, Charles and Isidore, were founders of Beth-El Congregation and several other local Jewish institutions; *Kindergarten College Catalog, 1913–1914*, Tarrant County Historical Society Records, Series II, Box 5, Folder 35, Genealogy and Local History Unit, FWPL; Families series, "Carb, Charles and Mathilda Rosenbaum," and "Carb, Isidore and Hattie Kahn" folders, Beth-El Archives, Fort Worth.

24. *Fort Worth Kindergarten Training School Journal*, Jenkins Garrett Collection, GA 33, Box 33, Folder 1, UTA Special Collections; "Club Histories of First District, Texas Federation Women's Clubs," 9; Sallie B. Capps Papers, GA 196, Folder 8, "Printed Material, Correspondence, 1908–1924," UTA; *Fort Worth Record*, September 20, 1908, in WPA Papers, 1941, Box 5-8, AR 316-3-7, UTA; "The Kindergartens in Texas," *Bohemian Worlds Fair Edition*, p. 144; Price, "Development of Leadership by Southern Women," 53–54; McArthur, *Creating the New Woman*, 55–56, 63; Mary King Drew, *A History of the Kindergarten Movement in Texas, from 1886 to 1942*, booklet (Dallas: no publisher, ca. 1942); See also R.L. Paschal, "First Kindergarten Here in 1874; Women Organized to Get System Established," *Fort Worth Star-Telegram*, 26 May 1940, archives of Tarrant County Historical Commission; Margaret Casky, "Turning back page of FW history . . . ," *Fort Worth Press*, May 14, 1972, 19-A, archives of Tarrant County Historical Commission.

25. *Texas*, vol. 28, p. 202C, R.G. Dun & Co. Collection, Baker Library, Harvard Business School.

26. "Friends to Honor Attorney Sidney L. Samuels," *Fort Worth Star-Telegram* (hereafter *FW Star-Telegram*), December 15, 1957, Families series, "Samuels, Sidney L." folder, Beth-El Archives; B. Buckley Paddock, *History of Texas: Fort Worth and the Texas Northwest Edition* (Chicago: Lewis, 1922), 60–61; "Graduates of the University of Texas School of Law thru June 1943," typescript, compiled by Helen Hargrave, Law Librarian, Rare Book Section, University of Texas Law Library; Sidney Lionel Samuels maintained that his father was a Confederate captain, but he was a private. Sidney also declared himself a native Texan, although the 1870 census for Louisiana and the 1880 census for Texas list his birthplace as Louisiana.

27. Annye W. Samuels married Archer G. Dawson, a *Fort Worth Telegram* (*FW Telegram*) employee, in a ceremony officiated by district Judge Irby Dunklin. In attendance was Bertha Samuels's sister from Tyler, Regenia (Mrs. Jacob) Lipstate (who became president of Tyler's NCJW section in 1908). *FW Register*, December 1, 1901, p. 10; Historian Leonard Rogoff, who has chronicled Jewish settlers in North Carolina, notes that it was "not unnatural for early settlers to assimilate into the Christian community." Furthermore, "intermarriage with elite families points to social acceptance." Rogoff, *Homelands*, 21, 34.

28. "Funeral of Mrs. Bertha Samuels to Take Place Thursday at 10:30 A.M.," *FW Star-Telegram*, December 2, 1914, p. 3; "Mrs. Bertha Samuels Dies at Age of 63," December 2, 1914, *Dallas Morning News*, online archive; Julia Kathryn Garrett, *Fort Worth: A Frontier Triumph* (Fort Worth: Texas Christian University Press, 1996), 205; Bertrand "B. B." Samuels's marriage ended in divorce after he fled to New York in 1937 amid a banking scandal. News clippings are in the Families series, "Samuels, Jacob and Bertha Wadel," folder, Beth-El Archives; Tenth Census of the United States, 1880, Tarrant County, Texas, enumeration district 89, sheet 10, line 6.

29. The Monday Book Club, begun in 1896, added May Samuels to its roster in 1903. The group was essentially a "daughters club" for the Woman's Wednesday Club. Fort Worth Clubs Yearbooks, Box 11, Monday Book Club folder, Genealogy/Local History Unit, FWPL; "History of the Monday Book Club, Fort Worth, Texas, 1896–1946," loose leaf binder, FWPL.

30. *Fort Worth Record*, January 13, 1904, retyped, in WPA Papers, Box 5-8, UTA Special Collections.

31. Gertrude M. Teter and Donald L. Teter, *Texas Jewish Burials: Alphabetically by Name* (Baytown, Texas: Texas Jewish Historical Society, 1997) 156.

32. Max K. Mayer graduated from the University of Texas Law School in 1898. "Graduates of the University of Texas School of Law thru June 1943," typescript, Rare Book Section, University of Texas Law Library.

33. A visiting Jewish journalist in 1879 applauded the efforts of Sabbath school principal Joseph Mayer and reprimanded other parents for "laxity in teaching their children in the ways of Judaism." Louis Schmier, ed., *Reflections of Southern Jewry: The Letters of Charles Wessolowsky, 1878–1879* (Macon, Ga.: Mercer University Press, 1982), 119; For importance of lay people in establishing religious schools in remote communities, see Deborah R. Weiner, "Jewish Women in the Central Appalachian Coal Fields," 25; Rich-

mond's turn-of-the century rabbi, Edward Calisch, wrote that the "country Jew is a religious derelict rolling aimlessly on the sea of religious life. . . . [He] is in measure cut off from the house of his brethren . . . like the limb of a tree that no longer draws nourishment from a life-giving trunk." Quoted in Leonard Rogoff, "Synagogue and Jewish Church: A Congregational History of North Carolina," *Southern Jewish History* 1 (1998): 44, 51; Sherry Blanton, "Lives of Quiet Affirmation: The Jewish Women of Early Anniston, Alabama," *Southern Jewish History* 2 (1999): 43, 48; Jenna Weissman Joselit, "The Special Sphere of the Middle-Class American Jewish Woman: The Synagogue Sisterhood," in *The American Synagogue: A Sanctuary Transformed*, ed. Jack Wertheimer (New York: Cambridge University Press, 1987), 207–08.

34. See Appendix I for list of Fort Worth's NCJW charter members. Although Edith Gross and her mother, Amanda Mayer, are listed as "charter members" in the NCJW golden anniversary program, the *Fort Worth Register* article listing those who attended the first Council meeting does not include them. "50th Anniversary Dinner, Fort Worth Section, National Council of Jewish Women," October 24, 1951, program booklet, Box 1, Golden Anniversary folder, FW/NCJW Collection, Beth-El Archives; *Fort Worth Register*, November 3, 1901, p. 10.

35. Families series, "Gross, Leon and Edith Mayer" folder, Beth-El Archives; Telephone conversations with Beanie Weil, 1997–2004, notes in possession of author.

36. Stella (Mrs. William) Christian, *History of the Texas Federation of Women's Clubs* (Houston: Texas Federation of Women's Clubs, 1919), 4–5, 44. By 1899, Mary Terrell was state president, indicating the strength of the women's-club movement in Fort Worth; See also, Elizabeth York Enstam, *Women and the Creation of Urban Life: Dallas, Texas, 1843–1920* (College Station: TAMU Press, 1998) 99.

37. Clubs represented were, from Austin, the American History Club and Pathfinders Club; from Cleburne, the Magazine Club; from Corsicana, the Nineteenth Century Club; from Dallas, Standard Club, Pierian Club, Shakespeare Club, and Current Events Club; from Denison, XXI Club; from Denton, Ariel Literary Society; from Fort Worth, Woman's Wednesday Club and '93 Club; from Galveston, Wednesday Club; from Houston, the Woman's Club and the Ladies Reading Club; from McKinney, the Owl Club; from Sherman, the Shakespeare Club; from Terrell, the Social Science Club; from Tyler, Quid Nunc; and, from Waco, the Literary Club and the Woman's Club. Those that did not initially join were Austin's Pathfinder Club, Denison's XXI Club, Fort Worth's '93 Club, and Sherman's Shakespeare Club. "The Charter Clubs: 21 charter clubs represented at the Waco meeting May 13–14, 1897," fiftieth anniversary booklet, Mss. 32, TFWC Collection, Texas Woman's University.

38. Ibid., 11.

39. Megan Seaholm, "Earnest Women: The White Woman's Club Movement in Progressive Era Texas, 1880–1920" (Ph.D. diss. Rice University, 1988), 346.

40. Following the TFWC formation, the next fifteen clubs to join were, from Abilene, the XXI Club; from Waco, Woman's Press Club; from Oak Cliff, Quaero Club; from Georgetown, F.A.D. Club; from Lockhart, Irving Club; from San Marcos, Sororis; from Colorado City, Up-to-Date Club; from Vernon, Yamparica; from Tyler, The First

Literary Club, Twentieth Century Club, Shakespeare Club, and Athenian Circle; from Cleburne, Shakespeare Club; from San Antonio, History Club; and, from Waxahachie, Shakespeare Club. Other member clubs described in the text are, from Tyler, the Elizabethean [sic] Club; from Gainesville, XLI Club; from Ennis, Standard Reading; from Palestine, Self-Culture Club; and, from Dennison, XXI Club. Croly, *History of the Woman's Club Movement in America*, 1094–1107.

41. Enstam, *Women and the Creation of Urban Life*, 97; Wenger, "Jewish Women of the Club," 316.

42. Christian, *History of TFWC*, 28; Under the "Carnegie Formula," industrialist Andrew Carnegie agreed to underwrite a public library if the municipality pledged an annual subsidy equal to ten per cent of the construction costs; accessed July 19, 2004, available online through <http://andrewcarnegie.tripod.com/carnformula.htm>.

43. Mrs. Nate M. [Belle S.] Washer (1870–1931) was listed as a charter member—but not a founding member—of the all-female Fort Worth Library Association (FWLA). *Dallas Morning News*, "Library Association Charter," April 25, 1892, online *Dallas Morning News* Archives. She and her husband, Nate, moved to San Antonio late in the century. In 1909 she became a founding member of the San Antonio NCJW. Her sister-in-law, Rosa Washer, was a charter member of the Fort Worth Council of Jewish Women; "New Library Will be Opened to the Public in a Few Days," *FW Register*, October 10, 1901, p. 5; "Carnegie Library Opens," *FW Register*, October 18, 1901, p. 8.

44. Oliver Knight, *Fort Worth: Outpost on the Trinity* (Norman: University of Oklahoma Press, 1953; reprinted, Fort Worth: Texas Christian University Press, 1990), 163–165.

45. Knight, *Outpost on the Trinity*, 85, 91, 95, 110; The mercantile pattern was replicated at railroad terminuses from coast to coast. As Rogoff notes in studies of Jewish settlers in frontier North Carolina, their "entrepreneurial energy very much fit the spirit" of a young state. "Jewish mercantilism harmonized with the . . . entrepreneurial culture." Rogoff, *Homelands*, 29, 64.

46. Knight, *Outpost on the Trinity*, 87.

47. *The Jewish Texans*, booklet (San Antonio: University of Texas Institute of Texan Cultures, 1984), 12.

48. Fort Worth City Directories, 1877–1890; Histories Box 1, Jewish-Owned Businesses folder, Beth-El Archives.

49. Caleb Pirtle III, *Fort Worth: The Civilized West* (Tulsa: Continental Heritage Press, 1980), 74–75.

50. Letter to editor, *American Israelite*, July 1, 1888; John Peter Smith also donated the acreage for Oakwood Cemetery in 1879. Cemetery box, Emanuel Hebrew Rest History folder, Beth-El Archives; Hollace Ava Weiner, *Beth-El Congregation Centennial: 1902–2002* (Fort Worth: Beth-El Congregation, 2002), 1–5.

51. "General and Jewish Immigration from Eastern Europe to the U.S., 1871–1920," Table 3 in Gerald Sorin, *A Time for Building: The Third Migration, 1880–1920, Jewish People in America* Vol. 3 (Baltimore: Johns Hopkins Univ. Press, 1992), 58.

52. "M. Samuels," listed on the congregation's 1893 roster, is presumably Jacob Samuels. For several subsequent years the original minutes list "J.A. Samuels." *Con-*

gregation Ahavath Sholom: 1892–1967 (Fort Worth: Ahavath Sholom, 1967), 10; David Brown's service on the Ahavath Sholom board is detailed in the minutes book covering 1898 to 1905. Yiddish Minutes Collection, Beth-El Archives.

53. Texas, and especially Fort Worth, was a far corner of the Diaspora. At the start of the twentieth century, Texas was the largest state geographically but had low concentrations of Jews — 15,000, or 0.5 percent of the state's population, compared with Ohio, which had 50,000 Jews (1 percent of its population) and New York, home to 400,000 Jews (5 percent of its residents). In 1900, Texas — which stretches 800 miles east to west and 1,000 miles north to south — had fifteen rabbis, twenty-five Jewish congregations, and forty Jewish organizations listed in the *American Jewish Year Book (AJYB)*. Fort Worth had one synagogue, no rabbi, a cemetery society, and approximately 100 Jewish families among its 26,000 residents. "Local Organizations," *AJYB* 2 (1900): 256–623; *AJYB* 3 (1900–1901): 463–75; Hollace Ava Weiner, "The Mixers: The Role of the Rabbi Deep in the Heart of Texas," *American Jewish History* 85 (September 1997): 315 fn129, fn130.

54. Galveston's Rabbi Shmuel Geller would not move his family to Fort Worth because his spouse, Sara Geller, "refused to even live in a community that did not have a mikvah. She held the strong conviction that all financial and material exigencies were secondary to the purity and *kedushah* [holiness] which her ethical and moral code demanded." Shmuel Geller, *Mazkeres Ahavah: Remembrance of Love* (Zichron Yaakov, Israel: Institute for Publication of Books and Study of Manuscripts, 1988), 36–37.

55. Hannah Solomon Scrapbook, Box X-172, Jacob Rader Marcus Center of the American Jewish Archives (hereafter, AJA), Cincinnati; *Jewish Messenger*, September 22, 1894, p. 4, quoted in Rogow, *Gone to Another Meeting*, 20–21.

56. Gerry Cristol, *A Light in the Prairie: Temple Emanu-El of Dallas, 1872–1997* (Fort Worth: Texas Christian University Press, 1998), 30, 43, 60–61, 270 fn19.

57. Caroll Smith-Rosenberg, *Disorderly Conduct: Visions of Gender in Victorian America* (New York: Alfred A. Knopf, 1985), 245–47.

58. Glazer and Slater, *Unequal Colleagues*, 7–8; for further discussion of single professional women, see Kathleen D. McCarthy, "Parallel Power Structures: Women and the Voluntary Sphere," 17, Kathryn Kish Sklar, "Who Funded Hull House?" 95, and Anne Firor Scott, "Women's Voluntary Associations: From Charity to Reform," 45, in Kathleen D. McCarthy, ed., *Lady Bountiful Revisited: Women, Philanthropy, and Power* (New Brunswick: Rutgers University Press, 1990); see also Evans, *Born for Liberty*, 161; When Rabbi Hyman G. Enelow once wrote Goldberg to congratulate her for entering into a "conjugal" arrangement, she responded, "It really is to laugh." Jeannette Miriam Goldberg to Dr. H.G. Enelow, Sept. 15, 1927, Ms. collection 11, Hyman G. Enelow Papers, Box 7, folder 12, AJA, Cincinnati.

59. Jeannette Miriam Goldberg, "Report of Miss Goldberg on Organizing," Proceedings of the Council of Jewish Women, Fourth Triennial Convention, Chicago, Illinois, December 5 to 12, 1905, p. 149.

60. "Jefferson, Texas," *Handbook of Texas Online*, cited July 17, 2004 <http://www .tsha.utexas.edu/handbook/online/articles/view/JJ/hgj2.html>. Journalist Charles Wessolowsky visited Jefferson in June of 1879 and observed that "our Israelitish brethren,"

who numbered approximately 150 people from twenty families, were remarkably pros-
perous and harmonious, regardless of ethnic background. "May their example of peace
and union be imitated by . . . our co-religionists at other places." He was astonished that
"a noble Jewish lady [Mrs. Eva Sterne]" had been appointed "Postmistress" by Presi-
dent Rutherford B. Hayes. The Jewish community was rehearsing an opera, "Esther,
the beautiful Queen." Wessolowsky said that he "will forever treasure up the parables
and wholesome teachings of our witty brother, Mr. Goldberg," who may have been
Jeannette's father, Louis, or her uncle, Hyman. Wessolowsky, *Reflections of Southern
Jewry*, 124–26.

61. "Resolutions. . . . Jewish Chautauqua Society," *Philadelphia Jewish Exponent*,
March 15, 1935, p. 3. The quote is repeated in plaque on wall, Jefferson's Hebrew Sinai
Congregation, quoted in Ruthe Winegarten and Cathy Schechter, *Deep in the Heart:
The Lives and Legends of Texas Jews* (Austin: Eakin Press, 1990), 113.

62. *Marshall Messenger*, May 8, 1909, quoted in Dorothy Craver, "The First One
Hundred Years: A History of the 1881 Study Club of Jefferson, Texas," p. 3, Historical
Files, Texas Federation of Women's Club Headquarters, Austin.

63. The Sunday newspaper singled out Goldberg for her "elegant" appearance in a
"delicate pink faille Francaise with drapery of pink crepe and moiré ribbon, corsage,
pointed V-shaped, sleeveless, long pink undressed kids, tied with pink moiré ribbon."
The bride, Louise Taylor, was elected president of the Texas Federation of Women's
Clubs in 1917 and served throughout World War I. The groom was Charles W. Connery.
Both were Jefferson natives. Both went to school in Boston, where the groom still resided.
Besides Goldberg, the wedding party included at least two other Jewish friends, ushers
A. R. Lipstate and L. Stern. "A Notable Wedding, Fort Worth Yields to the Bay State
One of her Most Charming Daughters," *The Sunday Mirror*, December 16, 1888,
Woman's Wednesday Club Scrapbook #1; Mrs. A. B. Case, "Biographical Sketch of
Mrs. C. W. Connery," in "History of Texas Federation of Women's Clubs, Period: (1917–
1931)" by Decca Lamar West, carbon copy of typescript, The Woman's Collection, Texas
Woman's University, Denton, Texas.

64. *Vassar Alumnae Biographical Register of 1939*, Dean M. Rogers, Special Collec-
tions assistant, Vassar College Library, e-mail message to Hollace Weiner, July 20, 2004.

65. Goldberg shared valedictory honors. Although her 95 percent grade point aver-
age was the highest, the class salutatorian, who scored 91 percent, argued that she de-
served top honors because Goldberg was a transfer student while she had attended
Rutgers for the full four years. The dispute got nasty when the challenger's attorney
threatened a lawsuit. According to the *American Israelite* and the New York *World*, the
school reached a compromise that allowed both women to deliver valedictory addresses.
The controversy served to publicize Goldberg's academic excellence as well as her re-
solve and fortitude. *American Israelite*, June 11, 1886, p. 1, col. 2; June 25, 1886, p. 9,
col. 3; The June 25 article cites the New York *World* as a source. New York City's Rutgers
Female Institute existed from 1839 to 1895.

66. Goldberg's Texas tombstone states that she was born on February 18, 1868. Teter,
Texas Jewish Burials, 131; However, several thumbnail biographical sketches give her

birth date as "ca. 1875." Jacob Rader Marcus, ed., *Concise Dictionary of American Jewish Biography*, vol. I (Brooklyn: Carlson Publishing Inc., 1994), 205; *American Jewish Year Book (AJYB)*, 7(1905–06): 62 and 37(1935–36): 256.

67. Jeannette Miriam Goldberg to Rabbi Max Heller, November 9, 1878, Ms. collection 33, Max Heller Papers, Box 2, folder 19, AJA, Cincinnati; J. M. Goldberg to Dr. H. G. Enelow, September 15, 1927, Ms. collection 11, Hyman G. Enelow Papers, Box 7, folder 12, AJA.

68. Penina Migdal Glazer and Miriam Slater, *Unequal Colleagues: The Entrance of Women into the Professions, 1890–1940* (New Brunswick and London: Rutgers University Press, 1987), 1–24, 209–46.

69. The Sherman school, better known by its later name, Kidd-Key College, had such a significant Jewish enrollment that school regulations stated that "all pupils except Jewesses must attend church on Sunday." Ruth O. Domatti, "A History of Kidd-Key College," *Southwestern Historical Quarterly* 63 (October 1959): 263–78.

70. *AJYB*, 7(1905–06): 62.

71. Goldberg was billed as a "National lecturer for the Jewish Council of Women" when she spoke at the 1909 TFWC conference. Her younger brother, Isaiah L. Goldberg, performed a piano duet with Miss Eva Eberstadt. Christian, *History of the TFWC*, 230; Music teacher Eva Eberstadt, whose father was president of Jefferson's Hebrew Sinai Congregation, is also mentioned in Wessolowsky's travel diary. Wessolowsky, *Reflections of Southern Jewry*, 125; Winegarten, *Deep in the Heart*, 67.

72. Jeannette Miriam Goldberg, "Report of the Tyler (Texas) Section," Proceedings of the Council of Jewish Women, Fourth Triennial Convention, Chicago, Illinois, December 5 to 12, 1905, pp. 149, 351.

73. The Dallas section's official history states that the chapter was begun in 1913. However, proceedings of earlier NCJW triennial conventions and accounts in the *SW Jewish Sentiment* reveal that an earlier Dallas section was founded in 1898. It thrived for several years, disbanding before the 1905 triennial convention. Miriam Jaffe, *National Council of Jewish Women, Greater Dallas Section, 1913–1988* (Dallas: NCJW, 1988); Proceedings of the Council of Jewish Women Third Triennial Convention, Baltimore, Maryland December 2–9, 1902; *SW Jewish Sentiment*, September 6–18, 1901; *History of Dallas Federation of Women's Clubs: 1898–1939*, 166–169; *FW Register* of November 3, 1901, p. 10, credits Goldberg with starting additional sections in Marshall, Palestine, and Corsicana. The *SW Jewish Sentiment*, October 5, 1901, p. 5, also mentions a Palestine section. These groups must have been short lived because they do not appear on lists included in national convention proceedings.

74. Although the Dallas section's official history states that the NCJW first organized there in 1913, news accounts, minutes of the Dallas Federation of Women's Clubs, and proceedings from early NCJW triennials reveal that a previous section, founded in 1898, thrived for several years. Rabbi Alexander Kohut, Mrs. L. M. Guggenheim, Miss Gloria Wormser, and Nora Wormser, according to the SW Jewish Sentiment, September 6–18, 1901, began the earlier section in 1898; in 1899, the Dallas NCJW planted trees in a Federation Memorial Grove. *History of Dallas Federation of Women's Clubs: 1898–1939*,

166–69; the section launched a junior division in 1901. Two Dallas men, "Mr. Sanger and Mr. Kahn," are listed as "$100 patrons" for the NCJW's 1902 Baltimore convention. The Dallas president in 1902 was Mrs. Morris Liebman and the secretary Miss Clara Woolstein. Proceedings of the Council of Jewish Women Third Triennial Convention, Baltimore, Maryland December 2–9, 1902; by the next triennial in 1905, the section was "out of existence." Nora Wormser, a founder of the original Dallas section, in 1919 revived a section in Sherman, a satellite city of Dallas. *1st Book of Minutes, Sherman-Denison Section National Council of Jewish Women,* July 13, 1919, AJA; The Dallas section's 1913 beginnings are detailed in Miriam Jaffe, *National Council of Jewish Women, Greater Dallas Section, 1913–1988* (Dallas: NCJW, 1988).

75. In the fall of 1901, Goldberg announced her intention to convene an organizing meeting in Gainesville following her Fort Worth sojourn. Gainesville, sixty miles north of Fort Worth on the border with Indian Territory, could not muster enough women to host a gathering, and Goldberg did not make the trip. Subsequently, the Jewish weekly reported "that Miss Jeannette M. Goldberg's noble effort to organize a Council of Jewish Women [t]here has not so far been successful. Expressions of disappointment at having lost the opportunity of listening to Miss Goldberg were heard on every side." *SW Jewish Sentiment* of October 25, 1901, p. 5, and November 15, 1901, p. 5; *FW Register,* October 13, 1901, p. 9; Four years later, at the Council's 1905 triennial, Goldberg discussed subsequent efforts to start and sustain a Gainesville section. Describing Gainesville as "a small circuit town with no one to lead them but themselves," she related, "[A]fter three years attempt . . . by correspondence . . . I decided to visit the town and present the work. They were responsive and immediately went into organization with a membership of 11." Unfortunately, the convention proceedings reported elsewhere that the Gainesville section "went out of existence" after one year. Goldberg was field secretary for the Council of Jewish Women at that time. In her report, she described visits to sections in Pine Bluff, Hot Springs, Little Rock, Huntsville, Birmingham, Mobile, Pensacola, Jacksonville, Macon, Savannah, and Louisville. "Report of Miss Goldberg on Organizing," *Proceedings . . . Fourth Triennial,* 1905, pp. 142–49.

76. "Discussion on Religion," *Proceedings . . . Fourth Triennial,* 1905, p. 110.

77. *FW Register,* October 13, 1901, p. 9.

78. "To Meet Miss Goldberg," *FW Register,* October 20, 1901, p. 9; *SW Jewish Sentiment,* October 20, 1901, p. 9, and October 27, 1901, p. 11.

79. *FW Register,* November 3, 1901, p. 10; *SW Jewish Sentiment,* November 3, 1901, p. 10.

80. The twenty-five women who initially enrolled, plus two others appointed to committees at the following meeting, are listed in Appendix A. They were named in the *FW Register,* November 3, 1901, p. 10, and November 10, 1901, p. 10; Elected officers were "Mrs. H. Brann, president; Mrs. [Tillie] Schloss, vice president; Mrs. Lee [Anna] Cohn, secretary, Miss Sara[h] Carb; treasurer." *SW Jewish Sentiment,* October 25, 1901, p. 5.

81. The Council's fiftieth anniversary booklet identifies thirty charter members. The list includes fourteen not mentioned in the initial newspaper articles and omits nine who were. Apparently, once the Council became a prestigious group, many women

wanted to bask in its prominence. Judging from the golden anniversary list, every woman involved in the Council's early years considered herself, and her mother, a charter member. "50th Anniversary Dinner, Fort Worth Section National Council of Jewish Women, October 24, 1951," booklet, NCJW Collection, Beth-El Archives.

82. *SW Jewish Sentiment*, August 2, 1901, p. 2; August 16, 1901, p. 4; August 30, 1901, p. 5; September 6–18, 1901, p. 17; September 20, 1901, p. 5.

83. Mrs. Theodore [Polly] Mack, "Report of Fort Worth Section," *Proceedings of the Fifth Triennial Convention*, Cincinnati, Ohio, December 1 to 10, 1908, pp. 288–89. Polly Mack, "Fort Worth," Proceedings of the Council of Jewish Women, Fourth Triennial Convention, Chicago, Illinois, December 5 to 12, 1905, pp. 149, 351.

84. Ibid.

85. The Atlanta NCJW section developed similarly in its first three decades. Wenger, "Jewish Women of the Club," 316; Sophia Brann and Sarah Carb were inducted into the Current Literature Club, according to the *FW Register*, February 16, 1902, p. 10; The next year, Brann is mentioned as being the club's president in the *FW Telegram*, February 1, 1903, p. 10.

86. Mrs. Flora [Weltman] Schiff, "History of the Jews of Fort Worth," *Reform* [Chicago] *Advocate*, January 24, 1914, pp. 1, 4.

87. Heppner Blackman (illustrator) and D.C. McCaleb, *Freshly-Made Heroes* (Fort Worth: Fort Worth Star, ca. 1908), 38–39.

88. Martin, "Hidden Work," 1–2, 27, 83, 195; "When the male members of Savannah's Mikve Israel hesitated to hire a rabbi, the women raised money and lent it out at interest." Bauman, "Southern Jewish Woman and Their Social Service Organizations," 44; Blanton, "Lives of Quiet Affirmation," 25–54; Money gave churchwomen "a controlling edge," notes Elizabeth Turner. "In a limited world where women were restricted on many. . . . fronts, there was might in having their own income . . . a sense of self-respect and a certainty that projects could be accomplished." Elizabeth Hayes Turner, *Women, Culture, and Community*, 85, 87.

89. David Kaufman, "Early Synagogue Architecture," in *California Jews*, eds. Ava F. Kahn and Marc Dollinger (Hanover, N.H.: Brandeis University Press/University Press of New England), 40.

90. Weiner, *Beth-El Congregation Centennial*, 17–26.

91. Mrs. Theodore [Polly] Mack, "Annual Report, Fort Worth Section Council of Jewish Women, May 6th 1907," Box 1, Annual Reports folder, FW/NCJW Collection, Beth-El Archives; Participation in the Fat Stock Show demonstrates what William Toll describes as easy "access to the town's commercial elite." Toll, "From Domestic Judaism to Public Ritual," 135; Construction of synagogues in Natchez and Galveston contributed to acceptance and prestige in the Bible Belt, where church participation was expected. Similar patterns across sectional lines highlight women's activism, fundraising ability, and influence, according to Bauman, "Southern Jewish Women and Their Social Service Organizations," 38, 64 fn40; *Galveston Daily News*, n.d., November 1866, in James Lee Kessler, "B.O.I., A History of Congregation B'nai Israel, Galveston, Texas" (Ph.D. diss., Hebrew Union College, 1988), 29.

92. *Fort Worth Telegram*, April 23, 1903, p. 1; May 10, 1903, p. 1; June 7, 1903, p. 1.

93. Besides Fort Worth, the Texas cities that staged mass meetings were Texarkana and Dallas. In Texarkana, Jeannette Miriam Goldberg and Rabbi Joseph Bogen spoke during a rally at Mount Sinai Congregation. In Fort Worth, "Governor [Fritz] Lanham wrote expressing his sympathy with the purpose of the meeting. A sermon on the Kishineff massacre was delivered by Rev. S. H. Werlein of the First Methodist Church." Cyrus Adler, ed., *The Voice of America on Kishineff*, microfiche (Philadelphia: The Jewish Publication Society of America, 1904) 75, 88 89, 201, 483; The Dallas gathering was a benefit performance at the Acme Family Theatre that was jointly sponsored by Shearith Israel, the traditional congregation, and the Young Men's Hebrew Social Club. It raised $227.80. "Kishineff Benefit: Performance at Acme Theater Sunday Night Nets the Sum of $227.80," May 28, 1903, *Dallas Morning News*, p. 12, online *Dallas Morning News* archives.

94. Congregation Ahavath Sholom minutes, May 10, 24, 31, 1903, and June 4, 1903, translated by Esther Winesanker, Ahavath Sholom Yiddish Minutes collection, 1903 folder, Beth-El Archives. A copy of the minutes is also on file at the Fort Worth Jewish Archives, Congregation Ahavath Sholom, and the AJA.

95. "Liberal Donations to Kishineff Fund," *Fort Worth Telegram*, June 5, 1903, p. 2.

96. Hollace Ava Weiner, "Removal Approval: The Industrial Removal Office Experience in Fort Worth, Texas," *Southern Jewish History* 4 (2000): 1–44.

97. Mrs. L. F. [Sarah Levy] Shanblum, "Ladies Hebrew Relief Society," in "Sketch of Jewish Institutions of Fort Worth," *Jewish Monitor*, September 10, 1915.

98. Mack, "Annual Report," 1907, FW/NCJW collection, Beth-El Archives.

99. Esther Shanblum Wexler, conversation with author, October 5, 2004.

100. Similarly in Seattle, the acculturation of the Scandinavian community contains parallels to Fort Worth. The first Scandinavians to settle in boomtown Seattle had lived elsewhere in the United States. Since Seattle was their place of second settlement, they knew the language and customs of America before arriving in the Pacific-coast city. When a fresh wave of Scandinavian immigrants landed in the port city in 1910, acculturation took place within Seattle. The newcomers were more ethnically conscious. They set up a distinctly Scandinavian enclave, with institutions, language, and dress that harked back to the Old Country. A similar pattern occurred in Fort Worth where the arrival East European immigrants increased the ethnic consciousness at Congregation Ahavath Sholom and sparked creation of the Ladies Hebrew Relief Society. Janice L. Reiff, "Scandinavian Women in Seattle, 1888–1900: Domestication and Americanization," in *Women in Pacific Northwest History: An Anthology*, ed. Karen J. Blair (Seattle: University of Washington Press, 1988), 170–184.

101. Hewitt observes that "the distinctive responses of working-class and more affluent Latins . . . help clarify both the degree to which gender served as a conduit for [philanthropy] and class served as a barrier to the flow of philanthropy across ethnic boundaries." Nancy A. Hewitt, "Charity or Mutual Aid?: Two Perspectives on Latin Women's Philanthropy in Tampa, Florida," in *Lady Bountiful Revisited*, 55–69.

102. "Within their own social stratum, these women were pleasantly inclusive, and

their clubs welcomed Jewish and Catholic members" whose families were among the local mercantile elite. In Dallas, the Sanger women were "privileged Jewish matrons" and "the very epitome of royalty." Enstam, *Women and the Creation of Urban Life*, 55–56.

103. *National Council of Jewish Women: Proceedings of the First Convention, November 15–19, 1896.* Philadelphia: Jewish Publication Society of America, 1897.

104. Ellen Sue Levi Elwell follows the factionalism and shows that by 1910 the NCJW had shifted from sectarian concerns to charity work. Elwell, "The Founding and Early Programs of the National Council of Jewish Women: Study and Practice as Jewish Women's Religious Expression" (Ph.D. diss., Indiana University, 1982).

CHAPTER THREE

1. "Free Immigrant Night School, organized 1907. Mrs. A. M. [Carrie] Friend president." *AJYB* 10 (1908–1909): 63; Polly Mack, "Annual Report," 1907, Box 1, Annual Reports folder, FW/NCJW Collection, Beth-El Archives.

2. Through the Americanization School, Jews were able to "reduce the 'otherness'" projected on them due to their religion, observes historian Seth Korelitz, adding, "NCJW members had their own status interests at least partially in mind when assisting East European immigrants." Seth Korelitz, "'A Magnificent Piece of Work': The Americanization Work of the National Council of Jewish Women," *American Jewish History* 83 (1995): 177–203.

3. Michael R. Olneck sees Americanization as "an effort to secure cultural and ideological hegemony through configuration of the symbolic order." Michael R. Olneck, "Americanization and the Education of Immigrants, 1900–1925: An Analysis of Symbolic Action," *American Journal of Education* 97 (August 1989): 399.

4. Josiah Strong, D.D., general secretary of the Evangelical Alliance for the United States, made frequent reference to perils of Romanism and Mormonism with few references to Jews. Strong attended a seminary in Cincinnati, home of the Jewish Reform movement. Apparently, Jews were not perceived as a problem in Cincinnati, where they were prominent, acculturated, and largely of German descent. Josiah Strong, *Our Country* (Cambridge, Mass.: Belknap Press of Harvard University Press, 1963), reprint of *Our Country: Its Possible Future and Its Present Crisis* (New York: Baker & Baylor Co. for the American Home Missionary Society, 1891), ix, xviii, xx–xxii, xxiv–xxv, 96–97.

5. Gere, *Intimate Practices*, 64.

6. Polly Mack, "President's Report," 1908, Box 1, Annual Reports 1908 folder, FW/NCJW Collection, Beth-El Archives.

7. "President's Report," 1908.

8. Galveston did not have an NCJW section until 1913. Its Ladies Hebrew Benevolent Association helped individuals on a case-by-case basis and was not a major player in the Galveston Plan that moved ten thousand Jewish immigrants through the port city between 1907 and 1914. For comprehensive information on the Galveston Movement, see Bernard Marinbach, *Galveston: Ellis Island of the West* (Albany: State University of New York Press, 1983).

9. Schiff, "History of the Jews of FW," *Reform Advocate*, p. 12.

10. Other groups sponsoring a day were Aid Societies of the Baptist Churches, Order of the Eastern Star, Aid Societies of the Methodist Churches, Aid Society of the Christian Science Churches, Atelier, Bohemian Club, Daughters of the Confederacy, Auxiliary of the Railway Mail Service, and Sorosis. Oglesby, "History of the Fort Worth Art Association," 16; In 1904, the Jewish women's council was among the hostesses at a Library show featuring antiques that local residents had loaned for an exhibit. "Loan and Art Exhibit," April 10, 1904, *Dallas Morning News*, p. 11, online *Dallas Morning News* archive.

11. The Fort Worth section was nearly nine years old at that point. It had made inroads into the community through its Americanization School, its potluck suppers, and its donations to local institutions. The Council was proving itself a vehicle for involvement in the larger community. Beth Wenger, in her study of Atlanta's Jewish women during the early decades of the twentieth century, also found the NCJW to be a catalyst for integration into the mainstream. She notes regional difference between North and South. Southern women were a significantly smaller proportion of the populace, yet Atlanta women "established organizational ties with non-Jewish women at a surprisingly early stage in their club development, a move rarely paralleled in the North." What she observed in Atlanta was replicated in Fort Worth as the NCJW participated wholeheartedly in the Fort Worth Federation of Women's Clubs. Wenger, "Jewish Women of the Club," 312.

12. Clubs included Woman's Wednesday, '93, Monday Book, Euterpean, Kindergarten Association, Symposium (later called Penelope), and the Woman's Progressive Club. *The Scimitar*, n.d. 1900, p. 4, WWC Scrapbook #1, FWWC Archives; By the winter of 1902, it also included the Kensington Club and the Cooperative Magazine Club. *FW Register*, February 16, 1902, p. 9; "Federation's Activities Date Back 35 Years," *Fort Worth Press*, December 9, 1932, p. 18.

13. "Federation's Activities Date Back 35 Years," *FW Press*, December 9, 1932, p. 18.

14. *The Scimitar*, n.d. 1900, p. 2, WWClub Scrapbook #1, FWWC Archives; "The entertainment Committee of the Federation is to meet with Mrs. Winfield Scott's committee to entertain the Cattlemen." *FW Register*, February 16, 1902, p. 9; One week later, the women voted to "protest the bull fight at the Cattlemen's Convention." Ibid., 23 February 1902, p. 9.

15. *FW Register*, March 23, 1902, p. 11.

16. The Chicago Woman's Club, founded in 1876, voted in 1883 to become a "department club" engaged in "practical work." The club created six departments, with each club member required to serve in one. The club successfully pushed to keep the Chicago World's Fair open on Sundays; it introduced kindergartens to Chicago's public schools; it organized a Protective Agency of Women and Children, a Physiological Institute, a Society of Physical Culture and Correct Dress, a Chicago Political Equality League, and a Public School Art Association. The Woman's Club of Denver, which turned into a department club in 1894 after women received state suffrage, enrolled two hundred members in a parliamentary law class; gave women elocution lessons so that they could project their voices to an audience of seven hundred people; persuaded the

legislature to appropriate money for the state library; printed five hundred copies of an abstract of state laws affecting property rights for women, then lobbied to change them. The Denver club also gave police copies of "nuisance ordinances . . . so they would be more intelligent about enforcing them." The women placed "anti-expectoration notices" in public buildings, elevators, and streetcars. Croly, *History of the Woman's Club Movement*, 62–72.

17. *FW Register*, May 18, 1902, p. 9; Enstam, *Women and the Creation of Urban Life*, 178.

18. *FW Register*, May 18, 1902, p. 9; May 25, 1902, p. 10; June 15, 1902, p. 10; Fort Worth women were apparently not as prepared as Chicago or Denver clubwomen to make the department club idea work. Croly observed that "it took time to educate members up to the required degree of courage and experience" necessary for reform work. Croly, *History of the Woman's Club Movement*, 66, 71–72; The Woman's City Club of Cincinnati, begun in 1915, fits the definition of a department club. It was started with assistance from Chicago clubwomen. Andrea Tuttle Kornbluh, *Lighting the Way . . . The Woman's City Club of Cincinnati, 1915–1965* (Cincinnati: Woman's City Club, 1986), 1–14.

19. *FW Register*, June 15, 1902, p. 10.

20. Ibid.; *FW Telegram*, September 12, 1902, Society sec., p. 1; December 14, 1902, p. 13; January 4, 1903, pp. 10–11; January 11, 1903, p. 9; January 18, 1903, p. 10; January 25, 1903, p. 19; February 8, 1903, p. 10; September 27, 1903, p. 14; October 11, 1903, Society sec., p. 1; "The Department Club of Fort Worth," *Bohemian Worlds Fair Edition*, p. 129.

21. The official history of the Fort Worth Woman's Club states that the city Federation reorganized in 1905. Mrs. T. Gordon Ryan, "Fort Worth Federation of Women's Clubs," in *A History of the Woman's Club of Fort Worth, 1923–1973*, ed. Marion Day Mullins, 116; However, the *Fort Worth Press* gives the reorganization year as 1906. "Between the period of Mrs. [J. C.] Berney's administration [1900] and 1906, the federation did not function." "Federation's Activities Date Back 35 Years," *FW Press*, December 9, 1932.

22. Minutes, Fort Worth Federation of Woman's Clubs (hereafter, FWFWC), May 5, 1910, Mss 423, FWFWC Collection, unsorted materials, The Woman's Collection, Texas Woman's University (hereafter, TWU), Denton, Texas.

23. Minutes, May, 11, June 2, June 17, July 7, October 6, 1910, FWFWC, Mss 423, The Woman's Collection, TWU, Denton, Texas; Jarvis's husband's health was in decline, and she withdrew from clubwork to care for him.

24. Minutes, November 1910, FWFWC, Mss 423, The Woman's Collection, TWU, Denton, Texas.

25. "Program, Council of Jewish Women, Fort Worth Section, 1910–1911," NCJW Yearbooks box 1, FW/NCJW Collection, Beth-El Archives.

26. Minutes, October 6, November 3, November 11, 1910, and January 5, February 2, March 2, April 6, and May 4, 1911, FWFWC, Mss 423, The Woman's Collection, TWU, Denton, Texas.

27. Mullins, *History of the Woman's Club of Fort Worth*, 116–17.

28. Minutes, May 4, 1911, FWFWC, Mss 423, The Woman's Collection, TWU, Den-

ton, Texas; Annual Report Fort Worth City Federation of Women's Clubs, 1918–1919, Mss 423, The Woman's Collection, TWU, Denton, Texas.

29. Minutes, December 1, 1910, FWFWC, Mss 423, The Woman's Collection, TWU, Denton, Texas.

30. Mrs. J. [Ida] Goldgraber, "Fort Worth Section," in *Council of Jewish Women Official Report of the Ninth Triennial Convention, Denver, Colo., November the Seventh to the Twelfth, 1920,* pp. 316–317; By 1920, the FWFWC included twenty clubs and seventy-two individual members. 1920–1922 Minutes Book, FWFWC, Mss 423, The Woman's Collection, TWU, Denton, Texas.

31. "Fort Worth NCJW Annual Report," May 16, 1918, Box 1, Annual Reports 1918 folder, FW/NCJW Collection, Beth-El Archives; When the Federation updated its Articles of Association to conform to state law, Mack's spouse, attorney Theodore (Theo) Mack, handled the paper work. The legal document includes the signatures of Polly Mack, who was Federation recording secretary, and Tillie Schloss, Council president. "Charter of The Ft. Worth Federation of Women's Clubs," May 17, 1916, Mss 423, The Woman's Collection, TWU, Denton, Texas.

32. "She drove an electric coupe that was all glass, like a moving aquarium. It steered with a tiller, like a boat," recalled Frances Rosenthal Kallison, whose father and uncles were among the founders of Fort Worth's Beth-El Congregation. "Reminiscences," accessed October 12, 2004, available online from Beth-El Brotherhood at <http://www.bethelfw.org/past/reminisces.htm>.

33. Minutes, May 22, and June 26, 1911, FWFWC, Mss. 423, The Woman's Collection, TWU, Denton, Texas.

34. "Annual Report Fort Worth City Federation on Women's Clubs. 1918–1919," Mss 423, The Woman's Collection, TWU, Denton, Texas.

35. Ann Arnold, *A History of the Fort Worth Medical Community* (Arlington: Landa Press, 2002), 101.

36. "Notable among the projects started under the leadership of Mrs. Theodore Mack was the founding of what was called the Fort Worth Baby Hospital, which was built on a site in what is now Park Hill." "Mack," p. 3, in Sesquicentennial Book Proposal folder, Jewish Sesquicentennial Papers, Beth-El Archives; Winegarten, *Deep in the Heart,* 114, erroneously credits Polly Mack with both the Baby Hospital and organizing Fort Worth's NCJW section, which started a year before she moved to the city.

37. Norma Mack, who moved to Fort Worth after her marriage in 1932, described the Baby Hospital as her mother-in-law's pet project. Norma Mack presumed that the NCJW started the hospital. She recalled that the hospital board enforced a nondiscriminatory policy that kept beds open to all needy children, regardless of race. "We wanted to take in any kind of babies, black and white. We didn't specify blacks. We just said 'all children.'" Norma Mack recalled being present at unsuccessful merger talks with the W. I. Cook Memorial Hospital, founded in 1929. One of the sticking points was a line in the donor's bequest that Cook Hospital be restricted to white working girls. Norma Mack interview with author, June 9, 2003, notes in possession of author.

38. Ibid.

39. Sioux Campbell, "Fort Worth Children's Hospital," WPA, 1936, microfiche, pp. 17766–75; *FW Star-Telegram*, October 11, 1959, sec. 3, p. 20.

40. Polly Mack, "Annual Report," May 1918, Box 1, Annual Reports 1918 folder, FW/NCJW Collection, Beth-El Archives; presumably the physician to whom she refers is Dr. Frank Beall, whose wife was president of the History Club in 1914. The U.S. Census for 1920 also lists another Fort Worth physician with the same surname, Kleeber Beall, M.D.

41. Oglesby, 18; Ida Simon was born in 1886 and immigrated to the United States in 1897. U.S. Census, Texas, 1910, online at Heritage Quest.

42. The glamorous Eva Potishman Brown was the daughter of East European immigrants and the aunt of future Fort Worth mayor Bayard Friedman. After her husband's death, she moved to Hollywood to give voice lessons to the stars. Families series, "Potishman" folder, Beth-El Archives; The TFWC convention was at the Westbrook Hotel. Christian, *History of the Texas Federation of Women's Clubs*, 277.

43. "University Women Organized 20 Years Ago," *Fort Worth Press*, March 17, 1923, p. 12; *Annual Directory of Women's Organizations, Fort Worth Texas* (Fort Worth: FW League of Women Voters, May, 1928).

44. This accusation of being "too assimilationist" was often uttered in conversations between the author and NCJW members who belong to Ahavath Sholom, the traditional synagogue. Roz Rosenthal recalled Dora Ginsberg, who was active in Hadassah, chiding her: "Why don't you people do something for Israel?" Rosalyn Gross Rosenthal, interview with author, October 22, 2003, notes in possession of author; Carol Minker recalled that when she was growing up "there was such a line between the shul and the temple people. You had your Hadassah group and you had your Council group. They may have thought we were 'heathens.'" Carol Minker, interview with author, January 15, 2004, notes in possession of author; Leslye Urbach, NCJW president from 1992–1994, recalled Hadassah women reacting to the NCJW with hostility during a Calendar Clearing Committee meeting at which presidents of Jewish organizations met to make sure that they scheduled no competing events. The Hadassah women suggested that the Council should be working for Israel and other distinctly Jewish causes. Leslye Urbach, conversation with author, September 15, 2004, notes in possession of author.

45. "Auxiliary Due to Mark Date," *FW Star-Telegram*, November 26, 1965; *Congregation Ahavath Sholom, 5741/1980* (Fort Worth: Congregation Ahavath Sholom, 1980), 52; The organization later became the Ladies Auxiliary to Congregation Ahavath Sholom and was still functioning in 2007.

46. Bauman, "Southern Jewish Women," 50.

47. Mirroring the larger American scene, new clubs for women and for men proliferated within the Jewish community during the 1910s and 1920s. The *Jewish Monitor* mentions a Thursday Bridge Club, a Jazz Club, The Kadimah Circle, and a Once in a While Club that included Mrs. B. B. Samuels and Mrs. Theo Mack. Rabbi Abraham Abramowitz of Ahavath Sholom complained that there were "too many clubs." *Jewish Monitor*, Nov. 14, 1919, p. 8; He worked with Rabbi G. George Fox to "amalgamate" the Miriam Club, the S.O.F. club, and the Young Men's Hebrew Association into one

group—a Junior Council of Jewish Women, open to boys and girls ages sixteen and older. The Junior Council operated with an advisor from the senior Council. The boys quickly dropped out and revived the Y.M.H.A. The all-girl Junior group experienced periods of strength and weakness. Its officers, roster, and sometimes its programs are printed in NCJW yearbooks from 1928 to 1949. Nationally, the NCJW encouraged creation of Junior sections. In Fort Worth, Jewish women who organized new clubs generally maintained membership in the core voluntary groups, i.e. the NCJW, Hadassah, Sisterhood, and the auxiliary attached to Ahavath Sholom. A chapter of B'nai B'rith Women, which came to Fort Worth in 1959, is discussed in Chapters 4 and 5.

48. Bauman, "Southern Jewish Women," 50.

49. Putnam, *Bowling Alone: The Collapse and Revival of American Community*, 65–79, 116–133; Jewish women, by and large, continued to participate in multiple voluntary organizations until the 1980s, when many women began working fulltime outside the home.

50. Mullins, *History of the Woman's Club*, 6.

51. Kenneth T. Jackson, *The Ku Klux Klan in the City, 1915–1930* (New York: Oxford University Press, 1967), 84, 239; see also Charles C. Alexander, *Crusade for Conformity: The Ku Klux Klan in Texas, 1920–1930* (Houston: Texas Gulf Coast Historical Association, 1962); Norman D. Brown, *Hood, Bonnet, and Little Brown Jug* (College Station: Texas A&M University Press, 1984).

52. For a period in 1922, Fort Worth became Texas Klan headquarters. Klansmen from around the state poured into Fort Worth for a nighttime parade; the KKK sponsored a Klan Day at the Fat Stock Show, and in 1924 the KKK opened a $100,000 Ku Klux Klan Hall with a four-thousand-seat capacity. Jackson, *The Ku Klux Klan in the City*, 84, 239; A weekly Klan newspaper, *The American Citizen*, published in Fort Worth, boasted 25,000 readers.

53. *Jewish Monitor*, February 3, 1922, p. 8.

54. Ibid., May 12, 1922, p. 8.

55. *FW Star-Telegram*, February 25, 1990, p. 1.

56. Eli N. Evans, *The Provincials: A Personal History of Jews in the South* (New York: Simon & Schuster, 1976, reprint, Free Press Paperbacks, 1997), 38; Leonard Rogoff writes, "In small towns, especially, non-Jews welcomed Jewish neighbors but considered outsiders suspect. . . . Jewish racial identity has never been fixed—in the South or elsewhere—and it has been alloyed invariably with social, economic, and religious elements." He adds that Southern Jews' "numbers were too small to be consequential. Jews did not pose the same cultural or political challenge" in Durham or Fort Worth as they may have in Boston or New York, where they were visible and concentrated. Leonard Rogoff, "Is the Jew White? The Racial Place of the Southern Jew," *American Jewish History* 85 (September 1997): 225, 228; Steven Herzberg concludes in his study of Atlanta, "There is no indication that the Caucasian standing of Southern Jews was ever seriously challenged." Steven Herzberg, *Strangers within the Gate City: The Jews of Atlanta, 1845–1915* (Philadelphia: Jewish Publication Society of America, 1978), 229.

57. In Denver, the local NCJW was an active member of the reform-oriented

Woman's Club of Denver. Croly, *History of the Woman's Movement in America*, 264; In Cincinnati, the Council of Jewish Women was part of the Woman's Civic League. Kornbluh, *Lighting the Way*, 5, 10.

58. Woman's Club of Fort Worth yearbooks 1923, 1925.

59. Enstam, *Women and the Creation of Urban Life*, xvi.

60. Rogoff, "Is the Jew White?" 230.

61. Wenger, "Jewish Women of the Club," 329; Elizabeth Jameson also makes this point, writing that these women "pulled the wagon, so to speak." Elizabeth Jameson, University of Calgary, Jewish Woman's Archive Internet site, accessed May 8, 2004, available online from <http://www.storiesuntold.org/womens_roles/community_builder.html>.

62. Enstam, *Women and the Creation of Urban Life*, xix–xx.

63. "President's Report," 1918.

64. Ibid.

65. Enstam, *Women and the Creation of Urban Life*, 63.

66. Graziani, *Where There's a Woman*, 32–33.

67. This line of argument follows a pattern among American women that Sara Evans links back to the pre-Civil War peace movement. Evans, *Born for Liberty*, 170.

68. The Woman's Peace Party, founded in 1915 in the wake of The Hague's International Women's Congress, grew to 25,000 members. Suffragist Carrie Chapman Catt chaired its platform committee. Socialists and radicals, who decried WWI as a contest among capitalists, joined the party, leading red-baiters to accuse the party of guilt by association. The party changed its name to the Women's International League for Peace and Freedom (WILPF). In 1925, Carrie Catt "guided creation of a broad peace coalition that excluded the [tainted] WILPF." Evans, *Born for Liberty*, 170–171, 190–91; Rogow, *Gone to Another Meeting*, 179, identifies the government body as the Department of Defense; however, it was still called the War Department. Rogow writes that the spider-web chart identified twenty-nine organizations, when in fact it named seventeen groups and twenty-one leading women reformers. Carrie Chapman Catt, "Poison Propaganda," *The Woman Citizen* (May 31, 1924): 14, 32–33, accessed July 27, 2004, available online from http://womhist.binghamton.edu/wilpf/doc4.htm; the spider-web chart is reproduced on the Internet. See Document 3: Lucia Maxwell, "Spider Web Chart: The Socialist-Pacifist Movement in America," *Dearborn Independent*, 24 (March 22, 1924): 11, accessed July 27, 2004, available online from http://wwwomhist.binghamton.edu/wilpf/doc3.htm; The NCJW's official history describes NCJW involvement in the peace movement without referring to the controversy. Campbell, *The First Fifty Years*, 69.

69. (Mrs. H. H.) Sophia Miller, "President's Report," and "Bylaws, Article IX," *FW NCJW Year Book* (1928–29): 13, 36, Yearbook Box 1, FW/NCJW Collection, Beth-El Archives.

70. Mrs. S. J. [Beatrice] Shaffran, "President's Annual Report," *FW NCJW Year Book* (1931–32): 15.

71. The Council's expenses for Jeanette Rankin's appearance were $16.50. Mrs. Harry [Libby] Ginsberg, "President's Annual Report," *FW NCJW Year Book* (1932–33): 13.

72. *Council Newsletter* (October 1935): 20–22, quoted in Rogow, *Gone to Another Meeting*, 180.

73. Mrs. Melvin F. [Lillian] Adler, "President's Report," *FW NCJW Year Book* (1938–39): 22.

74. Norma Mack interview.

75. Sophia (Mrs. H. H.) Miller, "President's Report," *FW NCJW Year Book* (1940–41): no page numbers.

76. (Mrs. Benjamin Edwin) Tobia M. Ellman, "President's Report," *FW NCJW Year Book* (1942–43): unnumbered pages; Two months after the U.S. entry into the war, one patriotic member introduced a motion to "dispense with serving of luncheons at our regular meetings." The proposal, described as a "matter of 'ration points,'" went down to defeat. FW NCJW Minutes Book, February 1, 1943, FW/NCJW Collection, Beth-El Archives.

77. "Quite an innovation was the Sewing Circle, organized under the auspices of the Council of Jewish Women last Monday afternoon. Twenty-four ladies attended the first meeting and over a dozen nightgowns were cut out and taken home. The efforts of the circle will be directed toward making garments for poor and orphaned children. Mrs. H. I. [Julia] Pincus has wanted to organize the circle for years and this year she has met with unusual enthusiasm . . . as the attendance will testify. . . . The Council purchased a sewing machine and Mrs. Morris [Ida] Fred offered the use of her machine." *Jewish Monitor*, November 21, 1919, p. 2.

78. "Women move beyond caring for their own . . . and alter boundaries of the 'private, female sphere.'" Enstam, *Women and the Creation of Urban Life*, 176, 178.

79. Bernice "Beanie" Weil, series of interviews with author, 1996–2004, notes in possession of author.

80. Enstam, *Women and the Creation of Urban Life*, 112–13.

81. Beanie Weil interviews.

82. Sarah P. Horwitz, "President's Report," *FW NCJW Year Book* (1941–42): no page numbers.

83. (Mrs. Benjamin Edwin) Tobia M. Ellman, "President's Report," *FW NCJW Year Book* (1942–43): n.p.n.

84. *Put Yourself in this Picture: Join Council*, booklet (New York: NCJW, 1958).

85. (Mrs. Abe M.) Amelia Rosenstein, "President's Report," *FW NCJW Year Book* (1944–1945); (Mrs. Abe M.) Amelia Rosenstein, "President's Report," *FW NCJW Year Book* (1945–1946); (Mrs. Bernard) Leonora W. Goldstone, "President's Report," *FW NCJW Year Book* (1946–47); (Mrs. Bernard) Lenore [sic, Lenora] W. Goldstone, "President's Report," *FW NCJW Year Book* (1947–48): 20; (Mrs. Maurice) Pearl J. Rabinowitz, "President's Report," *FW NCJW Year Book* (1948–49): 17; (Mrs. Maurice) Pearl J. Rabinowitz, "President's Report," *FW NCJW Year Book* (1949–50): 16.

86. Margot Schwartz, conversations with author, March–August 2004. She served as Beth-El Sisterhood president from 1967–1969.

87. Rogow concurs: "In part the reputation of elitism is based on reality. . . . Council members always have been counted among America's wealthiest Jews. . . . Council's reputation as an elitist organization will not abate." Rogow, *Gone to Another Meeting*, 199.

88. "Citizenship After 16 Years," *FW Star-Telegram*, evening, April 21, 1964; Amelia Rosenstein's mother-in-law, Sarah Rosenstein, was a charter member of the Fort Worth section. The Americanization School closed in 1973 when Amelia Rosenstein retired.

89. Bernard Rosenstein, interview with author, November 18, 2003.

90. The booklet's author, social worker and NCJW administrator Cecilia Razovsky, visited the Fort Worth section in 1937 to discuss aid to German Jewish children. Cecilia Razovsky, *Making Americans* (New York: NCJW, 1938); *The Immigrant*, a monthly newsletter with updates on immigration statistics, U.S. Department of Labor policies, and NCJW's related activities, was published by NCJW's Department of Immigrant Aid from 1921 to 1930, with Cecilia Razovsky and Etta Lasker Rosensohn as co-editors. Selected issues from 1924 to 1926 are at the Klau Library, Hebrew Union College, Cincinnati; Razovsky directed NCJW's Service to the Foreign Born and during the Roosevelt administration was appointed to the Secretary of Labor's Committee to Investigate Conditions at Ports of Entry. Rogow, *Gone to Another Meeting*, 154, 174–75, 235, 251 fn78; Razovsky's Fort Worth visit is mentioned in Lillian Adler's "President's Report," *FW NCJW Year Book* (1938–39): 22.

91. Fort Worth NCJW Minutes, September 30, and November 4, 1940. FW/NCJW collection.

92. "Citizenship Helps Blot Out Concentration Camp," *FW Star-Telegram*, June 20, 1950, p. 1, 2.

93. Livia Schreiber Levine, interview with author, June 4, 2003, notes in possession of author.

CHAPTER FOUR

1. "Council Comments," February 1952, Scrapbook #1, FW NCJW Collection; Calendar in *FW NCJW Year Book* (1961–62).

2. Ruth Rapfogel, president of the NCJW from 1955–1957, became involved in Democratic Party women's groups that quietly integrated eating facilities and movie theaters. "Very few Jews were involved," she said. Her husband, Irv Rapfogel, was a founder of the Fort Worth chapter of the American Civil Liberties Union and was the local B'nai B'rith Lodge's representative to the Anti-Defamation League. Ruth Rapfogel, telephone interview with author, Chicago, Illinois, November 11, 2003, notes in possession of author.

3. Bill Hitch, "Drive Started to Provide Home for Pre-Delinquents," *FW Star-Telegram*, morning, March 18, 1955, p. 1.

4. "Impact of Television in Relation to Juvenile Delinquency," accessed 15 November 2003, available online from <http://www.ez-essays.com/free/1684.html>; Anthony Hwang, Emily Hansen, Rachel Lafond, and Paul Robinson, "Is Juvenile Delinquency and Aggression Produced by Permissive or Punitive Parenting: Re-evaluating 50 years of Research," presented at The American Association of Behavioral and Social Sciences National Convention, 2002, accessed November 15, 2003, available online from <http://www.aabss.org/journa12002/Hwang.htm>.

5. "Groups to Discuss Home for Pre-Delinquent Boys," *FW Star-Telegram*, morning, March 11, 1955, Council of Jewish Women envelope, *FW Star-Telegram* clipping files, UTA Libraries.

6. "Drive Started," *FW Star-Telegram*.

7. "Boys' Center Proposal Gets Bar's Approval," *FW Star-Telegram*, evening, May 3, 1955, Council of Jewish Women envelope, *FW Star-Telegram* clipping files, UTA Libraries.

8. "Drive Started," *FW Star-Telegram*.

9. Mary Sears, "Book Fair Is to Be Opened Here, Pioneer Palace will be Locale for Project to Help Youth Center," *FW Star-Telegram*, April 13, 1958, Council of Jewish Women envelope, *FW Star-Telegram* Library, Fort Worth, Texas; The Book Fair continued under NCJW sponsorship until 1996 when, due to the paucity of NCJW volunteers, it was jointly sponsored with Friends of the Fort Worth Public Library. Thereafter, the Friends became the sole sponsors. Friends of the Fort Worth Public Library to Mara Berenson, February 4, 1998, Local Projects Box, Book Fair 1996 Correspondence folder, FW/NCJW Collection, Beth-El Archives.

10. "Appeal of Jewish Women for Books Given Response," *FW Star-Telegram*, December 1, 1957, *FW Star-Telegram* Library.

11. "Book Fair Is to Be Opened," *FW Star-Telegram*, April 13, 1958, *FW Star-Telegram* Library.

12. The Peale book was *Stay Alive All Your Life*. Ibid. April 13, 1958.

13. Norma Harris Mack, NCJW president from 1949–1951, was the daughter-in-law of Pauline "Polly" Sachs Mack, president from 1905–1909 and 1917–1919, and the mother-in-law of Ellen Feinknopf Mack, president from 1973–1975. Norma Mack, interview with author, June 9, 2003, Interviews folder, FW/NCJW Collection, Beth-El Archives.

14. "I knew these women through the Symphony League. My husband [Karl Snyder, a professor at Texas Christian University] had done a program on Shylock and asked [Beth-El] Rabbi [Robert] Schur for help. Rabbi Schur spoke to sorority coeds, and I was an advisor, active in Panhellenic. In many ways, we intersected with the Jewish community." Marion Snyder, telephone interview with author, December 28, 2003, Interviews folder, FW/NCJW Collection, Beth-El Archives; Diane Reischel, "Librarian seeks treasure among Book Fair tomes," *FW Star-Telegram*, April 10, 1983, sec. C, pp. 1, 10.

15. George Dolan, "Still-aromatic barn vents a sweet smell of success," *FW Star-Telegram* morning, March 13, 1987, p. 1.

16. *Meacham's Fashion News*, vol. 1, no. 5 (April 1969): 1, 5, 8, 15, 18–20, 23, Local Projects box, Book Fair 1969 folder, FW/NCJW Collection, Beth-El Archives.

17. Cecil Johnson, "Evicted Book Fair Looking for a Home, FW Bargain Book Fair Loses Long-time Home," *FW Star-Telegram* evening, October 14, 1975, pp. 1, 2.

18. Cecil Johnson, "Jewish Women's Book Fair Is Accepted by Lena Pope Home," *FW Star-Telegram* evening, October 30, 1975, p. 1.

19. "Something that always fascinated me was the caliber of people who shopped at the Book Fair. We never had a bounced check!" Carol Minker, interview with author, January 15, 2004, Interviews folder, FW/NCJW Collection, Beth-El Archives.

20. "Juvenile Services," Tarrant County home page; accessed November 1, 2003, available online from <www.tarrantcounty.com/juvenile/cwp/view.asp?a=672&q=419828>.

21. Scott, *Natural Allies: Women's Associations in American History* (Urbana and Chicago: University of Illinois Press, 1992), 3.

22. Blair, *Clubwoman as Feminist*, 119.

23. Rosalyn (Roz) Gross Rosenthal and Amy Jacobs Stien, interview with author, October 22, 2003, Interviews folder, FW/NCJW Collection, Beth-El Archives; "National Council of Jewish Women: Local Projects," flyer, July 8, 1970, Local Projects Box, Projects Summary/Bus Tour of Agencies folder, FW/NCJW Collection, Beth-El Archives.

24. Lilaine Goldman was the NCJW representative to the Bluff Street Day Care Center board and the driving force behind formation of the county Day Care Association, which remained a viable institution in 2007. She also founded a local Jewish summer day camp, Camp Shalom, and a nonsectarian preschool that bears her name. Goldman became the NCJW's regional president in 1960. Families series, "Goldman, Lilaine and Bernard" folder, Beth-El Archives.

25. Mary Dublin Keyserling, *Windows on Day Care: A Report Based on Findings of the National Council of Jewish Women on Day Care Needs and Services in Their Communities* (New York: NCJW, 1972).

26. Texas NCJW sections were located in Corpus Christi, the Greater Dallas area, El Paso, Fort Worth, Houston, San Antonio, Seguin, Sherman-Denison, Waco, Bay Area (which included Galveston and Baytown), and the Tri-County region between Austin and Houston. Tri-County members came largely from Schulenburg and LaGrange in Fayette County, from Columbus in Colorado County, and from Halletsville in Lavaca County. Graziani, *Where There's a Woman*, 125.

27. Mrs. Theodore [Ellen] Mack, "'Windows on Day Care: A View of the Day Care Situation in Tarrant County as Seen by a Committee of the Fort Worth Section, National Council of Jewish Women,' report in coordination with a National Study for the White House Conference on Children and Youth," 1970, Local Projects Box, Windows on Day Care folder, FW/NCJW Collection, Beth-El Archives.

28. They gained entrée to some day-care facilities by substituting for employees taking training classes at Tarrant County Junior College, according to "Book Fair Opens April 10," *FW Star-Telegram*, April 13, 1975; Mack, "Windows on Day Care."

29. Ibid.

30. Ibid.

31. Nancy Woloch, *Women and the American Experience*, second edition (New York: McGraw-Hill, Inc., 1994), 526–27.

32. Nixon vetoed the 1972 Comprehensive Child Development Bill that was an outgrowth of the White House Conference on Children and Youth. The bill would have provided a nationwide network of day-care centers. Woloch notes that as late as 1973, the *New York Times* editorial page questioned the wisdom of widespread day-care centers in an editorial headlined "It's Fine for Mother, but What about the Child?" Woloch, *Women and the American Experience*, 526–27.

33. LaRue Glickman Glazer, Dallas, telephone interview with author, November 11, 2003.

34. Rapfogel interview.

35. Betty Friedan, *The Feminine Mystique* (New York: W.W. Norton & Company, Inc., 1963).

36. Sally Armstrong, New York City, telephone interview with author, October 15 and 26, 2004; Dorothy DuBose, Boulder, Colorado, telephone interview with author, October 21, 2004. Notes in possession of author.

37. Katie Sherrod, Fort Worth, telephone interview with author, October 16, 2004, notes in possession of author.

38. Dubose interview; Journalist Gloria Steinem was among the founders of *Ms.* magazine, which began as a special issue of *New York* magazine, at which she was a staff writer. In 1972, Texas legislator Frances "Sissy" Farenthold narrowly lost the Democratic nomination for governor in a runoff. That same year, at the Democratic Party's national convention in Miami, Farenthold became the first woman to have her name placed in nomination for U.S. vice president. She came in second with four hundred votes.

39. Armstrong interview; Sherrod interview; Dubose interview.

40. Armstrong interview.

41. Ralph D. Mecklenburger to author, e-mail, November 11, 2004, Interviews folder, FW/NCJW Collection, Beth-El Archives.

42. *Life* put the "lag time" at twenty-five years. "Special Issue: The American Woman, Her Achievements and Troubles," *Life*, December 24, 1956, pp. 112–13.

43. Jerry L. Rodnitzky, *Feminist Phoenix: The Rise and Fall of a Feminist Counter-culture* (Westport, Ct.: Praeger, 1999), 4.

44. Esther Winesanker, interview with author, November 12, 2003, Interviews folder, FW/NCJW Collection, Beth-El Archives.

45. Sherrod interview; The NCJW's first grant to the Women's Center in 1981 was for "Pathways to Business," an employment program. By then, the agency included the Rape Crisis Program. The NCJW did not contribute to that program. By dint of its donations to Women's Haven and the Women's Center, the NCJW nominated one director to each agency's governing board. *FW NCJW Year Book* (1982–83): 5, 11, and (1983–84): 12.

46. Evans, *Born for Liberty*, 261.

47. Evans, *Tidal Wave*, 91–92; Evans, *Born for Liberty*, 290. Anne Ruggles Gere, *Intimate Practices: Literacy and Cultural Work in U.S. Women's Clubs, 1880–1920* (Urbana and Chicago: University of Illinois Press, 1997), 7.

48. Series I, Box 31, NCJW Board Meetings, 1971–1977, NCJW National Collection, LOC; Sarna's reference is to Orthodox women who made giant strides yet "in many cases eschewed the controversial 'f-word' (feminism)." Sarna, *American Judaism*, 344.

49. Mrs. Theodore Mack, "Prayer," in *FW NCJW Year Book* (1934–35): 7; Polly Mack, the section's matriarch, was a three-term president and originator of the section's Memorial and Happy Day Committee. She was named "honorary president" in 1922. She served as first-vice president of the State Conference of NCJW and became a life member of the Fort Worth Woman's Club. *Who's Who in American Jewry*, vol. 3, 1938–1939, ed. s.v. "Mack, Pauline Sachs."

50. Pauline S. Mack, "Prayer," *FW NCJW Year Book* (1978–89): 1.

51. "American Woman," *Life*, pp. 112–13.

52. Minker interview.

53. Dorothy Diamond Winston, interview with author, November 15, 2003, Interviews folder, FW/NCJW Collection, Beth-El Archives.

54. Mack interview; Winston interview.

55. Stien interview.

56. Winston interview.

57. New York debutante Mary Harriman started the Junior League, "where the blood was blue and the gloves were as white as the members." Alex Witchel, "Tacos, Stir-Fries and Cake: The Junior League at 102," *New York Times*, October 13, 2003, Dining sec., pp. 1, 6; Hollace Weiner, "Junior league members say they want to reach out to minorities," *FW Star-Telegram*, February 22, 1987, sec. C, p. 1; Janet Gordon and Diana Reische, *The Volunteer Powerhouse* (New York: Rutledge Press, 1982).

58. Louise Kuehn Appleman, telephone conversations with author, July 10, 2003 and June 7, 2007, notes in possession of author.

59. Appleman and Greenman also became the first and second women to serve as presidents of the city's Reform synagogue. Appleman's term was 1987–1989 and Greenman's was 1999–2001. Hollace Ava Weiner, *Beth-El Congregation Centennial*, 24.

60. Pauline Landman Wittenberg, conversations with the author, 2002–2004, notes in possession of author.

61. Council Sabbath, which was established by the national organization in 1920, was the Friday or Saturday preceding the holiday of Purim, which celebrates the story of Queen Esther. Members "often led or took active roles in the worship services of their individual congregations" with the long-term goal that "women's occasional presence on the pulpit would become commonplace." Rogow, *Gone to Another Meeting*, 65, 74; In Fort Worth, minutes, calendars, and annual reports first refer to a Council Sabbath in 1945. At that time, the *rebbitzen*, or rabbi's wife at Ahavath Sholom, Bess Graubart, was an officer on the NCJW executive board. Council Sabbath often alternated years between Beth-El and Ahavath Sholom. Once or twice, there were enough members and interest at Ahavath Sholom for both institutions to stage Council Sabbaths simultaneously. *FW NCJW Year Books* (1944–62).

62. Bauman, "Southern Jewish Women," 50.

63. Wittenberg interviews.

64. Nancy Webman, "Tanglewood still torn over park dispute," *FW Star-Telegram*, March 26, 1977, p. 1; Jimmie Cox, "Local Tranquility Worth Preserving," *FW Star-Telegram*, April 2, 1977, Carol Minker papers, Tanglewood Playground 1977 folder, FW/NCJW Collection, Beth-El Archives; Winston interview.

65. Ruth Roper, president, et al., to Concerned Council Members, March 28, 1977, Carol Minker papers, Tanglewood Playground 1977 folder, FW/NCJW Collection, Beth-El Archives.

66. "Council Says Bias Not Issue," *Fort Worth Star-Telegram*, March 27, 1977, Carol Minker Papers, Bicentennial Playground 1977 folder, FW/NCJW Collection, Beth-El Archives.

67. Sarna, *American Judaism: A History* (New Haven: Yale University Press, 2004), 318; Jack Wertheimer, *A People Divided: Judaism in Contemporary America* (New York: Basic, 1993), 29.

68. Sociologist Cynthia Fuchs Epstein, among others, credits *The Feminine Mystique* with providing "the ideological underpinning for a (new) woman's movement." Cynthia Fuchs Epstein, "Ten Years Later: Perspectives on the Woman's Movement," *Dissent* 22 (Spring 1975): 169.

69. Fannette Bronstein Sonkin, telephone interview with author, October 1, 2003, Interviews folder, FW/NCJW Collection, Beth-El Archives.

70. Rosenthal interview.

71. When Amy Stien was elected Council president in 1967, her married name was Scharff. She worked full time at the Jewish Federation for a decade.

72. Amy Scharff, "President's annual Report," *FW NCJW Year Book* (1969–70): 18.

<div align="center">CHAPTER FIVE</div>

1. William H. Chafe, "The Road to Equality: 1962–Today," in Nancy F. Cott, ed., *No Small Courage: A History of Women in the United States* (Oxford: Oxford University Press, 2000), 554.

2. Rogow, *Gone to Another Meeting*, 197.

3. Paula E. Hyman, "The Volunteer Organizations: Vanguard or Rear Guard?" *Lilith* 2, no. 5 (1978): 17, 22; "Pearl Water on NCJW," *Lilith* 2, no. 5 (1978): 18; "Betty Lieberman on Hadassah," *Lilith* 2, no. 5 (1978): 19, 21; Aviva Cantor, "The Sheltered Workshop," *Lilith* 2, no. 5 (1978): 20–21.

4. "Yale University Religious Studies, Paula E. Hyman, Curriculum Vitae," accessed 1 August 2004, available online from <http://www.yale.edu/religiousstudies/cvph.html>.

5. "Pearl Water on NCJW," 18.

6. In the early 1960s, the National Federation of Temple Sisterhoods, the auxiliary within Reform congregations, was the first Jewish women's group to lobby for ordination of women. Hebrew Union College admitted its first woman, Sally Priesand, in 1968; she was ordained in 1972. Sarna, *American Judaism*, 341; While Priesand was attending Hebrew Union College, the NCJW joined the chorus of Jewish organizations endorsing female ordination; Faith Rogow concurs about the NCJW's laggard pace toward breaking the glass ceiling. The Council "elevated woman's traditional role as mother" and encouraged members to be satisfied with their role and stature in Council. Rogow, *Gone to Another Meeting*, 73–74.

7. Ibid, 77.

8. "Pearl Water on NCJW," 18.

9. Letty Cottin Pogrebin, *Deborah, Golda, and Me: Being Female and Jewish in America* (New York: Crown Publishers, Inc., 1991), 248–49.

10. Membership figures in this section were gathered from several sources: Directories 1923–56, Series I, Box 101, National NCJW Collection, LOC; Directories 1965–78, Series II, Box 30, National NCJW Collection, LOC; National Board 1926 folder, Series I, Box 3, National NCJW Collection, LOC; "Fact Sheets Years of Progress,"

Series I, Box 102, National NCJW Collection, LOC; Campbell, *The First Fifty Years*, 88–91; Graziani, *Where There's a Woman, 75 Years of History*, 124–25; NCJW Web site, "NCJW Sections," accessed March 15, 2003, and May 15, 2004, available online at <www.ncjw.org/about/sections.htm/>.

11. Julie C. Klein and Ruthie Wurburg to Members San Antonio Section, May 15, 2005.

12. Robin S. Branch, NCJW Data Information Administrator, New York City, telephone interview, May 7, 2007, notes in possession of author.

13. Eileen Silverman, Houston, telephone interview with author, June 10, 2007, notes in possession of author; "Reorganization of Houston NCJW watched at national level," *Jewish* [Houston] *Herald-Voice*, May 31, 2007, accessed June 8, 2007, available online at <http://www.jhvonline.com/>.

14. The 123,000-membership figure is from Series I, Box 102, "Fact Sheets Years of Progress" folder, National NCJW Collection, LOC. The figure is improbable, because it would indicate a 13,000 increase over 1960 and a 13,000 decrease by 1965.

15. In Texas, the Sherman-Dennison and the Tri-County sections were among the "very small sections" that received awards for retaining 85 percent of their members. Both sections were soon to expire. "Minutes National Board of Directors, Thursday Afternoon April 6, 1967," p. 5, and "Minutes of the 27th National Convention, Thursday Morning, April 13, 1967," p. 18, Series II, Box 6, National Conventions, XXVII, 1967, National NCJW Collection, LOC; Another indication of the worrisome drop in membership was the national board's 1967 vote to set up "legal machinery to create a status for inactive sections as an interim before disbandment." "List of Official Motions Passed at Policy-Making Meetings Which Have Yet to be Implemented," Series II, Box 9, folder 1, National Conventions XXIX, 1971, National NCJW Collection, LOC.

16. Board Workshop—October 1972, Attachment B(d), Series I, Box 31, National Board Meetings, 1972–1974, National NCJW Collection, LOC.

17. Executive Committee Meeting (10/26–28/76), Series I, Box 32; NCJW Board Meeting 6/13–16/77, Series I, Box 32; Report of the 85th Anniversary Committee to the National Board of Directors (6/16/1977), Series I, Box 31, National NCJW Collection, LOC.

18. Elissa Gootman, "Grass Roots Seem to be Withering," *Forward*, February 13, 1998, pp. 1, 9; Stacy Kass, NCJW deputy executive director, New York, telephone interview with author, February 24, 2004, Interviews folder, FW/NCJW Collection; Membership totals for 2007 include 17,120 annual members and 31,470 life members. Robin S. Branch interview.

19. Featured guests were Fort Worth City Councilwoman (and future Mayor and U.S. Congresswoman) Kay Granger, a divorced schoolteacher-turned-insurance-broker; Sharon Benge, founder of Fort Worth's Shakespeare in the Park; and Louise K. Appleman, billed as president of Louise Appleman & Associates, a company that helps executives and their families relocate to Fort Worth. In 1988, Appleman was elected to the Tarrant County College Board and became its vice president in 1997. Invitation, in NCJW Scrapbook #2, 1985–1991, FW/NCJW Collection, Beth-El Archives.

20. "Privileged women by taking on men's roles (becoming doctors, lawyers, joining military). . . . achieve considerable status and power." Michelle Zimbalist Rosaldo and Louise Lamphere, eds., *Woman, Culture, and Society* (Stanford: Stanford University Press, 1974), 37; Price, "Development of Leadership by Southern Women," 155–56.

21. Austin's Council section had 180 members in 2006, including 92 life members and 88 annual members. Susan Pintchovski, Austin NCJW president, to Hollace Weiner, e-mail dated February 9, 2006.

22. NCJW Year Books, Box 2, FW/NCJW Collection, Beth-El Archives.

23. "Analysis of NCJW Sections/Units According to Community and Membership Profiles," Series I, Box 33, National NCJW Collection, LOC.

24. Board Workshop—October 1972, Attachment B(c), p. c-2, Series I, Box 31, National Board Meetings, National NCJW Collection, LOC; To stem loss of members, some NCJW national leaders suggested "encouraging participation of husbands[, for] when husbands believe that Council is a worthy organization, women are strengthened in their commitment." Minutes of Executive Meeting and Board, February 26, 1971, p. 27, Series I, Box 31, National NCJW Collection, LOC.

25. Board Workshop—October 1972, National NCJW Collection, LOC.

26. Ibid., 173, 203.

27. Series I, Box 31, "Membership-Expansion Workshops, October 19, 1971, Addendum," p.1, NCJW Board Meeting 10/71 folder, National NCJW Collection, LOC.

28. Putnam, *Bowling Alone*, 184.

29. Price, "Development of Leadership by Southern Women," 129; See also Steven Windmueller, "Leadership Challenges for the 21st Century: Reinventing Brotherhood," *Achim Magazine* 4 (Spring 2005): 4–5.

30. Moshe Hartman and Harriet Hartman, *Gender Equality and American Jews* (Albany: State University of New York Press, 1996), 15, 55–57, 61–114; Sylvia Barack Fishman, *Jewish Life and American Culture* (Albany: SUNY Press, 2000), 101, 105, 111–13, 153–59, 161–68.

31. Putnam, *Bowling Alone*, 194, 202.

32. Fishman, *Jewish Life and American Culture*, 110.

33. In a focus group of Jewish women, Fishman reported that the top issues attracting them to volunteer work were oriented around their children, local disadvantaged persons, feminist causes, and Jewish causes. Ibid.

34. Hartman, *Gender Equality and American Jews*, 197.

35. Ibid., 198.

36. Fishman, 101.

37. Sarna, *American Judaism*, 339; Wertheimer, *A People Divided*, 145.

38. Meredith L. Woocher, "Radical Tradition: The Ideological Underpinnings of the Early Havurah Movement," unpublished seminar paper, Brandeis University, 1997, quoted in Sarna, *American Judaism*, 310, 415 fn87.

39. Paula E. Hyman, "The Other Half: Women in the Jewish Tradition," *Response, A Contemporary Jewish Review* 7 (Summer 1973): 67–73. The background and doctrines of *Ezrat Nashim* are expounded on in this issue of *Response*, which was edited by Liz

Koltun and devoted to the Jewish Woman's Movement. The journal issue was later published in book form as *The Jewish Woman: An Anthology* (Waltham: Brandeis University Press, 1973).

40. Other "demands" presented to the Rabbinical Assembly of America were for women to be counted in the minyan, to be recognized as witnesses under Jewish law, to initiate divorce, to perform as rabbis and cantors in synagogues, and to assume positions of communal leadership. Wertheimer, *A People Divided*, 145.

41. Hyman, "The Other Half."

42. Judith Plaskow Goldenberg, "The Jewish Feminist: Conflict in Identities," *Response*, 7 (Summer 1973): 11–18.

43. Jacqueline K. Levine, "The Changing Role of Women in the Jewish Community," *Response* 7 (Summer 1973): 59–66.

44. Vivian Silver Salowitz, "Sexism in the Jewish Student Community," *Response* 7 (Summer 1973): 55–59.

45. "Why had we waited so long to attend to our backgrounds? Had we been ashamed of being Jewish? Were we afraid of exposing ourselves as Jews? . . . Given Jewish paranoia (a perfectly realistic fear of anti-Semitism), perhaps we needed the security of tenure to venture work on ethnicity?" Susan Gubar, *Critical Condition: Feminism at the Turn of the Century* (New York: Columbia University Press, 2000), 82.

46. Ibid., 89–90.

47. Rogow, *Gone to Another Meeting*, 195–96; Within its local federations, the UJA created "women's divisions." Intended as a fundraising strategy, women's divisions turned into "pockets of sisterhood" in which women demonstrated not only their fundraising clout but also their ability to galvanize others for Jewish communal and international causes. For many women of the 1970s and 1980s, such work had more relevance than the National Council of Jewish Women because it enhanced their sense of peoplehood.

48. Pogrebin credits Rachel Adler with coining the phrase "peripheral Jews." Pogrebin, *Deborah, Golda, and Me*, 238, 243.

49. Other Fort Worth women named "Jewish Man of the Year" were Ella Brachman (1954), a past president of Hadassah; Sophia Miller (1956), former president of NCJW and Sisterhood; Ceil Echt (1976), former president of Sisterhood and Hadassah; Marcia Kornbleet Kurtz (1977), a seasoned volunteer and former president of the Ladies Auxiliary to Ahavath Sholom; Faye Berkowitz (1979), a past president of Hadassah and B'nai Brith Women, Burnis Cohen, longtime president of B'nai B'rith Women; Sandra Freed (1982), past president of NCJW, Sisterhood, Hadassah, and the Jewish Federation; Karen Brachman (1988), a founder of the Fort Worth Hebrew Day School; Hortense Deifik (1989), a past president of Hadassah and the Jewish Federation; Ruby Kantor (1990), past president of Sisterhood and B'nai B'rith Women; and Beverley Moses (1992) founding president of the B'nai B'rith Women chapter. The B'nai B'rith lodge changed the name of its award to "Person of the Year" in the 1990s. Weiner, *Beth-El Congregation: Centennial*, 24; *B'nai B'rith Community Directory of Tarrant County, 2003 to 2004*, pp. 13, 19; *Fort Worth Chapter Hadassah 2003–2004 Membership Directory*, 13; Pogrebin, *Deborah, Golda, and Me*, 247.

50. Weiner, *Beth-El: Centennial*, 24.

51. Ibid., 24, 82, 83; Ahavath Sholom elected its first woman president, Sylvia Luskey, in 1994. She was a past president of Hadassah. Her daughter-in-law, Susan Luskey, who was active in the Junior League, became Ahavath Sholom's second female president in 2006.

52. Mona Karten, immediate past president Fort Worth Hadassah, telephone conversation, June 6, 2007; Forth Worth Chapter Hadassah 2006–2007 Membership Directory, pp. 28–56.

53. Estelle Freedman, "Separatism as Strategy: Female Institution Building and American Feminism, 1870–1930," *Feminist Studies* 5 (Fall 1979): 512–529.

54. "B'nai Brith Women Call off Split," *Lilith* 14 (Fall/Winter 1985–1986): 3; "B'nai B'rith Goes Co-Ed," *Lilith* 14 (Spring 1989): 5; "Women and Power, B'nai B'rith Style," *Lilith* 15 (Spring 1990): 4; See also Linda Gordon Kuzmack, "B'nai B'rith Women," in *Jewish Women in America*, vol. 1, 162–67.

55. "On September 17, 1984, B'nai B'rith Women denounced a B'nai B'rith International resolution to begin admitting women to the previously all-male organization, saying that the proposal was financially motivated and a threat to the independence of the women's organization." This Week in History, Jewish Women's Archive, accessed September 17, 2004, available online from <http://www.jwa.org/this_week/week38 .html>; "B'nai B'rith Goes Co-Ed," *Lilith* 14 (Spring 1989): 5.

56. *Lilith* 14 (Fall/Winter 1985–1986); 3; *Lilith* 14 (Spring 1989): 5; *Lilith* 15 (Spring 1990): 4; Kuzmack, "B'nai B'rith Women," in *Jewish Women in America* vol. 1, 162–67.

57. Loribeth Weinstein, telephone interview with author, February 17, 2004. Interviews folder, FW/NCJW Collection, Beth-El Archives.

58. "Thinking Outside the Brisket," was a JWI program that featured celebrity chefs demonstrating Passover dishes. "These popular programs were attended by over 250 women and brought in more than one hundred new members to JWI. Proceeds . . . benefited the JWI Women's Economic Security Fund." "We're Making a Name for Ourselves," *JWI Today* 2 (Spring/Summer 2003): 8.

59. The night chapter dissolved around 1999. It did not draw working women, but rather, less affluent Jews who, rather than hire a babysitter, attended night meetings when their spouses could watch the children. Faye Berkowitz, telephone interview with author, October 20, 2004, notes in possession of author.

60. Evans, *Born for Liberty*, 162, 256–57.

61. Freedman, "Separatism Revisited," in *U.S. History as Women's History*, 170–88.

62. Patricia R. Hill, *The World Their Household: The American Woman's Foreign Mission Movement and Cultural Transformation, 1870–1920* (Ann Arbor: University of Michigan Press, 1985), 5.

63. Marsha I. Atkind, NCJW National president, to NCJW Fort Worth Section Members, May 13, 2002, FW/NCJW Collection, Beth-El Archives.

64. Marsha Atkind to Pauline Wittenberg, September 9, 2002, form letter, Box 1, Dissolution folder, FW/NCJW Collection, Beth-El Archives.

65. Ellen Mack, interview.

Bibliography

ARCHIVAL COLLECTIONS

Beth-El Congregation Archives, Fort Worth, Texas
 Fort Worth Section/National Council of Jewish Women Collection
 Beth-El Congregation Collection
Fort Worth Jewish Archives at Congregation Ahavath Sholom, Jewish Federation of
 Fort Worth and Tarrant County
Fort Worth Public Library, Genealogy and Local History Unit
 Death Records, Texas, 1903–1940. Microform.
 Women's Club Collection
Jacob Rader Marcus Center of the American Jewish Archives, Cincinnati, Ohio
 Enelow, Hyman G., Papers
 Heller, Max, Papers
 NCJW, Sherman, Texas, minutes, 1919–1924
 NCJW Savannah, Ga., minute book, 1895–1898
 Jewish Chautauqua Society Minutes 1907–1939
 Ladies Aid Societies, Victoria, Texas, minutes, 1876–1901
 Ladies Aid Societies, Galveston, Texas, minutes 1907–1939
 Mack Collection
 Solomon, Hannah G., Scrapbooks.
Library of Congress, Washington, D.C.
 NCJW Administrative Collection, 1893–1975
R. G. Dun & Co. Collection. Baker Library, Harvard Business School
Tarrant County Historical Commission Archives
Texas Library, Woman's Club of Fort Worth Archives
University of Texas at Arlington Libraries, Special Collections
 Fort Worth Star-Telegram Collection
 Jenkins Garrett Collection
 Works Progress Administration Papers, Federal Writers Project, Fort Worth, 1936
The Woman's Collection, Texas Woman's University, Denton, Texas

Texas Federation of Women's Clubs Collection
Fort Worth Federation of Women's Clubs Collection

PERIODICALS AND ANNUALS

American Hebrew. 1915

American Israelite. 1886

American Jewess. St. Louis and Chicago. 1895–1999.

American Jewish Year Book. Philadelphia: Jewish Publication Society of America. 1899–2002. Annual.

Bohemian Worlds Fair Edition, Texas Past Present. 1904. Fort Worth, Texas.

Council News. January 1968–September 1971.

Council Newsletter. 1933–1938.

Council Woman. 1940–1977.

Dallas Morning News. 1897–1910. Online Archive.

Fort Worth City Directory. 1877–1925. Annual.

Fort Worth Press, 1921–1934.

Fort Worth Register, 1899–1902.

Fort Worth Star-Telegram. 1902–1974.

Hadassah Magazine. 2002–2007.

Harpers Bazaar. January 1900.

Houston Jewish Herald-Voice. 2007.

Immigrant, Bulletin of the NCJW Department of Immigrant Aid. 1924–1926.

Jewish [Fort Worth] *Monitor.* 1915–1930.

Jewish Woman Magazine. 2001–2007.

JWI Today. 2001–2007.

Lilith. 1978–2007

Meacham's Fashion News. April 1969.

National Council of Jewish Women: Proceedings of the First Convention, November 15– 19, 1896. Philadelphia: Jewish Publication Society, 1897.

National Council of Jewish Women, Triennial Proceedings. 1905–1926.

NCJW Journal. 2002–2007.

Philadelphia Jewish Exponent. 1935.

Southwest Jewish Sentiment. 1898–1901, incomplete. Microfilm.

Tarrant County Historic Resources Survey. 4 Vols. Fort Worth: Historic Preservation Council for Tarrant County, Texas. 1991.

Texas Jewish Post. 1954–2005, selected issues.

INTERVIEWS

Appleman, Louise Kuehn. Fort Worth. By telephone. 10 July 2003, June 7, 2007.

Armstrong, Sally. New York. By telephone. October 15 and 26, 2004.

Berkowitz, Faye. Fort Worth. By telephone. October 20, 2004.

Bogart, Ann. Fort Worth. July 5, 2006.

Branch, Robin S. New York City. By telephone. May 7, 2007.

DuBose, Dorothy. Boulder, Colorado. By telephone. October 21, 2004.

Florsheim, Leslye. Fort Worth. September 16, 2004.

Gaines, Bess Rutlader. Fort Worth. August 2, 2006.

Ginsburg, Martine. Fort Worth. By telephone. December 28, 2003.

Glazer, La Rue Glickman. Dallas. By telephone. November 11, 2003.

Kass, Stacy. New York. By telephone. February 24, 2004.

Levine, Livia Schreiber. Fort Worth. June 4, 2003

Mack, Ellen Feinknopf. Fort Worth. August 7, 2003.

Mack, Norma Harris. Fort Worth. June 10, 2003.

McConnal, Jon "Bunky." Granbury, Texas. By telephone. November 6, 2004.

Rapfogel, Ruth. Chicago. By telephone. November 11, 2003.

Riddell, Pat. Fort Worth. By telephone. October 25, 2003.

Roper, Ruth. Fort Worth. By telephone. December 28, 2003

Rosenstein, Bernard. Dallas. November 18, 2003.

Rosenthal, Rosalyn Gross. Fort Worth. October 22, 2003.

Schwartz, Margot. Fort Worth. March thru August 2004.

Sherrod, Katie. Fort Worth. By telephone. October 16, 2004.

Silverman, Eileen. Houston. By Telephone. June 10, 2007.

Sonkin, Fannette. Fort Worth. October 1, 2003.

Stien, Amy Jacobs. Fort Worth. June 24, October 22, December 10, 2003.

Weil, Bernice "Beanie." Fort Worth. Conversations, 1997–2004.

Weinstein, Loribeth. Washington. By telephone. February 17, 2004.

Wexler, Esther Shanblum. Fort Worth. 5 October, 2004.

Winesanker, Esther. Fort Worth. November 12, 2003.

Winston, Dorothy Diamond. Fort Worth. November 15, 2003.

Wittenberg, Pauline Landman. Fort Worth. Conversations 2003–2004.

INTERNET SITES

Carnegie, Andrew. "The Gospel of Wealth." *North American Review* 148 (June 1889), 653–664. Accessed 15 August 2004. Available from www.fordham.edu/halsall/mod/ 1889carnegie.html.

Chicago Public Library. "1893 World's Columbian Exposition." Accessed 15 September 2003. Available from www.chipublib.org/004chicago/timeline/columbianx.html.

Hadassah: The Women's Zionist Organization of America. Accessed 16 January 2004. Available from www.hadassah.org/home.asp.

Handbook of Texas Online. Accessed January 2003–November 2004. Available from www.tsha.utexas.edu/.

Heritage Quest Online. Census data. Available from www.heritagequest.com/. Fort Worth Public Library.

"Impact of Television in Relation to Juvenile Delinquency." Accessed 1 November 2003. Available from www.ez-essays.com/free/1684.html.

"Is Juvenile Delinquency and Aggression Produced by Permissive or Punitive Parenting: Re-evaluating 50 years of Research." American Association of Behavioral and

Social Sciences National Convention, 2002. Accessed 1 November 2003. Available from www.aabss.org/journal2002/Hwang.htm.

Lilith, The Independent Jewish Women's Magazine. Accessed 15 May 2004. Available from www.lilithmag.com/resources/lilithsources.shtml.

"NCJW Sections." Accessed 2 March 2003–June 10, 2007. Available from www.ncjw .org/about/sections.htm/.

Tarrant County. Accessed 1 November 2003. Available from www.tarrantcounty.com/ juvenile/cwp/view.asp.

"Women and Social Movements in the United States, 1775–2000." Accessed 10 September 2003. Available from http://womhist.binghamton.edu/nacw/doclist.htm.

Women in Community Service, Inc. Accessed 15 May 2003. Available from www .charityadvantage.com/wics/Home.asp.

Yale University Religious Studies. "Paula E. Hyman Curriculum Vitae." Accessed 15 May 2004. Available from www.yale.edu/religiousstudies/cvph.html.

JOURNAL AND MAGAZINE ARTICLES, SPEECHES

Ackelsberg, Martha. "Introduction." *Response, A Contemporary Jewish Review* 7 (Summer 1973): 7–9.

Adler, Rachel. "The Jew Who Wasn't There: *Halakha* and the Jewish Woman." In *On Being a Jewish Feminist*, Schocken Books, 1995, 12–17.

"American Woman, Her Achievements and Troubles." *Life.* Special Issue. 24 December 1956.

Antler, Joyce. "After College, What? New Graduates and the Family Claim." *American Quarterly* 32 (Fall 1980): 409–435.

Bauman, Mark K. "Southern Jewish Women and Their Social Service Organizations." *Journal of American Ethnic History* 22 (Spring 2003): 34–78.

Berkowitz, Max D. "The Jewish Chautauqua Society: Personal Reminiscences of Its Early Days." *The Jewish Layman* 17 (April 1943): 5–9.

Blanton, Sherry. "Lives of Quiet Affirmation: The Jewish Women of Early Anniston, Alabama." *Southern Jewish History* 2 (1999): 26–53.

Chambre, Susan. "Parallel Power Structures, Invisible Careers, Benevolence and Reform: Implications of Women's Philanthropy." *Nonprofit Management and Leadership* 4, no. 2 (1993): 233–239.

Cook, Blanche Wiesen. "Female Support Networks and Political Activism." *Chrysalis* 3 no. 3 (1977): 43–61.

Cott, Nancy F. "What's in a Name: The Limits of 'Social Feminism' or Expanding the Vocabulary of Women's History." *Journal of American History* 76 (December 1989): 809–29.

Domatti, Ruth. "A History of Kidd-Key College." *Southwestern Historical Quarterly* 63 no. 3 (1959): 262–78.

Epstein, Cynthia Fuchs. "Ten Years Later: Perspectives on the Woman's Movement." *Dissent* 22 (Spring 1975): 169–76.

Freedman, Estelle B. "Separatism as Strategy: Female Institution Building and American Feminism, 1870–1930." *Feminist Studies* 5 (Fall 1979): 512–29.

———. "The New Woman: Views of Women in the 1920s." *Journal of American History* 61 (September 1974): 372–93.

Friedan, Betty. "Women Are People, Too." *Good Housekeeping* 151 no. 10 (September 1960): 59–61, 161–62.

Goetting, Mrs. Charles A. "Tribute to Olga Bernstein Kohlberg," *Password* 17 no. 4 (1972): 159–62.

Goldberg, Jeannette Miriam. "Religion Should be Taught in the Home." *American Hebrew.* September 10, 1915, p. 468–70.

Goldenberg, Judith Plaskow. "The Jewish Feminist: Conflict in Identities." *Response, A Contemporary Jewish Review* 7 (Summer 1973): 11–18.

Golomb, Deborah Grand. "The 1893 Congress of Jewish Women: Evolution or Revolution in American Jewish Women's History?" *American Jewish History* 70 (September 1980): 52–67.

Gootman, Elissa. "Grass Roots Seem to be Withering." *Forward.* February 13, 1998, pp. 1, 9.

Johnson, Joan Marie. "'Drill unto us . . . the Rebel Tradition': The Contest Over Southern Identity in Black and White Women's Clubs, South Carolina, 1898–1930." *Journal of Southern History* 66 (August 2000): 525–562.

Kellam, Tom. "The Mind of an Anti-Semite: George W. Armstrong and the Ku Klux Klan in Texas," *Chronicles: A Publication of the Texas Jewish Historical Society* 1 no. 1 (1994): 13–32.

Korelitz, Seth, "'A Magnificent Piece of Work': The Americanization Work of the National Council of Jewish Women," *American Jewish History* 83 (1995): 177–203.

Lerner, Elinor. "Jewish Involvement in the NYC Woman Suffrage Movement." *American Jewish History* 70 (June 1981): 442–61.

Levine, Jacqueline K. "The Changing Role of Women in the Jewish Community." *Response, A Contemporary Jewish Review* 7 (Summer 1973): 59–66.

Myres, Sandra Lynn, "Fort Worth, 1870–1900." *Southwestern Historical Quarterly* 72 (October 1968): 200–10.

Nadell, Pamela S. "On Their Own Terms: America's Jewish Women, 1954–2004." *American Jewish History* 91 (September–December 2003): 389–404.

Olneck, Michael. "Americanization and the Education of Immigrants, 1900–1925: An Analysis of Symbolic Action." *American Journal of Education* 97 (August 1989): 398–417.

Porter, Jack Nusan. "Rosa Sonneschein and *The American Jewess*: The First Independent English Language Jewish Women's Journal in the United States." *American Jewish History* 68 (September 1978): 57–63.

Rapp, Rayna. "Review Essay: Anthropology." *Signs* 4 (1979): 500, 508–13.

Rogoff, Leonard. "Is the Jew White: The Racial Place of the Southern Jew." *American Jewish History* 85 (September 1997): 195–230.

———. "Synagogue and Jewish Church: A Congregational History of North Carolina." *Southern Jewish History* 1 (1998): 43–82.

Sahli, Nancy. "Smashing: Women's Relationships before the Fall." *Chrysalis* 8 (Summer 1979): 17–27.

Salowitz, Vivian Silver. "Sexism in the Jewish Student Community." *Response, A Contemporary Jewish Review* 7 (Summer 1973): 55–59.

Scott, Anne Firor. "Most Invisible of All: Black Women's Voluntary Organizations." *Journal of Southern History* 56 (February 1990): 12–20.

———. "On Seeing and Not Seeing: A Case of Historical Invisibility." *Journal of American History* 71 (June 1984): 7–21.

———. *Making the Invisible Woman Visible.* Urbana: University of Illinois Press, 1984.

Selavan, Ida Cohen. "The Founding of Columbian Council." *American Jewish Archives* 30 (April 1978): 24–42.

Shaw, Stephanie. "Black Club Women and the Creation of the National Association of Colored Women." *Journal of Women's History* 3 (Fall 1991): 10–25.

Shoub, Myra. "Jewish Women's History: Development of a Critical Methodology." *Conservative Judaism* 35 (Winter 1982): 33–46.

Smith-Rosenberg, Carol. "The Female World of Love and Ritual: Relationships Between Women in Nineteenth Century America." *Signs* 1 (Autumn 1975): 1–29.

Sochen, June. "Some Observations on the Role of American Jewish Women as Communal Volunteers." *American Jewish History* 70 (September 1980): 23–34.

Szajkowski, Zosa. "Returnees." *American Jewish Historical Quarterly* 67 (June 1978): 291–306.

Tefteller, Carol. "The Jewish Community in Frontier Jefferson." *Texas Historian* 35 (September 1974): 2–9.

Toll, William. "A Quiet Revolution: Jewish Women's Clubs and the Widening Female Sphere, 1870–1920." *American Jewish Archives* 41 (Spring/Summer 1989): 7–26.

Wall, Helena M. "Notes on Life since *A Little Commonwealth:* Family and Gender History Since 1970." *William and Mary Quarterly* 57 (October 2000): 809–25.

Waxman, Chaim I. "The Impact of Feminism on American Jewish Communal Institutions." *Journal of Jewish Communal Service* 57 (Fall 1980): 73–79.

Weiner, Deborah R. "Jewish Women in the Central Appalachian Coal Fields, 1890–1960: From Breadwinners to Community Builders." *American Jewish Archives* 52 no. 1–2 (2000): 10–33.

Weiner, Hollace Ava. "The Mixers: The Role of the Rabbi Deep in the Heart of Texas," *American Jewish History* 85 (September 1997): 289–332.

———. "Removal Approval: The Industrial Removal Office Experience in Fort Worth, Texas." *Southern Jewish History* 4 (2001): 1–44.

———. "Tied and Tethered *(Geknippt und Gebinden):* Jews in Early Fort Worth." *Southwestern Historical Quarterly* 107 (January 2004): 389–414.

———. "Whistling Dixie While Humming Hatikvah: Acculturation and Activism among the Orthodox in Fort Worth." Presented at 2006 Biennial Scholars' Conference on American Jewish History, Charleston, South Carolina, June 6, 2006.

Welter, Barbara. "The Cult of True Womanhood, 1820–1860." *American Quarterly* 17 no. 2, part 1 (Summer 1966): 151–74.

Wenger, Beth S. "Jewish Women and Voluntarism: Beyond the Myth of Enablers." *American Jewish History* 79 (Autumn 1989): 16–36.

———. "Jewish Women of the Club: The Changing Public Role of Atlanta's Jewish Women (1870–1930)." *American Jewish History* 76 (March 1987): 311–33.

Wilhelm, Cornelia. "'Jews, Christians and the Dictates of Brotherly Love': Abraham E. Frankland, the B'nai B'rith and Interfaith Solidarity During the Yellow Fever Epidemic in Memphis, 1873." Presented at Southern Jewish Historical Society Conference, Memphis, Tennessee, October 31, 2003.

———. "The Independent Order of True Sisters: Friendship, Fraternity, and a Model of Modernity for Nineteenth Century American Jewish Womanhood." *American Jewish Archives* 56 no. 1 (2002): 37–62.

Wilkerson-Freeman, Sarah. "Two Generations of Jewish Women: North Carolina, 1880–1970." *Southern Jewish Historical Society Newsletter.* July 1989, pp. 3–6.

Zuckoff, Aviva Cantor. "The Oppression of the Jewish Woman." *Response, A Contemporary Jewish Review* 7 (Summer 1973): 47–54.

DISSERTATIONS AND THESES

Elwell, Ellen Sue Levi. "The Founding and Early Programs of the National Council of Jewish Women: Study and Practice as Jewish Women's Religious Expression." Ph.D. diss. Indiana University, 1982.

Goldman, Marilyn Kay Cheatham. "Jewish Fringes Texas Fabric: Nineteenth Century Jewish Merchants Living Texas Reality and Myth." Ph.D. diss., Texas A&M University, 2003.

Jackson, Emma Louise. "Petticoat Politics: Political Activism among Texas Women in the 1920s." Ph.D. diss. University of Texas at Austin, 1980.

Kessler, James Lee. "B.O.I.: A History of Congregation B'nai Israel, Galveston, Texas." Ph.D. diss. Hebrew Union College, 1988.

Martin, Patricia Summerlin. "Hidden Work: Baptist Women in Texas, 1880–1920." Ph.D. diss. Rice University, 1982.

Pearlstein, Peggy Kronsberg. "Understanding through Education: One Hundred Years of the Jewish Chautauqua Society, 1893–1993." Ph.D. diss. George Washington University, 1993.

Price, Margaret Nell. "The Development of Leadership by Southern Women through Clubs and Organizations." Ph.D. diss. University of North Carolina at Chapel Hill, 1945.

Seaholm, Megan. "Earnest Women: The White Woman's Club Movement in Progressive Era Texas, 1880–1920." Ph.D. diss. Rice University, 1988.

Weiner, Hollace Ava. "The Jewish Junior League: The Rise and Fall of the Fort Worth Council of Jewish Women, 1902–2002." Master's thesis: University of Texas at Arlington, 2002.

BOOKS

Adler, Cyrus, ed. *The Voice of America on Kishineff.* Philadelphia: The Jewish Publication Society of America, 1904. Microfiche.

Ammerman, Nancy Tatom. *Bowling Together: Congregations and the American Civic*

Order. Tempe, Arizona: Arizona State University Department of Religious Studies, 1996.

Anderson, Terry H. *The Movement and the Sixties: Protest in America from Greensboro to Wounded Knee*. New York and Oxford: Oxford University Press, 1995.

Antler, Joyce. *The Journey Home: Jewish Women and the American Century*. New York: Schocken Books, 1997.

———, ed. *Talking Back: Images of Jewish Women in American Popular Culture*. Hanover: Brandeis University Press/University Press of New England, 1998.

Arnold, Ann. *History of the Fort Worth Medical Community*. Arlington, Texas: Landa Press, 2002.

Barkai, Avraham. *Branching Out: German-Jewish Immigration to the United States, 1820–1914*. New York: Holmes and Meier, 1994.

Baum, Charlotte, Paula Hyman, and Sonya Michel, eds. *The Jewish Woman in America*. New York: The Dial Press, 1976. Reprinted. New American Library, 1977.

Bauman, Mark K. *Dixie Diaspora: An Anthology of Southern Jewish History*. Tuscaloosa: University of Alabama Press, 2006.

Beckwith, Esther, and Helen M. Katz. *Handbook for Naturalization Workers*. New York City: Council of Jewish Women, Inc., 1942.

Behnke, Donna. *Religious Issues in 19th Century Feminism*. Troy, New York: Whitston, 1982.

Berkin, Carol Ruth, and Mary Beth Norton. *Women of America: A History*. Boston: Houghton Mifflin, 1979.

Berkowitz, Max E. *The Beloved Rabbi: An Account of the Life and Works of Henry Berkowitz, D.D.* New York: MacMillan Company, 1932.

Blackman, Heppner (illustrator), and D. C. McCaleb. *Freshly-Made Heroes*. Fort Worth: *Fort Worth Star*, ca. 1908.

Blair, Karen J. *The Clubwoman as Feminist: True Womanhood Redefined, 1868–1914*. New York: Holmes and Meier, 1980.

———. *The History of American Women's Voluntary Organizations, 1819–1960: A Guide to Sources*. Boston: G.K. Hall & Co., 1989.

———, ed. *Women in Pacific Northwest History: An Anthology*. Seattle: University of Washington Press, 1988.

Bodnar, John. *The Transplanted: A History of Immigrants in Urban America*. Bloomington: Indiana University Press, 1985.

Braunstein, Peter, and Michael William Doyle, eds. *Image Nation: The American Counterculture of the 1960s & '70s*. New York and London: Routledge, 2002.

Brooks, Elizabeth. *Prominent Women of Texas*. Akron: The Werner Co., 1896.

Campbell, Monroe Jr., and Willem Wirtz. *The First Fifty Years: A History of the NCJW 1893–1943*. New York: National Council of Jewish Women, 1943.

Carb, David. *Sunrise in the West*. New York: Brewer, Warren & Putnam, 1931.

Carlson, Robert A. *The Americanization Syndrome: A Quest for Conformity*. London & Sydney: Croom Heom, Ltd., 1987.

Carrington, Evelyn M., ed. *Women in Early Texas.* Austin: Jenkins Pub. Co., Pemberton Press, for American Association of University Women, Austin Branch, 1975.

Cawelti, John. "America on Display: The World's Fairs of 1876, 1893, and 1933." In *The Age of Industrialism in America: Essays in Social Structure and Cultural Value,* ed. Frederick Cople Jaher, 317–63. New York: The Free Press, 1968.

Chambers-Schiller, Lee Virginia. *Liberty, a Better Husband: Single Women in America: The Generations of 1780–1840.* New Haven: Yale University Press, 1984.

Christian, Stella L., ed. *History of the Texas Federation of Women's Clubs* Vol. 1. Houston: Texas Federation of Women's Clubs and Dealy-Adey-Elgin Co., 1919.

Cohen, Joshua, Mathew Howard, and Martha Nussbaum, eds. *Is Multiculturalism Bad for Women? Susan Moller Okin with Respondents.* Princeton: Princeton University Press, 1999.

Cott, Nancy F., ed. *No Small Courage: A History of Women in the United States.* Oxford: Oxford University Press, 2000.

———. *The Bonds of Womanhood: "Women's Sphere" in New England, 1780–1835.* New Haven: Yale University Press, 1977.

———. *The Grounding of Modern Feminism.* New Haven: Yale University Press, 1987.

Craver, Dorothy. *The First One Hundred Years, 1881–1981: A History of the 1881 Study Club of Jefferson, Texas.* Austin: Texas Federation of Women's Clubs, 1981.

Crawford, Ann Fears. *Women in Texas: Their Lives, Experiences.* Burnet: Eakin Press, 1982.

Cristol, Gerry. *A Light in the Prairie: Temple Emanu-El of Dallas, 1872–1997.* Fort Worth: Texas Christian University Press, 1998.

Croly, Jane Cunningham [Jennie June, pseud]. *History of the Woman's Club Movement in America.* New York: Henry G. Allen and Co., 1898.

Cunningham, Mary S. *The Woman's Club of El Paso: Its First Thirty Years.* El Paso: Texas Western Press, 1978.

Dallas and Fort Worth Social Register, 1932. Dallas: O. L. Hopper, 1932.

Davis, Elizabeth Lindsay. *Lifting as They Climb.* New York and London: G. K. Hall and Prentice Hall International, 1996.

Diner, Hasia. *Her Works Praise Her: A History of Jewish Women in America from Colonial Times to the Present.* New York: Basic Books, 2002.

Diner, Steven J. *A Very Different Age: Americans of the Progressive Era.* New York: Hill and Wang, 1998.

Dobkowski, Michael N., ed. *Jewish American Voluntary Organizations.* New York, Westport, London: Greenwood Press, 1986.

Downs, Fane, and Nancy Baker Jones, eds. *Women and Texas History: Selected Essays.* Austin: Texas State Historical Association, 1993.

Drew, Mary King. *A History of the Kindergarten Movement in Texas, from 1886 to 1942.* Booklet. Dallas: ca. 1942.

Duberman, Lucile. *Social Inequality: Class and Caste in America.* Philadelphia: J.B. Lippincott Co., 1976.

Elliot, Mrs. Leslie R. *A Mosaic of Memories: The Story of the Euterpean Club.* Fort Worth: Euterpean Club, 1946.

Enstam, Elizabeth York. *Women and the Creation of Urban Life: Dallas, Texas, 1843–1920.* College Station, Texas: Texas A&M University Press, 1998.

Evans, Eli N. *The Provincials: A Personal History of Jews in the South.* New York: Simon & Schuster, 1973. Revised. Free Press Paperbacks, 1997.

Evans, Sara M., and Harry C. Boyte. *Free Spaces: The Sources of Democratic Change in America.* 1992 edition. Chicago and London: University of Chicago Press, 1986.

Evans, Sara M. *Born for Liberty: A History of Women in America.* New York: The Free Press, 1989.

——, ed., *Journeys that Opened up the World: Women, Student Christian Movements, and Social Justice, 1855–1975.* New Brunswick: Rutgers University Press, 2003.

Faust, Drew Gilpin. *Mothers of Invention: Women of the Slaveholding South in the American Civil War.* New York: Vintage Books, 1997.

Feibelman, Julian B. *The Making of a Rabbi.* New York: Vantage Press, 1980.

Fishman, Sylvia Barack. *A Breath of Life: Feminism in the American Jewish Community.* New York: The Free Press, MacMillan, Inc., 1993.

——. *Jewish Life and American Culture.* SUNY Series in American Jewish Society in the 1990s. Albany: State University of New York, 2000.

Flanagan, Maureen A. *Seeing with Their Hearts: Chicago Women and the Vision of the Good City, 1871–1933.* Princeton and Oxford: Princeton University Press, 2002.

Fort Worth Social Directory, 1937. Houston, Galveston, Austin, Waco, San Antonio, Tulsa, Oklahoma City, Little Rock, Jackson, Memphis, Nashville, Chattanooga: Southern Social Directory Publishers, 1937.

Frankenberg, Ruth. *White Women, Race Matters: The Social Construction of Whiteness.* Minneapolis: University of Minnesota Press, 1993.

Freedman, Estelle B. *No Turning Back: The History of Feminism and the Future of Women.* New York: Ballantine Books, 2002.

Friedan, Betty. *The Feminine Mystique.* New York: W.W. Norton & Company, Inc., 1963.

Friedman, Jean E. "The Politics of Pedagogy and Judaism in the Early Republican South: The Case of Rachel and Eliza Mordecai." In *Women of the American South: A Multicultural Reader*, ed. Christie Ann Farnham, 56–73. New York: New York University Press. 1997.

——. *The Enclosed Garden: Women and Community in the Evangelical South, 1830–1900.* Chapel Hill: University of North Carolina Press, 1985.

Garrett, Julia Kathryn. *Forth Worth: A Frontier Triumph.* Forth Worth: Texas Christian University Press, 1996.

Geller, Shmuell. *Mazkeres Ahavah, Remembrance of Love: A Biographical Account of Rabbi Yaakov and Sara Geller and Family, the Transplanting of Jewish Life from Galicia to Texas, 1863 to the Present.* Zichron Yaakov, Israel: Institute for Publication of Books and Study of Manuscripts, 1988.

Gere, Anne Ruggles. *Intimate Practices: Literacy and Cultural Work in U.S. Women's Clubs, 1880–1920.* Urbana: University of Indiana Press, 1997.

Gestle, Gary and John Mollenkopf, eds. *E Pluribus Unum?: Contemporary and Historical Perspectives on Immigrant Political Incorporation.* New York: Russell Sage Foundation, 2001.

Glanz, Rudolph. *The Jewish Woman in America: Two Female Immigrant Generations, 1820–1929.* 2 Vols. Washington, D.C.: KTAV Publishing and the National Council of Jewish Women, 1976.

Glazer, Penina Migdal, and Miriam Slater. *Unequal Colleagues: The Entrance of Women into the Professions, 1890–1940.* New Brunswick: Rutgers University Press, 1987.

Goldman, Karla. *Beyond the Synagogue Gallery: Finding a Place for Women in American Judaism.* Cambridge, Mass.: Harvard University Press, 2000.

Goldstein, Eric L. *The Price of Whiteness: Jews, Race, and American Identity.* Princeton: Princeton University Press, 2006.

Gordon, Janet and Diana Reische. *The Volunteer Powerhouse.* New York: Rutledge Press, 1982.

Graziani, Bernice. *Where There's a Woman: 75 years of History as Lived by the National Council of Jewish Women.* New York: NCJW and the McCall Corporation, 1967.

Greenwald, Maurine Weiner. *Women, War, and Work: The Impact of World War I on Women Workers in the United States.* Westport, Conn.: Greenwood Press, 1980.

Gubar, Susan. *Critical Condition: Feminism at the Turn of the Century.* New York: Columbia University Press, 2000.

Gunter, Jewel Boone Hamilton. *Committed: The Official 100-Year History of the Women's Club of Houston, 1893–1993.* Houston: Women's Club of Houston, 1993.

Hall, Colby D. *History of Texas Christian University: A College of the Cattle Frontier.* Fort Worth: TCU Press, 1947.

Hartman, Moshe, and Harriet Hartman. *Gender Equality and American Jews.* Albany: State University of New York, 1996.

Hartmann, Edward George. *The Movement to Americanize the Immigrant.* New York: AMS Press, Inc., 1967. Reprint. New York Columbia University Press, 1948.

Herzberg, Steven. *Strangers within the Gate City: The Jews of Atlanta, 1845–1915.* Philadelphia: Jewish Publication Society of America, 1978.

Heschel, Susannah, ed. *On Being a Jewish Feminist: A Reader.* New York: Schocken Books, 1983.

Hill, Patricia. *The World Their Household: The American Woman's Foreign Mission Movement and Cultural Transformation, 1870–1920.* Ann Arbor: University of Michigan Press, 1985.

History of the Dallas Federation of Women's Clubs, 1898–1936. Dallas: Dallas Federation of Women's Clubs, 1936.

Hollinger, David A. *Postethnic America: Beyond Multiculturalism.* New York: Basic Books, 1995.

Hyman, Paula E. *Gender and Assimilation in Modern Jewish History: The Roles and Representation of Women.* Seattle: University of Washington Press, 1995.

Hyman, Paula E. and Deborah Dash Moore, eds. *Jewish Women in America: An Historical Encyclopedia.* 2 Vols. New York: Routledge, 1997.

Hyman, Paula E. and Steven M. Cohen, eds. *The Jewish Family: Myths and Reality.* New York: Holmes and Meier, 1986.

Jackson, Kenneth T. *The Ku Klux Klan in the City, 1915–1930* New York: Oxford University Press, 1967.

Jaffe, Miriam. *National Council of Jewish Women, Greater Dallas Section, 1913–1988.* Dallas: NCJW, 1988.

James, Janet, ed. *Women in American Religion.* Philadelphia: University of Pennsylvania Press, 1978.

Jewish Chautauqua Society. *Proceedings of 12th Annual Summer Assembly at Buffalo, July 14–19, 1908.* Philadelphia: Jewish Chautauqua Society, 1908.

Jones, Nancy Baker, and Debbie Mauldin Cottrell. *Women and Texas History: An Archival Bibliography.* Austin: Texas State Historical Association, 1998.

Joselit, Jenna Weissman. "The Special Sphere of the Middle-Class American Jewish Woman: The Synagogue Sisterhood, 1890–1940." In *The American Synagogue: A Sanctuary Transformed,* ed. Jack Wertheimer, 206–30. New York: Cambridge University Press, 1987.

Kammen, Michael G. *American Culture; American Tastes: Social Change and the Twentieth Century.* New York: Knopf, 1999.

Kerber, Linda, Alice Kessler-Harris, and Kathryn Kish Sklar, eds. *U.S. History as Women's History: New Feminist Essays.* Chapel Hill: University of North Carolina Press, 1995.

Keyserling, Mary Dublin. *Windows on Day Care: A Report Based on Findings of the National Council of Jewish Women on Day Care Needs and Services in Their Communities.* New York: NCJW, 1972.

Knight, Oliver. *Fort Worth: Outpost on the Trinity.* Norman: University of Oklahoma Press, 1953. Reprinted. Fort Worth: Texas Christian University Press, 1990.

Kolmerten, Carol A. *The American Life of Ernestine L. Rose.* Syracuse: Syracuse University Press, 1999.

Koltun, Liz. *The Jewish Woman: An Anthology.* Waltham: Brandeis University Press, 1973.

Kornbluh, Andrea Tuttle. *Lighting the Way . . . The Woman's City Club of Cincinnati, 1915–1865.* Cincinnati: Woman's City Club, 1986.

Kuzmack, Linda Gordon. *Women's Causes: The Jewish Women's Movement in England and the United States, 1881–1933.* Columbus: University of Ohio Press, 1990.

Lavender, Abraham D., ed. *A Coat of Many Colors: Jewish Subcommunities in the United States.* Westport, Conn.: Greenwood Press, 1977.

Lemons, J. Stanley. *The Woman Citizen: Social Feminism in the 1920s.* Urbana: University of Illinois Press, 1975.

Lilly, Mrs. Clyde A. *Woman's Book Club of Fort Worth Cook Book.* Fort Worth: The Bunker Press, 1928.

Malone, Ann Patton. *Women on the Texas Frontier: A Cross-Cultural Perspective.* El Paso: Texas Western Press, 1983.

Marcus, Jacob Rader. *The American Jewish Woman.* Cincinnati: American Jewish Archives, 1981.

——. *The American Jewish Woman: A Documentary History.* Cincinnati: American Jewish Archives, 1981.

Markgraf, Helen McKelvy, and Rob G. Yoder, eds. *Historic Oakwood Cemetery with Calvary Cemetery and Old Trinity Cemetery of Fort Worth, Texas.* Fort Worth: Fort Worth Genealogical Society, 1994.

McArthur, Judith N. *Creating the New Woman: The Rise of Southern Women's Progressive Culture in Texas, 1893–1918.* Urbana: University of Illinois Press, 1998.

McCarthy, Kathleen D., ed. *Lady Bountiful Revisited: Women, Philanthropy, and Power.* New Brunswick: Rutgers University Press, 1990.

McElhaney, Jacqueline Masur. *Pauline Periwinkle and Progressive Reform in Dallas.* College Station: Texas A&M University Press, 1998.

Millenium Evenings at the White House. Women as Citizens: Vital Voices Through the Century. Sixth in a Series. Video. Washington, D.C.: White House Millenium Council, 2000.

Miller, Elizabeth. *The Woman's Club of Fort Worth: The First Twenty-Five Years, 1923–48.* Fort Worth: The Woman's Club of Fort Worth, 1948.

Mullins, Marion Day. *A History of the Woman's Club of Fort Worth, 1923–1973.* Fort Worth: The Woman's Club, 1973.

Nadell, Pamela S. *American Jewish Women's History: A Reader.* New York: NYU Press, 2003.

Nadell, Pamela S., and Jonathan D. Sarna, eds. *Women and American Judaism: Historical Perspectives.* Hanover and London: Brandeis University Press/University Press of New England, 2001.

Oates, Paula, ed. *Celebrating 150 Years: The Pictorial History of Fort Worth, Texas, 1849–1999.* Fort Worth: Landmark Publishing, Inc., 1999.

O'Neill, William L. *A History of Feminism in America.* Second edition. New Brunswick, N.J: Rutgers University Press, 1989.

Ornish Natalie. *Pioneer Jewish Texans: Their Impact on Texas and American History for Four Hundred Years, 1590–1990.* Dallas: Texas Heritage Press, 1989.

Papers of the Jewish Women's Congress. Philadelphia: Jewish Publication Society, 1894.

Pirtle, Caleb. *Fort Worth: The Civilized West.* Fort Worth: Fort Worth Chamber of Commerce, 1980.

Pogrebin, Letty Cottin. *Deborah, Golda, and Me: Being Female and Jewish in America.* New York: Crown Publishers, Inc., 1991.

Potter, Fannie C. *History of the Texas Federation of Women's Clubs, 1918–1938.* Denton: W. H. McNitzky, 1941.

Putnam, Robert D. *Bowling Alone: The Collapse and Revival of American Community.* New York: Simon & Schuster, 2000.

Quandt, Jean B. *From the Small Town to the Great Community: The Social Thought of Progressive Intellectuals.* New Brunswick: Rutgers University Press, 1970.

Razovsky, Cecilia. *Making Americans: A Manual.* New York City: NCJW Committee on Naturalization and Citizenship, 1938.

Reiter, Rayna R. *Toward an Anthropology of Women.* New York: Monthly Review Press, 1975.

Rodnitzky, Jerry L. *Feminist Phoenix: The Rise and Fall of a Feminist Counterculture.* Westport, Conn.: Praeger, 1999.

Rogoff, Leonard. *Homelands: Southern Jewish Identity in Durham and Chapel Hill, North Carolina.* Tuscaloosa: University of Alabama Press, 2001.

Rogow, Faith. *Gone to Another Meeting: The National Council of Jewish Women, 1893–1993.* Tuscaloosa: University of Alabama Press, 1993.

Rosaldo, Michelle Zimbalist, and Louise Lamphere, eds. *Woman, Culture, and Society.* Stanford: Stanford University Press, 1974.

Rosenberg, Rosalind. *Beyond Separate Spheres: Intellectual Roots of Modern Feminism.* New Haven, Conn.: Yale University Press, 1982.

Roth, Darlene Rebecca. *Matronage: Patterns in Women's Organizations, Atlanta, Georgia, 1890–1940.* Brooklyn: Carlson Publishing Inc., 1994.

Rowe, Beverly J. *Women's Status in Texarkana, Texas in the Progressive Era, 1880–1920.* Lewiston, N.Y. and Lampeter, Wales: Edwin Mellen Press, Ltd., 2002.

Rubin-Dorsky, Jeffrey, and Shelley Fisher Fishkin, eds. *People of the Book: Thirty Scholars Reflect on Their Jewish Identity.* Madison: University of Wisconsin Press, 1996.

Ryan, Mary P. *Cradle of the Middle Class: The Family in Oneida County, New York, 1790–1865.* Cambridge: Cambridge University Press, 1981.

Sacks, Maurie, ed. *Active Voices: Women in Jewish Culture.* Urbana and Chicago: University of Illinois Press, 1995.

Sangster, Margaret E. *Winsome Womanhood.* New York, Chicago, Toronto: Fleming H. Revell Co., 1900, 1901.

Sarna, Jonathan. *American Judaism: A History.* New Haven, Conn.: Yale University Press, 2004.

Schmier, Louis, ed. *Reflections of Southern Jewry: The Letters of Charles Wessolowsky, 1878–1879.* Macon, Ga.: Mercer University Press, 1982.

Schultz, Debra L. *Going South: Jewish Women in the Civil Rights Movement.* New York: New York University Press, 2001.

Schultz, Rima Lunin, and Adele Hast, eds. *Women Building Chicago, 1790–1990: A Biographical Dictionary.* Bloomington and Indianapolis: Indiana University Press, 2001.

Scott, Anne Firor. *Natural Allies: Women's Associations in American History.* Urbana and Chicago: University of Illinois Press, 1991.

——. *The Southern Lady: From Pedestal to Politics, 1830–1930*. Chicago: University of Chicago Press, 1970.

——. "Women, Religion, and Social Change in the South, 1830–1930." In *Religion and the Solid South*, ed. Samuel S. Hill Jr., 144–148. Nashville: Abingdon Press, 1972.

Smith, Daniel Scott. "Family Limitation, Sexual Control, and Domestic Feminism in Victorian America." In *Clio's Consciousness Raised*, ed. Mary Hartman and Lois W. Banner, 119–36. New York: Harper and Row, 1974.

Smith-Rosenberg, Carroll. *Disorderly Conduct: Visions of Gender in Victorian America*. New York: Alfred A. Knopf, 1985.

Sochen, June. *Consecrate Every Day: The Public Lives of Jewish American Women*. Albany: State University of New York Press, 1981.

——. *The New Woman: Feminism in Greenwich Village, 1910–1920*. New York: Quadrangle Books, 1972.

Solomon, Hannah Greenebaum. *A Sheaf of Leaves*. Chicago: Privately printed, 1911.

——. *Fabric of My Life: The Story of a Social Pioneer*. New York: Bloch Publishing Company, 1946.

Sorin, Gerald. *A Time for Building: The Third Migration, 1880–1920, Jewish People in America*. Vol. 3. Baltimore: Johns Hopkins University Press, 1902.

Stanton, Elizabeth Cady, and the Revising Committee. *The Woman's Bible*. Seattle: Coalition Task Force on Women and Religion, 1974.

Stanton, Elizabeth Cady. "Document 19, Stanton Introduction and Commentaries on Genesis, Chapter 1–4, *The Woman's Bible*." In *Elizabeth Cady Stanton, Susan B. Anthony, Correspondence, Writings, Speeches*, ed. Gerda Lerner, 228–45. New York: Schocken Books, 1981.

Staub, Michael E., ed. *The Jewish 1960s: An American Sourcebook*. Waltham: Brandeis University Press, 2004.

Strong, Josiah. *Our Country*. Cambridge, Mass. The Belknap Press of Harvard University Press, 1963. Reprint of *Our Country: Its Possible Future and Its Present Crisis*. New York: Baker & Taylor Co. for the American Home Missionary Society, 1886, 1891.

Tarpley, Fred. *Jefferson: Riverport to the Southwest*. Austin: Eakin Press and Jefferson Carnegie Library, 1983.

Teeter, Donald L., and Gertrude M. Teeter. *Texas Jewish Burials: Alphabetically by Name*. Baytown, Texas: Texas Jewish Historical Society, 1997.

Texas Almanac. Millenium Edition. Dallas: *The Dallas Morning News*, 1999. Texas Federation of Women's Clubs. *Yearbook 1900–01*.

Turner, Elizabeth Hayes. *Women, Culture and Community: Religion and Reform in Galveston, 1880–1920*. New York and Oxford: Oxford University Press, 1997.

Van Nuys, Frank. *Americanizing the West: Race, Immigrants, and Citizenship, 1890–1930*. Lawrence: University Press of Kansas, 2002.

Waggenspack, Beth. *The Search for Self-Sovereignty: The Oratory of Elizabeth Cady Stanton*. New York: Greenwood Press, 1989.

Weiner, Deborah R. *Coalfield Jews: An Appalachian History*. Urbana and Chicago: University of Illinois Press, 2006.

Weiner, Hollace Ava. *Beth-El Congregation, Fort Worth Texas, Centennial: 1902–2002*. Fort Worth: Beth-El Congregation, 2002.

———. *Jewish Stars in Texas: Rabbis and Their Work*. College Station: Texas A&M University Press, 1999.

Weiner, Hollace Ava, and Kenneth D. Roseman, eds. *Lone Stars of David: The Jews of Texas*. Lebanon, N.H.: Brandeis University Press, University Press of New England with the Texas Jewish Historical Society, 2007.

Wiesepape, Betty Holland. *Lone Star Chapters: The Story of Texas Literary Clubs*. College Station: Texas A&M University Press, 2004.

Welter, Barbara. "The Feminization of American Religion." In *Dimity Convictions: The Rise of American Women in the Nineteenth Century*, ed. Barbara Welter, 83–102. Athens: Ohio University Press, 1976.

Wertheimer, Jack. *A People Divided: Judaism in Contemporary America*. New York: Basic Books, 1993.

———, ed. *The American Synagogue: A Sanctuary Transformed*. New York: Cambridge University Press, 1987.

Who's Who of the Womanhood of Texas. Vol. I. Austin: Texas Federation of Women's Clubs, 1923–1924.

Williams, Mack. *In Old Fort Worth*. Fort Worth: *The News-Tribune*, 1986.

Winegarten, Ruthe, and Cathy Schechter. *Deep in the Heart: The Lives and Legends of Texas Jews, A Photographic History*. Austin: Eakin Press, 1990.

Winegarten, Ruthe. *Black Texas Women: 150 Years of Trial and Triumph*. Austin: University of Texas Press, 1995.

———. *Texas Women: A Pictorial History, from Indians to Astronauts*. Austin: Eakin Press, 1993.

Woloch Nancy. *Women and the American Experience*. 2nd ed. New York: McGraw-Hill, Inc., 1994.

Index

The abbreviation, NCJW, indicates National Council of Jewish Women. Photos are indicated with *f*.

AAUW (American Association of University Women), 46
Abilene, Federation clubs, 133n40
Abramowitz, Rabbi Abraham, 145n47
acculturation process. *See specific topics,* *e.g.,* Beth-El Congregation; feminist movements; fundraising activities; leadership development, overviews
Ackin, Phil, 57*f*
ACLU (American Civil Liberties Union), 149n2
Addams, Jane, 52
Adler, Lillian, 111
Adler, Rachel, 157n48
Ahavath Sholom. *See* Congregation Ahavath Sholom, Fort Worth
Aid Societies, art show sponsorships, 142n10
Alabama, NCJW sections, 1, 92
Alexander, Pheenie, 107, 108, 111
All Church Home for Children, 55
All Saints Hospital, 45
American, Sadie, 13, 15, 116
American Association of University Women (AAUW), 46
The American Citizen, 146n52

American Civil Liberties Union (ACLU), 149n2
American History Club, 133n37
Americanization School, 38–40, 57–60, 141n2, 149n88
American Jewess, 19
American Red Cross, 10, 55
Anthony, Susan B., 127n47
anti-Semitism, 6, 22, 81–82, 83–85, 98
Anton, Harriet, 93*f*, 112
appellations, yearbook names, 79–81
Appleman, Louise Kuehn, 82, 93, 100, 153n59
Archenhold, Ruby, 54–55
Archer, Isabel, 126n39
Ariel Literary Society, 133n37
Arkansas, NCJW sections, 1, 92
Armistice Day participation, 51, 53
Armour meatpacking company, 25
Armstrong, Sally, 76, 77
arrival in Fort Worth, Jewish immigrants, 5–6
Art Associations, 25, 40, 46, 142n10
art show, 40, 142n10
assimilation resistance. *See* Congregation Ahavath Sholom; gender *entries*

Weil, Bernice "Beanie," 54, 55, 62
Weil, Marion, 54
Weiner, Deborah, 129n15
Weiner, Lillian Blanc, 56
Weinstein, Loribeth, 102
Welsch, Sophia, 111
Weltman, Bettie, 108
Weltman, Leah, 108
Weltman, Louis, 61f
Weltman, Louisa, 108
Wenger, Beth S., 9, 50–51, 124n19, 142n11
Werlein, S. H., 140n93
Wessolowsky, Charles, 135n60
Wichita Falls section, NCJW, 118
WICS (Women in Community Services), 78
Wilhelm, Cornelia, 125n24
Wilkerson-Freeman, Sarah, 129n10
Wilson, Woodrow, 51
Windows on Day Care, 72–75
Winesanker, Esther, 78
Winesanker, Michael, 57f
Winston, Dorothy Diamond, 81, 82, 112
Wittenberg, Pauline Landman, 83, 112
WJCC (Women's Joint Congressional Committee), 51, 52
Wolf, Erwin, 59f
Wolf, Mrs. Alex, 80
Woloch, Nancy, 12, 151n32
Woman's City Club, 143n18
Woman's Civic League, 146n57
Woman's Club, Fort Worth, 48–51, 152n49
Woman's Club, Houston, 133n37
Woman's Club, Waco, 133n37
Woman's Club of Denver, 142n16, 146n57
Woman's Peace Party, 52, 147n68
Woman's Press Club, 133n40
woman's suffrage movement, 125n24
Woman's Wednesday Club: art show sponsorship, 40; as Federation member, 133n37; founding, 18, 20, 128n6; membership standards, 130n18; and Monday Book Club, 132n29

Women in Community Services (WICS), 78
"Women in Power" luncheon, 93, 155n19
Women's Center, 76–77, 152n45
women's clubs movement, overview: Fort Worth clubs listed, 119–20, 130n20; Jewish participation, 18–20, 129n10; origins/development, 11–16, 23–25; regional patterns, 122n13, 123n14. *See also specific topics, e.g.,* Congregation Ahavath Sholom; immigrant/refugee assistance; leadership development, overviews
Women's Department Club, 41–42
Women's Haven, 77, 152n45
Women's Joint Congressional Committee (WJCC), 51, 52
Woolstein, Clara, 137n74
World Government Day, 53
World Parliament of Religions, 13
world's fairs, 12–13, 16, 126n44
World War I, 51
World War II, 53–54, 60, 61, 148n76
Wormser, Gloria, 137n74
Wormser, Nora, 116, 137n74
Wynne, Laura B., 41, 42, 116

XXI Clubs, 133n37, n40

Yamparica club, 133n40
yearbook, name structure, 79–81
Young Men's Hebrew Association, 145n47
Young Men's Hebrew Social Club, 140n93
youth support activities: African American neighborhoods, 43; Boys' Shelter, 43, 44; Department Club's, 42; Junior Council, 145n47; juvenile delinquent facility, 66, 71–72; playgrounds, 43, 44, 83–84

Zepin, Rabbi George, 32
Zionism, 32, 47, 85. *See also* Hadassah
Zulouf, Theresa, 59f